Early Love and Brook Trout

Preston Mountain Club

BOOKS BY JAMES PROSEK

Trout: An Illustrated History

Joe and Me: An Education in Fishing and Friendship

*The Complete Angler: A Connecticut Yankee
Follows in the Footsteps of Walton*

Early Love and Brook Trout

Early Love and Brook Trout

WRITTEN AND ILLUSTRATED BY

JAMES PROSEK

THE LYONS PRESS

Design by Liz Driesbach

Printed in Canada

10 9 8 7 6 5 4 3 2 1

Library of Congress Cataloging-in-Publication Data
available upon request.

Early Love and Brook Trout

Brook trout in a pond

Speak what you think now in hard words and
tomorrow speak what tomorrow thinks in hard words
again, though it contradict everything you said today.

Ralph Waldo Emerson, "Self-Reliance"

I have spread my dreams under your feet;
Tread softly because you tread on my dreams.

W. B. Yeats, "He Wishes for the Cloths of Heaven"

It was July-hot in New York and I was going downtown to have lunch with Nick. He asked me if I would write and illustrate a little book about brook trout. "Okay," I said.

This is that little book, ranging lightly over my years from nine to twenty-four, trying to open a window to my thoughts during that time as a river's surface occasionally does to its depths. It is a lyric book, not one with a lot of explanations and analyses. And it is maverick—a handful of varied thoughts and glimpses, placed under the elusive heading of "early love and brook trout." The text and paintings in this book are meant to convey the hidden and dreamlike qualities that I associate with this, my favorite fish.

Self-portrait, casting in the Mill River

1

Early Love and Brook Trout

WHEN I dream, I sometimes smell the resin on my pillow as if I were in the tent again. Thick pine forests, bull moose sloshing in the shallows of a north woods lake, the call of a loon at dawn, clear running water over colorful stones, and mosquitoes in thick dark shadows highlighted by rays of sun and light thickets of green fern. I think of the Ausable Lakes in the Adirondacks, mountain laurel and rhododendron in bloom in the Smokies of Tennessee, the trill of a banjo or the haunting warble of a wood thrush under a thick summer canopy. I think of first kisses with a freckled girl, of abandoned New England farms and limestone Civil War homes on Pennsylvania spring creeks. Old books and passionate anglers, garden worms and colorful fishing flies, old friends, old habits, my father. Mason jars filled with homemade pickles. Small boxes filled with lures, light hair-wisp lines, autumn leaves covering mirrored ponds.

I have written this little book in order to recapture something in my-self that is still within me that I never want to forget. I don't want this to be a big book, because big books have no place in the brook trout fishing I have in mind; neither do big thoughts. I want to be innocent again. I want to wake up at my friend Stephen's house to snow in February, to follow that twelve-year-old down the road and through the woods, by the old abandoned barn and silo, and over Patterson Brook to the Mill River. I want to lay out the topo map on his kitchen table where hot toast is steaming and follow that thin blue line of the Mill River with my finger to the spot that we had in mind. I want to throw the spinner in that pool where wild life first came flashing and feel that pause and rolling pull of a little colorful mass and lay his length of grams in the snow, and see the precious imprint he leaves there when he swims away.

2

Warblers

WHEN the world was perfect we found two warblers that had flown into the window of our house in Connecticut. Those days I didn't fish for

Small brook trout chasing moth

trout. I took naps with my head in my mother's lap as the sun came in and out of clouds. Those days we put tobacco nets over the blueberries while they were still green to keep the birds from eating them. Once there were scarlet tanagers under the net. They had come to eat the berries, which were now blue. I thought I'd never seen such a red as the red under the black wings of the male tanagers. A dead warbler in my hand was some kind of wonderful mistake. One that hit the window was a chestnut-sided warbler, the other a magnolia. Their bodies were still warm, their colors vibrant, their eyes black.

I had a good friend named Candy. She was my neighbor's short-haired hunting dog. Candy's belly was warmer than a spring sun. She liked to nap in the freshly mown grass. We fished together at the pond for pump-kinseed sunfish. In summers you could hear the *pop* of sunfish picking snails from the undersides of lily pads.

My father and I walked the warm fields on our street. The grass was taller than I was. We collected the caterpillars of monarch butterflies and grew them in jars with milkweed leaves until they spun their chrysalises. We hung the colored silken drops from the eaves over the back porch. That's where we lunched in summer, sharing pieces of salami sandwiches with the dog Candy.

Warblers

3

Discovery Pond

THERE are black crows overhead. You can see them now through the forest because some leaves have fallen. The rest of the leaves on the trees are colored: red-mauve for oaks, orange-yellow for maples, green still for the roots of beech leaves, fire red for the poison ivy vines that cling here and there to bark by hairy tendrils. I flush a ruffed grouse in a dark part of the swamp and its sound shakes the stillness of the woods. In corners of black water the tufts of grass have ice at the root, hoary remnants of the morning frost. The frost crisped the apples in the orchard and crippled the basil in the pot on the porch. At home my father was talking about how the frost gave the Swiss chard in the garden a nutty flavor.

That morning on the stainless steel countertop of the kitchen I packed a sandwich in the rucksack with my box of lures and hooks. The linoleum on the kitchen floor was cold to my feet. It felt nice to get out early. I wore comfortable clothes and leather boots and I drove north under purple clouds. I saw few cars on the way. It was me, a map, a sandwich, and fishing gear. It was me and the open window in the car and dry leaf smells and migrating hawks far up overhead.

Heron on Discovery Pond

I passed only small streams on the way. I was distracted several times by gray squirrels carrying nuts and acorns across the road and by chipmunks doing the same; they were the color of rusted hardware on old barns. The brooks bubble black this time of year under the falling leaves, cold as the crisp air. Death smells good.

The roads in the town of Redding are narrow. Some are narrower than is convenient for two-way traffic. There are 180-degree turns and steep humps in the road. The roads take you by sheltered nooks with homes that have stood since before America was independent of England. A lot of the older ones are saltbox homes, with back roofs that slope farther than the front. In the woods off Spring Hill Road there's a small group of gravestones. You can see them dark against the yellow sugar maples. There is light green lichen on them.

The roads have taken me to a small windy path called Dodgingtown. I leave my car and go by foot in my leather boots with the rucksack.

Nobody but me knows that today I'm an explorer. I'm in the wild because I'm out of view of any houses. I'm walking in a wooded preserve of several hundred acres that was once owned by a woman named Huntington. One hundred fifty years ago this was open pasture, vast fields divided by stone walls. Some trees are older than that; some big sugar maples, some white oaks. It is high enough here on Sunset Hill to see Long Island Sound. Turkey buzzards are circling in the last warm sun.

I'm exploring the upper reaches of a little brook that I know has natives farther below. On my map I can see two small ponds where I have never been. The ponds are fed by the brook and I'm thinking the fish can grow bigger there. The creases on the map where I folded it are new and crisp. Above me are the horning cluck and the blow and wind of moving wings: Canada geese heading to their wintering grounds.

I get lost a little because I want to and it's too early to eat lunch. Where I get lost is below the dim green of a white pine stand. The white pines are tall and straight. There are as many down as standing. Where they have split and rotted the insides are red. I walk along on top of their horizontal trunks from tree to tree and over stone walls until I am free of them. I use my fishing rod as a balance tool here and there where I lose my footing. It is quiet to walk on the pine trunks. Quiet sounds and smells come from the live needles on the living trees. For some time I'm walking on a bed of soft needles. When I leave the stand of tall pines, the leaves fallen and dried are loud underfoot.

I see the flash of a white-tailed deer making its way from me through the wood. The sky is all clear of clouds now. The sun has warmed the ground but my nose is still dripping from the cool morning. I run my hand over the wool of my knit sweater. I'm perspiring when it hadn't seemed possible. I've walked some two miles. Below me, through the trees, the standing water in the swamp has run into a little brook. Below that, through some spots of sun, is the first of two ponds on my topo map.

I come up on it quietly. It has no name on the map. I call it Discovery Pond.

The pond is large enough for the sun to meet at any time of day. It spreads out like a mirror on the floor of the wood, reflecting the whole world. On a rock in the middle there is a heron standing. Behind him a fire of leaf color is burning. The heron flies and perches on a tree. Beneath him the water is dark. The water is tea in a clay mug fired black. Sometimes there are submerged branches in the water. If they are close enough to the surface, they appear red. I have a little lure on my rod. It came from my little orange box. Between the dividers in the box are lures of all colors. They are mostly spinners with silver blades and minnows carved out of balsa wood. The one on my rod has a yellow body and yellow hackle on the tail. It weighs one twenty-fourth of an ounce. When I cast the lure in Discovery Pond it plops and disturbs the reflection of the fire burning in the water. Now it's a fire behind heat waves. The heron is still there. I can tell that the blade on my lure is spinning because it resists my pull through the water as I reel it in. When it's close to me I can see it flashing in the red tea water. A dark shadow passes over it.

Missed.

The shadow is a solid object because it makes a swirl and wake behind the lure. The shadow is a tenacious little fish. I cast again in the same spot and kneel on the damp bank when I retrieve. I'm thinking the fish may have spooked when he saw me.

I begin to retrieve the lure and the shadow hits it. The fish pulses in the dark water. It's a toothy pickerel—a slim fish with rows of white teeth from the tip of his nose to the place in the back of the mouth where our wisdom teeth grow. It's a fifteen-inch pickerel with yellow-green and sienna brown and a pattern of chain links on his sides. The sun is warm on my neck. I see a little tail sticking from his mouth. The tail has a black rim on its square margin. The pickerel has swallowed a brook trout headfirst.

I throw the pickerel on the bank to let him die. He flops his sticky sides in dry autumn grass and leaves. He flops on the fallen wiry fingers of a thorny wild rose. A line of blood drips down his pectoral fin and circles to his white belly. The slime on his eye dries. He is a moving ball of ochre grasses and red leaves. I cast in the pond and turn my back to the fish. He flops for a minute or two. I run my hand down my neck to wipe off the sun. Then I put my rod down, pick up the pickerel, and bring him to the rim of the pond. I walk in the peat bank and water crawls up my boots above the laces. As I lay the pickerel in the pond I feel cold water in the wool of my socks. I hold the pickerel by the tail and submerge him. Then I stroke the grasses off his scales and the hard plate on the top of his long flat head. He shakes in crescent curves as his gills work the cold dark water. He swims away when he is ready. I let him be a predator again.

I cast the lure along the peaty bank of the pond and then out across it. I don't want to change anything. Then I hook a brook trout. It is an eight-inch brook trout, a male with a fire-engine red belly. His back and eyes

are black from living in the tannic water. He is larger than the ones I caught in the stream lower down. There must be a few big trout in this pond, I think.

I am happy with the name Discovery Pond. I pull my rucksack off. There is cold sweat on my back where it had been. I sit on a rock warmed by the sun to eat my lunch. The mayonnaise on my sandwich makes the dry turkey easier. My pickle ran a little on my cookies. That's all right. A can of apple juice. A red apple with yellow smears. A paper towel for a napkin. Migrating hawks are dark, like apple seeds, against the blue sky.

It is a late lunch. Already there are signs of the afternoon sadness. The sky becomes platinum, overcast, cool. The crows are flying closer and roosting in the trees. I can hear the force of them in the pine forest, harassing an owl.

I make more casts as my fingers grow stiff with the cold. I can feel the lure hit by fish. A male brook trout lodges the hook in its upper jaw. It planes on the water with its long-white rimmed fins. I see its long broad jaw and proud colors as it lies gasping on the peat.

I cast now by a fallen tree. I let the lure sink to see how deep the pond is. As I pull it spinning through the branches it hits a snag. I pull the line straight and break off the lure. I take off my rucksack to get another lure. This time I try a red spinner. I tie it to the bare end of the line.

Again I cast the lure to the deep sunken tree. Again I let it sink. It snags—but this snag is a fish. It gives like a limber waterlogged branch and

pulls back when it can bend no more. The fish pulls drag across the pond and then I take line on it. It must have a broad tail to make such a *thump* in the water. There is no seeing it, especially now with the clouds heavy and dark. I believe this fish to be big. I have it close now and it turns its deep amber flanks on the surface. It is a trout. It has grown too big for pickerel to swallow.

The large fish fans its olive dorsal fin as it turns and breaks my line.

4

Natives

JOE Haines, an old game-warden friend of mind, lived in a red eighteenth-century home on Old Oak Road. He wore a green hooded sweatshirt and green Dickies. His face was ruddy and his white hair floated in wisps above his forehead. Out in the yard and in the garden, he had a pair of rubber boots that he often wore. They had no laces; he just slipped them on. Through his terraced yard ran a small brook with native trout. "These are natives," he'd say every time we turned over the leaves to find the wiggly

worms; "their bellies are fire-engine red." We tossed the worms in the pool by his house and watched them disappear. "Zoom," said Haines and showed his teeth, laughing at how quick the trout were. "Ha ho, did you see that one, James?" They were little trout, six inches maybe, with little pink spots haloed by blue. They had been there as long as trout had been trout. Sometimes when the brook went low, Haines found Indian spear points among the dry stones.

Brook trout were always connected with old-timers. "Old Emil Hubert used to tell me how they caught brook trout in spring," said Haines. "They waited until the skunk cabbage had grown up along the brook so they could sneak up on them and hide behind it. Just a little garden worm on a hook. And they only took the trout they needed, never more than five fish out of one brook every year. I get a hankering once in a while for fresh brook trout in the pan. I take my little yellow rod, dig up some worms in the garden, and I go catch three or four natives. I've got a dozen spots I go to that no one else knows about."

The largest wild brookie he'd caught was in a branch of the Pequonnock River just up the road from where I lived. "It's a swampy section and you got to push through a lot of brush. That's why no one goes there. No one wants to work for it. But put in the time, James, and you'll see what you find. I caught a seventeen-inch native in there

Joe Haines fishing the Aspetuck River

once. That was thirty-five years ago. I haven't seen a fish like that since."

With scant clues I took out my maps and found the streams Haines spoke of. I searched the little roads of town and caught and released many trout. I was sixteen years old. Haines was pleased to hear there were still natives in streams he had not fished since before I'd been born.

On occasion Haines brought me places to watch native brookies. The spring behind old Bill Franklin's house bubbled up under white sand and if you snuck up carefully, there were dark black backs darting like swallows, slipping into moss and algae, zipping under stones and splashing at the outlet of the small pool it made. In the tiny creek that ran below the spring there were three-inch wild brook trout that we caught with our hands. The creek went into Patterson Brook, which laughed its way on down through beech and oak and swamp maple and hemlock to the reservoir. When big rains came there was a ditch within a hundred yards of Stephen's house where brook trout would travel and get stranded.

My friend Josh and I used to spend hot summer days in the brook by Haines's house digging out pools and building little dams by piling rocks and sticks to hold water for the trout for the dry months. Some summers were bad for the trout. The water went very low and the herons and raccoons cleaned out at least the bigger fish. Old-timers told us about days when the brooks never ran dry, and told us that too many wells and garden hoses and private pumps and golf courses were taxing the water table. It was

up to us, we felt, to save the wild trout. It was a duty we relished. It gave us pause and purpose, and me and my little circle of like-minded friends had mapped out all the spots for wild brook trout in town. These were our secrets. No one knew about them and mostly no one cared.

Some of my favorite spots to fish for brookies were where the little brooks ran through town centers and under bridges. There I felt covert and sneaky, stealing along grassy plots and people's yards, inconspicuously catching trout where no one thought there were any.

"You are fishing for what?" homeowners would say.

I never got any trouble from people for fishing in their yards except once when a guy thought that instead of a fishing rod I was carrying a gun. He ran out of his house screaming at me and I just stood still. But when he saw I was only fishing he left me to the brook. Once or twice, maybe more, I'd meet an older fisherman who was fishing one of my secret streams. These fishermen loved small streams overhung with willows and alders, too, and we became friends. We traded streams as stockbrokers trade tips and each of us always came out the wealthier for it. We had good parts of the western half of Connecticut mapped in a web of unnamed, barely discernible waterways, some in out-of-the-way places, some near strip malls and gas stations. Our conversations would turn to different names as the seasons passed. In the fall it was the Halfway River, where the big browns ran up out of Lake Zoar to spawn. In spring it was Wewaka Brook. The Pootatuck was always good, and the one with the longest name was Naromiyocknowhusunkatatankshunk.

Old Bill Franklin told me about "Naromiyock," as he called it. "The way to say it," he said, "is *Naromiyock-nowhusun-katatankshunk*." He had stolen the road sign off the bridge under which the brook flowed in Sherman and he wasn't going to conceal it; he hung the sign over his fireplace. But I liked to think I was the only one he told the truth to about where the sign was from, that it was his favorite brook trout stream of all.

5

A Kiss

BEFORE we left, she snuck me up the stairs to show me her bedroom. She was fourteen—pale, thin, and blue-eyed. I was late to pick her up. My baseball game had gone into extra innings. She seemed excited I had arrived.

Whitney's room was dimly lit: soft white walls, a pleasant shuffle of papers, a dresser with photos of friends, clothes, underwear, a wool cap. I had never been in a girl's room before.

Her hair was still wet from her shower. It was long and dark and straight. She was silent and smiling.

Heron on the Aspetuck River

I had found out through a friend that she liked me. I had just come of age to drive and a girl had never sat in my car before. I felt clean and light.

Kate and Keith were waiting at Kate's house. Whitney's mom would not let us on a date alone, so they would accompany us to a movie in New-town. They were friends from Whitney's freshman class.

I had thought it out well. I felt comfortable by rivers and I thought we'd all go to one before the movie and sit there. I said that we could eat dinner at Monroe or go to the river. The four of us thought the river would be nice. That's where I'd be anyway at this hour on a Friday in spring, pushing up the stream in my waders. This river, intimate and small, was a series of sharp bending pools, deep with cold water over clean gravel.

The proximity of the stream to the Newtown theater had not occurred to me until now. The stream flowed under the shadow of Interstate 84 but before that it ran through farmland—great black fields with the first greens of the ryegrass rising sharp like swords. There would be goldfinches at the edge of the field. By now the males were yellow. Even from a distance you could recognize their undulating flight.

This was the Pootatuck. I had learned of it from Joe Haines. He hinted that in it I might find wild trout. I'd been discovering the stream for a year now. Already I'd caught memories of submerged tree roots where trout hid, places the cardinal flowers grew, and the otter den.

I parked my car at the dead end where I had picked winterberries last autumn. There were two big bushes of it. I had brought two blankets to sit on. I handed one to Keith.

We first saw the river at the spot where Josh had caught the big brook trout. The log under which he'd caught it was still there. Maybe the fish was, too. It must have come down from the fishing club upstream, where they stocked big fish. We had not expected such a big fish to come from this modest stream.

It occurred to me how meaningless this place was to Kate and Keith. I assumed that Whitney would know what it meant to me.

It felt strange to walk the river without my fishing rod. The surface of the river was purple-black and cold and I knew there were trout in its depths. I expected the river to ask me why I was here if I did not intend to fish but it went on about its business, making its swirls where it always did, waving its reeds in the breeze, burning its breath over wet stones. I was almost mad at it for not noticing.

"This is fine for us here," said Kate. They called the bit of bank where they'd lay the blanket a peninsula. It had not occurred to me to call it that. Whitney walked on with me up the Pootatuck. We came to a small brook pushing into the main flow under a stand of trees. There was a big field on the other side. "Let's go beyond the stream," she said. "Should I take off my shoes?"

"I don't mind my feet wet," I said and picked her up, then sloshed across the brook with her weight on my forearms. She recovered her step on the opposite bank.

I heard the fine metal sound of a cock pheasant. Soon the farmer would plow over the rye and plant corn. I lay out the blanket in the grass. I didn't ask Whitney if she liked the spot. She lay down on the blanket and I lay next to her.

This was no longer a place where I had caught fish. I was facing up to the sky. The barn swallows had returned. I recognized nighthawks. I turned and saw that a deer had come quite close to us.

In the stillness Whitney asked, "Have you ever heard someone's heartbeat?" Her voice rose unevenly from the ground.

"Can you?"

I nestled closer and she lowered my head with her hands and rested my ear on her breast.

"Gosh," I said.

There was a cavern there that echoed in boundless seas. The waves rose and fell with respiration. The fibers of the blanket felt soft. I put my hand on her warm belly. She gave her lips and then withdrew with a smile. She gave her lips again. She knew when to give.

We were late for the movie.

Otter tracks in the snow

6

The Otter

I FOLLOWED otter tracks in the snow. I'd brought my fishing rod but the brook was only a continuation of white drifts. The otters went sledding down the hills. You could see the imprints of their bodies in the snow. There was a spot wide enough, by the inlet, where they could slip into the pond.

I started to follow the track of a coyote. Here and there in the snow I saw spots of blood. The trees had already shaken the snow from their branches. Swaying overhead in a breeze the trees bellowed long creaks. The coyote track became two tracks. There was more blood and now there was hair on the snow. Snow clung to the north side of the trees. It was frozen there. Now the hair was in clumps. It was deer hair, and I could not count the number of coyotes there were so many. Here was where the deer had fallen, but there was hardly any bone left at the kill. It was only blood and hair.

7

Whit

WHITNEY and I came into our own that summer when we were visiting her father, a cigarette-smoking architect who lived in a house near the West Redding train station. I remember taking off Whitney's clothes in the dark of the living room and the sound of the train pulling into the station and itching the poison ivy bumps on her freckled breasts. Her father had just gone upstairs to bed. A butt in the ashtray was still smoking.

I made a laurel crown for her one morning after we walked from her father's house to the nearby Saugatuck River. A smile snuck out across her face under each of her blue eyes when I put it on her brown hair. Her little brother Robby came along and caught his first fish in the pool near the railroad tracks. It was a small silver chub with little horns on the top of its head. It had some orange on its belly. Whitney caught her first fish, too, and I remember how her smile reflected in the green water. Whitney's mother eased into the idea of me being around when I started coming just to take Robby fishing. He had taken to it with enthusiasm. Fishing became a way for me to spend time with Whitney away from her house. We also went to

watch Robby's baseball games. On Whitney's fifteenth birthday her father made hamburgers on the Weber grill.

When school started in the fall Whitney and I ate lunch together. We took our lunch outside the school halls and cafeteria in the open on the fringe of the playing fields. I packed two of the apples we had picked together that weekend. Since our relationship had begun some months earlier in spring, we had memories of playing tennis and looking for crayfish in the brook that ran through her backyard. On our way back to her house one day, on a walk from the Saugatuck Reservoir, a thunderstorm came up on us suddenly and Whitney was afraid. We took walks on trails through Devil's Glen, we shared thoughts, and we talked every day. So it was difficult for me when Whitney did not want to take walks anymore.

I took Whitney to my favorite spot for brook trout where Wolf Pit Brook fed Discovery Pond. She had lived all this time not far from where I'd spent my best times alone. It was the peak of autumn colors. The leaves and the moss-covered ledge near the inlet of the deep dark tea-stained pond were as I remembered them when I first saw them. Whitney caught a trout there. It was a handsome male with a large square jaw and thick profile.

The death of this season seemed sadder now that Whitney failed to smile.

Blueberries in the orchard

8

Johnny Troutseed

THERE are basically two major watersheds or drainages in the western part of Connecticut: that of the Housatonic River and that of the Naugatuck. Bob Perella lived and fished mostly the Naugatuck drainage streams. I dubbed my friend Johnny Troutseed because he raised wild trout stock in his basement and released the offspring around various streams when he decided they had grown big enough. His efforts were illegal but he was helping the local populations along, or at least he thought he was, so that was all right. His pet stream was the one that went through his yard in Southbury, Bullet Hill Brook.

Bullet Hill Brook was one of the few spring-fed streams I knew of in the state and Bob had showed it to me.

I had met Bob, a middle-aged engineer's assistant, on Sawmill Brook one October. We had both come to Sawmill Brook to see the run of monster brown trout that came to spawn there. Some were as large as twelve pounds and no one knew about them but us. The day I met him we got to talking and he must have decided I was okay because he showed me some pools on the Shepaug River and told me about Bullet Hill Brook.

As the light was leaving us that day by the Shepaug he pulled out of his glove box a small pile of color photos. Several were of a massive brook

trout, maybe twenty inches and four pounds, which he had seen and caught in this little brook.

"Where did it come from?" I asked him. I couldn't believe the size of the fish. The idea of such a fish, a wild fish, in Connecticut, bred in the tannic babbles of my home state, was just short of miraculous.

"It must have come up out of a larger stream," I said to my new friend.

"You'll have to come and see," he said, laughing under the umbrella of my youthful enthusiasm for the treasure he had found and decided to share.

Bob made stream thermometers in his basement and had a small business selling them. Through this small enterprise, for which he had also employed his teenage daughter, Bob made enough money every year to buy new fly lines and maybe a rod or a pair of waders to replace the leaky ones. Besides adoring this small stream that ran clogged with watercress at its jubilant source, he was also its keeper. He prided himself with this private and secret position.

Bob always spoke of opening day of trout season with scorn. In Connecticut this was the third Saturday of every April. One year he asked me to help him prepare for the opening-day frenzy, when anglers of all years and skills assault, pound, ambush, and tackle every waterlet in the state. Even Bullet Hill Brook, barely a running spitule to most and incomprehensible as a viable trout stream, saw pressure. So several days before, in the sometimes pleasant, sometimes dreary and cold of early April, we walked the stream from its source to its confluence with the Pomperaug River, a stretch of about half a mile or more, and strung dental floss and

cotton string from the trees to cover all the big pools where most of the trout were. The major threat to the trout lasted only about three weeks. Ninety percent of the anglers retired their rods after the initial rush. That's when Bob would walk again and remove all the floss and cotton string from every branch and twig, leaving no traces of his preservationist art, picking off and saving, too, the lures and flies of frustrated anglers caught in his charming web.

Consider a man who loves trout so much. His efforts produced astounding results. There were both wild brown trout and wild brook trout in this brook that never exceeded seven feet in width except during very high water. The largest resident brown I caught here was fifteen inches, the largest brook trout thirteen, which was a fine native brookie. Most Connecticut streams with wild trout held the odd big fish. But if there was a dry summer, most of the larger fish fell victim to the raccoons and herons, and the next season there were no big fish. It was only after wet summers that you caught big fish in the following season. But in Bullet Hill Brook, Bob's stream, the water flowed well even in dry summers.

Before Bob had introduced me to this stream, I had probably found on my own, wandering and exploring, thirty or more separate streams with native brook trout populations, but this was the jackpot. I remember one December day—it may have been the winter solstice—when I caught twenty-seven trout out of one pool. Fishing all year I came to realize what the trout did as seasons passed, that they often stacked up in the

Male and female brook trout

deepest pools to winter over. My best day on any river in Connecticut, in terms of numbers, was sixty-seven trout, out of the Halfway River, all released, but that was a full day of fishing and on a full two miles of stream. I rarely fished more than five hundred yards in Bullet Hill.

One day, one October, Bob called, excited to tell me to come over and see the big brookie that had come up out of the Pomperaug to spawn. I rushed over to the bridge in the center of Southbury.

"My God," I said to Bob, leaning over. "I've never seen a fish like that."

It was like the one he'd showed me, the one in the photo he kept in the glove box of his car.

9

Blueback Country

ON our way from the north woods to the Rangeley Lakes one night, Taylor and I camped on a slope of green above a graveyard. As we were packing up that morning, the tent still wet with dew, we saw a bull moose tossing his weight through the tombstones.

This was the summer after graduation from high school. We had gone up to Maine in search of blueback and brook trout. From a small map supplied by the Inland Fisheries and Wildlife Department, we'd identified where we wanted to go—nearly to Fort Kent at the headwaters of the Red River in the north woods. The Red River Camp was owned and operated by Mike Brophy and was accessed by logging road from Portage. It was a fourteen-hour drive from our hometown to the Maine camp. Taylor's Jeep was good on the logging roads.

We had not made it to Portage by dark. We were twenty miles out of the last town on Route 11 and decided we'd pull off the road, save the money we'd spend on a motel, and pitch the tent. It was disastrous. To see, we set up the tent by the headlights of the Jeep. This was a mistake. It was early July and swarms of bugs were attracted to our lights. When the tent was half pitched, we ran inside and zipped our sleeping bags to our noses. Inside the tent it was hot and sticky. Mosquitoes dive-bombed the nylon. The din of insects outside was horrific. I wondered how they made such a noise. Then we realized we'd left the lights on in the Jeep.

"You forgot to turn off the headlights," I said to Taylor, who was snug in his sack.

"*I* did? What good are you?"

"It's your car."

"But neither of us is getting out of here tomorrow if one of us doesn't move now."

When Taylor returned from the Jeep we had more flies in the tent, flies that preyed on our only exposed flesh—the tips of our noses. Taylor managed to fall asleep. I don't know how. The sleeping bags protected us mostly, but the air had not cooled after sunset and if we stayed we would have sweated away our lives by morning. So we pulled up the tent, threw it in the Jeep, and found a hotel room in Ashland.

In the morning we turned onto the logging roads, a left after Portage. The closer we got to camp the worse the roads got. A stream ran over the road and Taylor crossed it. Up a steep hill, down a steep hill, and then there was the pond, with a cluster of red cabins on the margin.

Mike Brophy came out to greet us. He had hands the size of moose antlers and a broad face with bear eyes. He cooked eggs and bacon the way I liked them and was determined in our three days at Red River Camp to get us a blueback trout. He kept the camp open from ice-out in late May until October. In the autumn he guided moose hunts. In the winter he worked at the paper mill near Presque Isle. Mostly, though, Aroostook County was potato farms. If you didn't farm potatoes you ran a hunting and fishing camp, and if you did neither of those you were in the lumber and paper business.

Taylor and I had never been on our own for a month before. We had started our journey at Taylor's home in the winter, laying out topographic maps on the floor of the loft above his parents' room. New England was a

web of waterways. We traced blue lines with our fingers and dreamed of fishing in them as the snow fell on the orchard outside the loft window.

Then summer came and we were free and starting our new lives away from home. Once we were on the road we scrapped the order of things. Our trip would take us to the north woods of Maine, the Rangeley Lakes, then the headwaters of the Connecticut River in New Hampshire. Taylor's grandmother had a house in the White Mountains. We planned to stop there too and fish the little streams that come off Mount Jefferson and Mount Washington to form the Ammonoosuc River.

Mike Brophy's camp was on Island Pond—though in Maine a *pond* is really a lake. Taylor and I contrived a slogan and used it between ourselves. "Everything is bigger in Maine." The brook trout were the biggest we'd ever caught, the moose were huge, the mosquitoes were the size of hummingbirds.

We were settled there now. We rigged our fly rods and through the window looked out at new waters. There was nothing to diminish our excitement. But when night came to the cabin by Island Pond, Whitney's image crept on me like an illness. I could not help thinking I had done something wrong. Could I be tired from travel? Had I lost some of my interest in fishing? Was fishing merely a reflex now? Before I had fallen in love, fishing was everything. Whitney would be a junior next year. I was going off to college. It had been nearly a year since we'd spoken. Maybe I had not

listened well to her. She'd said, "You don't get angry, James. Doesn't anything bother you? I don't think you care about anything."

"Is that why you don't want to see me anymore? You think I have no feelings? I need a reason, Whit. You can't just do this."

"Why do I need a reason?" she said. "You're not the first guy I've dumped, you know."

In the cool morning, as we paddled a canoe on Black Pond, the reflex told me to cast. My line went out across the lake. Then I stripped in the line, cast again, brought my fly back slowly. It was hot now for Maine. During the day the temperature reached ninety degrees. The surface of the lake was warm. We needed sinking lines to get our flies down to where the water was cool enough to hold trout.

Taylor and I decided to pull the rowboat close enough to shore so we could anchor and take a swim. The back of my neck was burned from the sun. I peeled off my clothes and slipped into the water. Below us in the dark water as we swam were sunken trees. We got back into the boat and paddled to deep water.

"Tell me you're not thinking about her," said Taylor. The sun was hot.

"Not really," I said.

"Who needs her, man? It's been a year now. We're going to find you a girl in Whitefield. You don't need a girl with a lot of problems. Her family's all messed up."

"So's mine," I said.

"Well, you don't need it from both sides."

"I kind of like fucked-up people," I said.

"Believe me, James, there are lots of other girls out there."

I did not believe him, but he was still a good friend.

Mostly I was angry with Whitney. I felt uncomfortable with loose ends. Being dumped for no tangible reason was a loose end. On account of her, there were many places at home I could no longer fish. I hated the consequences of association. The same thing had happened when my mother left home. All of my favorite places in the woods where we had been together turned to black roses. I did not come to think how devastated my father had been when my mother left him. Every day of our trip that went by I understood something better.

We had little luck fishing on our own. The second day Brophy offered to take us out to troll for bluebacks on Pushineer Pond. We caught many brook trout with him, but no bluebacks. In summer in the ponds the brookies were gray, almost white, and their colored spots pale. Trolling. It was dreamy to let the engine run, thinking it might pull you over a fish. I watched Mike Brophy. He ran the camp with his wife and they had two children. His face was intent. This day he had no other object but to catch us a blueback trout. We might cook it. No, I decided that if we caught one we'd let it go. Bluebacks were a rare and old relative of arctic char. I wondered if bluebacks in deep Maine lakes had the mystique for Brophy that they did for Taylor and me.

We loved to hear the loons at night. They made a melancholy sound and we could see them from the deck of the cabin. It seemed there was a pair of them that emerged from opposite ends of the lake and met in the middle. Sometimes the cry was long and drawn. Other times it was a whinny like a horse. You could count on them every evening like the green drake mayflies. It was comforting to know there were things in nature you could rely on.

Brophy liked us from the start. The first day he took us down to the pond and he said, "At eight tonight there'll be a hatch of green drakes. The trout will be up feeding on them. The pond will be pocked with their rises. What do you have for flies?" We showed him our fly boxes. He pushed through the feathered piles with his big thumb and took out a big hair-wing salmon dry fly on a size four hook. It was as big around as the mouth of a mustard jar. "You should get them on this," he said. At seven-thirty we were out on Island Pond in the canoe, and not a minute after eight giant mayflies began unfolding their wings on the surface of the water. We set our hooks to the sound of rising fish.

The third morning I heard big steps on the cabin deck. Tomorrow Taylor and I would leave camp and head south. Brophy knocked. We were assembling our fishing gear and dressing for breakfast. "I'm going to get you a blueback today," he said. His voice through the door was a comforting breeze. We could not mistrust the prophet after what we'd seen the night before. But all day we fished without a blueback. At twilight Brophy

rowed us over a deep bar in Black Pond. I was pulling a streamer over the bar and got a hit. "It's a blueback," Brophy said, extending the handle of his net over the canoe. Its sides were pink and orange. It had a little head and a slim body. The sun was setting behind high hills.

Taylor and I were happy with our trip so far. We kept tenting on roadsides, bathing in rivers, fishing wherever we found likely water. We found good fishing for landlocked salmon in the Rangeleys, below the dam at Richardson Lake. Taylor and I both caught fish. The air had cooled since we'd left the north woods and now the sky was blue, bruised by cotton white clouds with violet underbellies. We stopped at small fishing shops and bought local fly patterns. I was making a collection of colorful flies tied by local tyers throughout New England. I lined them up neatly in a foam box.

I was swimming in a state of general malaise. I kind of liked it. I no longer saw the image of Whitney but cradled some formless uneasiness she had brought me—like the feeling I get when I eat too many apples. Why, I thought, should I not enjoy this pain as much as that thing I usually called pleasure? I savored the hurt like a lollipop, trusting time would relieve me of it.

Coming through Wilsons Mills on Route 16 one morning on the road to Errol, New Hampshire, we saw the flashing lights of a police car and an old red Suburban askew to the road. Its front bumper was smashed beyond recognition and there was long black hair and blood in the grille.

We slowed nearly to a stop but were encouraged to move on by a uni-formed man. Before the red Suburban was the large black flank of a bull moose. Had the driver also died on impact? The moose was headed to the swampy wood on the other side of the road. What intent had made him incautious? How could the driver not slow in time? Surely you could see such a huge animal some way off. The scene set a strange mood for the rest of the day. Everything we saw, we saw differently. It was a wonderful veil to look through. We judged the river through tragedy and it became a tragic day.

Usually Taylor and I fish within sight of each other. That day on the upper Connecticut River near Pittsburg this meant that we both saw the same deer step into the river and swim across. It swam at equal distances between us. We stopped casting to watch it. It was good to fish this way because often we saw the same things; when we came within talking dis-tance on the river, or over dinner that evening, we had a platform for conversation. Also, if one of us caught a fish the other would come over and help land it or just play witness. If we fished out of sight of each other, things were more personal, and if one of us saw something the other had missed there was cause for regret and a need to share.

Toward late afternoon Taylor wandered upstream and out of sight, where the river went through a narrow, thickly wooded glen with steep

Taylor and a deer on the upper Connecticut

sides. I was working a trout below a small riffle. An hour went by, though it didn't seem that long. I left the trout uncaught and headed upstream to find Taylor. The Connecticut River here is a freestone trout stream tame enough in places to cross by foot. The spurce were so thick beyond the bank it was nearly impossible to walk unless you were following a game trail. There was a fisherman's path up to a point and then the going was difficult. Now it was late afternoon. I did not see Taylor. I walked for an hour looking for him. I began to think that I had missed him somewhere along the way. Maybe he had been casting below the trail where I could not see. I was not getting any fishing this way.

Stopping to pee in a stand of tall grass, I took off my vest and camera and put them on the ground so I could peel down the suspenders of my waders. Then I dressed again and walked on. I walked for another half hour. Now that the trail had ended I was pushing with my arms through unyielding spruce boughs. I could not find Taylor. He probably had not come this far— why should I think he had? Why did he have to go walking ahead? Now I was worried for him, and he was probably fishing somewhere. If I turned around now I'd make it to the car by dark. Even if something happened to Taylor he could spend a night out here if he had to. The river was fast in places and deep in others. I did not want to think he might have fallen in.

I started back. In the forest it was dark by now. I would have walked in the river if the banks were not so steep. I was above the river and could hear it below me. Then I heard some crashing in the branches. It was a moose cow. It was probably too dark to take a picture and the moose was

concealed, but I reached for my camera. It wasn't there. Where had I left it? It had been everywhere with me. It had been my father's camera. Where did I leave it? Where I stopped to pee? Where was that? Don't panic, I thought. Where the hell was that? It wasn't so far from here. Had I dropped it on the way? In these thick spruce I would never find it. Had the old leather strap given way? Maybe it had happened when I was walking in the water. Then there was no hope for it. If I didn't find it today I would come back tomorrow. I would convince Taylor to stay an extra day. Maybe I'd find it in the morning and we could head out early. I hoped it wouldn't rain that night. I began to hum to myself to keep calm.

I walked bent over for a quarter mile, thinking the camera had dropped on the floor of the forest, until I came to the water. I saw my own footprints in the mud of the riverbank. I was glad to be out of the wood. I followed myself through grass whose undersides shone silver in the twilight where I had bent them with my step coming upstream. The river was dark blue. Surely that's the stand of grass, I thought. It was the only tall stand of grass I could remember seeing. It was fortunate that I'd peed on a landmark. My camera was there.

Now I only had to get back. Here was the trail again. I would be furious with Taylor. Did I have a reason to be? I supposed not. He was not at the river by the bridge where we'd started, so I made my way back to the car.

There he was on the road, halfway down. "Taylor, you wouldn't believe how long I spent looking for you." I was hot now that I had stopped. I had not realized how fast I had been walking.

"I figured you had, so I came back here. You had to come back here eventually."

"Let's not do that again on a river like this. Do you know how thick those woods are? I was worried about you. It's nearly dark."

I felt a pang of uncertainty and that something had ended. It was a feeling that I had been handed the controls to my world. It came like the leaves fall in autumn. It was certain that this new freedom Taylor and I stepped into would be tragic and beautiful. We could stay or go, fish or not fish, drink, sleep, eat, be homesick, be scared, concerned, or indifferent, and no one was there to tell us otherwise. We pushed down the road to a pool near the car. We fished it together, alone with our thoughts, casting flies to rising trout.

10

A Tracing

JUST as every human is unique, so is every brook trout. I enjoy the ink prints the Japanese make of fish. They're called *gyotaku*. More than a painting, though the fish must be killed to make one, a print leaves behind the

Gyotaku prints of brook trout on rice paper

presence of the actual animal. The Japanese ink the actual fish and then press it with rice paper. Even if it is a century old, a print has the power of immediacy, like an entry in a journal or a gravestone rubbing. In back-woods hunting and fishing camps of Maine and Québec it is customary to trace a big brook trout on paper or birch bark to make a record of his size and to remind the angler of the day he was caught.

Sometimes when I'm traveling and I keep a trout for food, I like to trace him in my journal. When I lift him up, scales are left stuck to the paper. I note the fish's length and list the contents of his stomach. It's an activity that inspires both pause and purpose.

11

———

Brook Trout Diversity

THE species of concern in this book is the brook trout, *Salvelinus fonti-nalis*. Along their native range from Hudson Bay, Québec, to the Southern Appalachians of Georgia brookies vary tremendously—to the point that they are often mistaken for other fish. The four single specimens below provide a glimpse of their diversity.

1. SOUTHERN APPALACHIAN BROOKIE

Southern Appalachian brook trout are native to the seven-thousand-square-kilometer drainage area of the Hiwassee River in the laurel- and rhododendron-studded mountains of Tennessee, Georgia, and North Carolina.

Gary Williams and a team of researchers surveyed eighty-one high-elevation headwater streams of the Hiwassee in the summer of 1995. They reported finding twenty-nine self-sustaining native populations. Those like Gary who have seen hundreds of native Southern Appalachian trout will tell you that compared to northern brook trout their mouths and eyes are larger, and they generally have more and larger red spots. On these grounds, some biologists have granted them subspecific status. This little golden specimen is from Big Net Branch Creek in Georgia.

2. QUÉBEC BROOKIE

This slender fish with cerulean sides is from Lac Doigt d'Or, a small lily pond in the woods north of Mistassini on Lac St-Jean. The lakes and rivers of Québec, in particular Labrador, are known for nurturing the

largest native brook trout. Brook trout I have caught and observed in northern Maine, New Brunswick, and southern Québec are slim in the caudal peduncle, that area of the tail between the anal fin and the tail. Populations in small ponds can be dense and the fish sometimes stunted.

3. TANNIC BROOKIE

My home state of Connecticut harbors an inexhaustible network of small streams, most of which drain the Housatonic, Thames, and Connecticut rivers. Many of these, shaded by hemlock and oak, are dark through win-

ter and summer. Protected from direct sun, the water stays cool through the hot and muggy Julys and Augusts. The streams are dark and tannic stained, especially in autumn, when the oak, maple, hickory, and beech leaves collect and steep like tea in pools and eddies. Often the brookies from these streams are dark as well. Pictured here is what my friend Joe Haines would call a "black-bellied brook trout," from Lebanon Brook, a small trickle in Newtown that seeps from a peat bog at the southern range of the black spruce.

4. LIGHT GRAVEL BROOKIE

To some degree, the coloration of a brookie is determined by what it eats; trout feeding on crustacea or other invertebrates high in carotene become reddish in flesh and sides. But like a chameleon, the brook trout also takes on the color of its surroundings. Placed in a white bucket with water, a brook trout will quickly become pale, but if kept in a dark well it will

after some time become very dark. This fish, from a small tributary of Lake Lillinonah, was caught over a sun-drenched pool with light gravel.

12

———

Dr. Quakenbos

I HAVE always loved books, maybe because I love my father and my father loves books. My father also loves birds—in particular, warblers. If I had my pick of birds I'd pick the scarlet tanager. I love fish, in particular brook trout, maybe because they're like scarlet tanagers and warblers—concealed (but by water, not treetops), brilliantly colorful, and mysterious. My father's favorite book on birds is the three-volume *Birds of Massachusetts and Other New England States,* by Edward Howe Forbush. He learned of the book from reading his favorite essayist, E. B. White. Sometimes I think my love of brook trout is as strong as my love of books.

I also love a book on brook trout—*The Geological Ancestors of the Brook Trout,* by Dr. John D. Quakenbos. Both Forbush and Quakenbos, now deceased, suffered from a passion, the same passion from which my father and I suffer. White said that if "Forbush's prose is occasionally

Sunapee trout

overblown, this results from a genuine ecstasy in the man, rather than from lack of discipline. Reading the essays one shares his ecstasy." Much the same could be said of Quakenbos. To describe his prose as "overblown" would be an understatement. He comes across almost as mad, enraptured to the point of delirium with the cold-water char of New England, including the brook trout and the sunapee of Sunapee Lake in New Hampshire.

On a cold snowy day when the right mood comes, when the blankets are still warm in the morning, Dr. Quakenbos's little book is a special treat. His description of the spawning ritual of the sunapee trout reads more like a Harlequin Romance than a book on fish.

"As the pairing-time approaches, the sunapee fish becomes resplendent with the flushes of maturing passion," he begins, ending a stream of descrip-

tion with, "The wedding garment nature has given to this char is indeed agleam with heavenly alchemy." Then he describes what it is to catch one. "To land a 4-pound sunapee in his prime implies the sublimination of vigilance and dexterity," he says. "But brother of the sleave-silk and tinsel, when you gaze upon your captive lying asphyxiated on the surface, his last mad rush for life frustrated, his last wintle over, a synthesis of qualities that make a perfect fish—when you disengage him from the meshes of the landing net, and place his icy figure in your outstretched palms, and watch the tropaeolin glow of his awakening loves soften into the cream tints, and the cream tints pale into the pearl of moonstone as the muscles of respiration grow feebler and more irregular in their contraction—you will experience an erethism of internal exaltation that the capture of no other fish can excite."

According to Quakenbos, the brook trout evolved from this char, which came every autumn to certain shoals of Sunapee Lake to spawn.

"And this is the fish," he continues, "from which has diverged our 'gold-sprinkled living arrow of the white water, able to zigzag up the cataract, able to loiter in the rapids, whose dainty meat is the glancing butterfly' (Myron Reed). Can we wonder that he is the one perfect fish in all the world? God be praised that he had the good taste to abandon in the course of his evolution the lacustrine depths where we never should have known him, and give his life to the riffles that chatter through the enameled champaign and to the stately flow of the silent river under the demitints of the soundless forest."

13

Fish That Live with Brook Trout

THERE are a host of native fish, from Atlantic salmon to eels, that inhabit rivers, lakes, and ponds with brook trout. Among these is the yellow perch, which Joe Haines calls "barred trout." Haines and I used to troll long lines across Taunton Pond. I had an old Fenwick fly rod then with a

Yellow perch

Study of a dead bluegill sunfish

Pflueger reel. My favorite fly was the Gray Ghost. Any movement in the aluminum boat echoed in the water. We sat still in the boat, plying the leafless shoreline. On average we caught two perch to every trout. The perch were highly colored from the dark water. Their sides were yellow and olive and their pectoral fins were vermillion red. "They're all right for eating now," Haines said, "but barred trout taste better when you catch them through the ice."

When the water in the area ponds got cold in the late fall, some brook trout from Patterson Brook would sneak into Sherwood's Pond by way of a small tributary and live with the bluegill sunfish. I know because I once caught one there.

14

Interstate 84

THERE was a no-name creek that started and stopped in a fifty-yard-wide median between the eight lanes of two-way traffic on Interstate 84. I wonder what the people driving at seventy to ninety miles an hour thought when they saw a kid running across four lanes of highway with a fishing rod to a little swath of green between the guardrails. The town workers didn't mow its banks, probably because the ground was soggy, and they had let some cedars grow. If you could shut off the traffic sounds, you would see the small yellow and red feathers of the waxwings in the trees and notice that the water ran clear and cold and that there were wild trout in the brook.

This kind of juxtaposition excited me. I'm not sure why. It was something about the clashing and conflict of things. Big snowstorms conjured

the same feelings, and so did the stories old Mrs. Kachele told me about killing rats with a frying pan on the farm.

I once fished up the short interstate stretch a few hundred yards, and then lay on the bank and felt the ground shake from the cars.

15

Kate's Hole

AT present, Taylor and I have been fishing together for more than ten years. We've been friends since we were in kindergarten. Taylor is one day short of a year older than me. He is fair-haired with light eyes. We were born on May the 23rd and 24th: Geminis. His mother took the earliest photo of us. I was five and Taylor was six and we are standing watching a large female snapping turtle lay her eggs in his neighbor's yard.

Taylor grew up in a beautiful house in Easton overlooking an apple orchard. It was built on a slope and the bottom floor was part basement. We used to play down there and look through the illustrated books of Rien Poortvliet on gnomes. We shared a love for secret places and imagined

Trout lilies, or adder tongue

there were gnomes and trolls living in the rock ledge in his yard. This same sensibility translated into enjoyment of trout and, later, women.

We came to the joys of fishing separately, sometime around the age of nine. Then we began fishing together. At first we fished the ponds and reservoirs of Easton, and then Lake Candlewood, where Taylor's family had a summer home on an island.

When Taylor came close to the age for work (he never liked school much) his father, Richard, began to stroke him for a position in the family steel business. Bob Gibby, who worked under Taylor's father as vice president, liked fishing—a good caressing tool. Gibby had a house he had inherited on private land in the Poconos of Pennsylvania and I benefited from attempts by Bob to get to know Taylor under the pretense, "Why don't you and a friend come fishing?" The grounds for acquaintance were the thick woods that enchanted the Tobyhanna, a fine trout river that ran near Gibby's cabin.

Mornings, Taylor and I took Bob's old open-canopy Jeep and drove down to the river with our rods rigged. The dirt roads wound over roots under dark trees. There, where light could penetrate through branches to the forest floor, giant light green ferns grew.

We reminisced on our way to the river, for by that time we had accumulated some experiences worth telling concerning trout and women.

Brook trout with winterberries, still life

"I'll never forget when you made me stop fishing that evening on the Housey because we were late for dinner at Antonia's. I'll never see a hatch like that again," I said.

"But remember Antonia's friend."

"You are bad! Samantha. That still doesn't make up for missing such a hatch of sulfurs."

Our waders were still damp from the day before. It was June and the evenings were cool. The metal hardware on our rod butts was icy. We rigged our rods and tripped over tree roots until we worked the London broil and beer from the evening before out of our systems.

All the pools had names. This was convenient for bragging because you could indicate with precision where you had triumphed over a big fish.

Often we ended up in Kate's Hole, where there were two hammocks strung under the hemlocks. It was good for daydreaming and talking, and the name of the pool amused both of us because Kate had been the name of the obsession of Taylor's youth. Kate Hunt.

I never liked Kate. This may have been because Kate never liked me. We played a doubles date of tennis once and I might have been too competitive. I took nothing off my serve. Why should I have? But she was clean in whites, a country club girl, tall and slim with hazel eyes, good breeding, and long straight brown hair. She would look fine with a five-

iron and sensual on a putting green. Her children would be pretty and in-
telligent and she would maintain a perfect figure until death.

My obsession had been a wicked demon girl with the gentleness of a
sparrow's kiss. We lamented. It was the same thing.

We agreed on many things, Taylor and me. We laughed at things no
one else did and no one else understood. We were best friends. We both
felt these woods were enchanted.

"It's just a chance thing, Taylor," I said, "but did you see those naked
women running through the woods?"

"You mean the ones running in the ferns when we were driving down
here?"

"I think they're wood nymphs."

The ferns, I imagined, must have been soft underfoot, the rays of sun
through the woods of special comfort to the nymphs. At night they must
have huddled under their goose bumps by fallen timber, still as stones.

"What do they do in winter?" Taylor asked.

"They live under the ledges on the south side of the river eating the
berries they stored there until their skin is white enough so they can be
camouflaged in the snow."

He nodded.

"Mostly in summer," I continued, "their skin is browned to the color of
dried leaves. That's why they're so hard to see in the forest."

"But in the ferns."

"Yes, in the ferns," I said. "But even in the ferns not everyone can see them."

16

Richard Adams

THIS is a legendary old salmon guide on the Matapédia. His name is Richard Adams. He's been guiding there for most of his life—on the Restigouche, too. When I painted this he was eighty-nine. Here he is holding a sea-run brook trout I caught on a Green Machine fly. This is in front of the check-in house at Glenn-Emma.

In black-and-white photos of Adams from early in the century, he stands with salmon, a fiction of himself. He is a living glimpse of a past time. A legend in the flesh. Every year of Adams's life there are fewer salmon in the rivers. Occasionally you will catch a brook trout in the rivers where Adams used to guide. I think of him when I think of brook trout.

Richard Adams

17

Under the Belly of the Fog

"CATCH, pull! Catch, pull! Smooth, graceful, strong. Bring it up one—power ten at two—one, two. Okay, bring out the demons. Three, four, five—you're up on them. You're up on them half a boat lead. Four seats up—six seats—taking the stroke. Now I want open water! Open water!"

The coxswain pealed through his little megaphone.

I had been dreaming in my bed back home, the late-May air gentle and just fine for a nap, when Coach called.

"Oh, good, you're there," said Justin. There was shortness in his breath.

"Yeah, I'm here."

"How would you like to come to the Ferry?"

"Not so much," I said. "Why, you need a rower?"

"We need an alternate, James."

"Till when?"

"Until the race. That's two weeks."

"Coach. I haven't fished since last September. That's like death to me. This is some of the best fishing of the year."

"Bring your rod. We're right on the river. We can take the launch to the mouth of the Thames and you can fish for bass. You won't regret it, James. Everyone is asking for you here."

This was Connecticut's Thames: New London. It was not the Henley but the Yale-Harvard regatta, the oldest intercollegiate competition in America.

I had just returned home after my first year at college and didn't want to leave, but I threw some things in my car and drove east along the coast.

The "Ferry" is Gales Ferry, the town on the river where the Yale Boathouse has stood for 150 years. Harvard's boathouse was a quarter mile up the river on the same side. The Harvard oarsmen arrived from their home on the Charles in Cambridge a week after we did from Derby. When they did it was the closest thing to war an Ivy Leaguer of the 1990s could step into.

My life during my freshman year was not as a student but as a rower. Justin Moore had just taken the position of coach for first-year oarsmen. The previous coach had unexpectedly quit at recruiting time, leaving Yale Crew at the brink of autumn with no new blood. So Justin went out on the old campus next to a single scull propped on sawhorses and pulled tall young men off the green. We were taken into Payne Whitney Gymnasium. At first the training was moderate. I had pulled many skiffs around Long Island Sound and many aluminum rowboats across New England lakes, but this was different. When we had learned enough, we took to the water in long sleek eight-man sculls, making puddles in the Housatonic River above the Derby dam where I grew up fishing for perch and eels. I enjoyed the rides out of New Haven and a chance not to miss the fall colors on the river.

As the season progressed the number of walk-ons diminished from about forty to fifteen. We had four recruits who had rowed at prep school and by winter many of us walk-ons had matched or exceeded their technical skills. Slowly, the scope of things became more serious. We were told that we were soldiers in a war that had been fought for a century and a half. Our hands bled, our muscles bulged, all else in our lives dissolved. For many this meant giving up drinking; for me it meant abstinence from fishing. Giving up studies was taken for granted.

Toward spring we rowed twice a day, six days a week. We watched videos of the great Olympic regattas. The Germans were the ones with the strong faces; they symbolized power. They bent their oars in the water. The Italian team personified finesse. I was an Italian; I was not in the "engine room," the middle four in an eight-man scull. By ten pounds I was the lightest heavyweight rower. I could have rowed lightweight but before I had a chance I was best friends with eighteen young men who averaged six foot four and two hundred pounds, with whom I ate, slept, worked, and showered.

That spring after Florida training, I stroked the second freshman boat. Nothing had brought me as close to death as the last pull of the oar through the finish line. By the end of the season I had pretty much decided I would not row the next year. The anxiety before races was too great, I was too thin, and there was more I wanted out of Yale.

I admired the upper-class rowers like the brothers I never had. They were beautiful people; they teased, taunted, and put you down, but when they

were done reducing your ego to the size of an aspirin they encouraged you. They were fine brutes whose naked backs flared like cobras when they pulled an oar through water. All the spring regattas were preface to one thing: the Yale-Harvard race the first Saturday in June. I had not been in the first freshman eight. My season ended at eastern sprints in Worcester, Massachusetts.

It was not until they arrived on the Thames that the crew realized their folly. They had three boats of eight, twenty-four oarsmen, and no alternate. My first morning at the Ferry I went out on the water with Justin in a pair. I had not missed rowing in my week away from it but I enjoyed the beauty of its rhythms again. The chosen twenty-four were resting in the house. I enjoyed rowing with Coach. He was smooth and perfect. I liked rowing with him better than talking to him. I had not planned to train as hard as the others but I did. The idea was to take things down a bit the second week, to be ready but not exhausted for the race. I felt comfortable as mostly an observer. I enjoyed tasting Yale's past. The old oars hung in the boathouse marked with the distance and times of past regattas. Our sleeping quarters were walls of yellowed photos and old programs that printed pictures of the alumni yachts anchored along the route. The second week, Harvard arrived.

It was tradition to have the large ledge across the river painted with the first initial of our university name. We guarded our big white *Y* on a blue field with torches one evening, fighting off the Harvard freshmen who

eventually won and replaced it with their *H*. Coach didn't ask questions; it was the freshmen's duty to protect the rock and row well on race day.

In rare idle times the rowers were amused to drive range balls into the river and play croquet on the lawn that sloped to the Thames. Evenings we read books and played table tennis. It was strange to see these big men in quiet and serene poses. They plotted ways to murder Harry Parker, the Harvard varsity coach.

During our time there we had one half day off. Some went to the mall in New London to see a matinee. I wanted to be alone. I had been rowing some with the second varsity and though there was little chance I would end up in the race, you never knew. I went brook trout fishing.

I did not feel as though anyone was tightening a vise on my will as I drove upstate. The greens were still light. I had not missed everything. I was free. Who would keep me from going back to the warlike anticipation of this regatta. The Tankerhoosen River was a fine place to be AWOL.

My fly rod rested on the calluses that stood up from my hand. I walked by a red barn in a green field. The gravel in the brook was bright, almost foreign in color—reds and blues and sienna browns—and the water was clear. I spooked a trout. It swam under the bank near a protruding tree root. I tied on a small dry fly, made a short cast, and let it float down a rif-fle. I caught a brook trout, let it go, then walked up out of the water and into the wood. I came up on a little fawn curled up in the leaves. I hadn't

Fawn

expected this and could not believe how big its eyes were. The fawn had big white spots on ginger fur. It didn't stir. I could have cradled it in my two hands. When does your little life begin? I asked it. It did not answer me. I walked upstream. Suddenly I was paralyzed by a cold shiver. My stomach tightened and I asked myself what I'd do if I actually had to row in the race. I felt a great sense of duty and needed to return to the compound to complete my ten-month service, as the old college song goes, "for God, for country and for Yale."

I was awakened earlier than normal the next morning by a member of the first varsity boat.

"Vogel wants you to paddle with us. Mann's got a cramp."

Dave Vogel was the varsity coach. We freshman had considered Justin tough, but reports from upperclassmen made Vogel out to be a drill sergeant. I was nervous to enter into this.

We were getting very close to race day. Vogel was worried about disrupting both boats, so instead of pulling someone up from the second boat he put me, the alternate, in. The docks were still wet with dew. I held up the bow; we felt the wet wood under our bare feet. We pivoted and lay the scull on the water. The river was flat and the mist had risen just enough so that the tops of our heads would skim the belly of the fog.

From the bow I could read in the silence the precision of the oars catching water. Coach Vogel, stern and determined, rode a fine distance in the launch. I wished the coxswain would shut up so I could watch this

undistracted. He did shut up. I knew Coach Vogel as a mad moth, but today he was still and held his megaphone low. The air was cool and had salt in it from the sound. The water did not feel this way when I fished it. This is what it felt like when your home became a battlefield. Before anyone else had broken the surface, including the sun, we were rowing in enemy territory.

Harry Parker and his crimsons triumphed in all three races. I was on the red rock with the *H* drinking beer with classmates when the Yale oarsmen, as is tradition for the losers, rowed up parallel to their competitors' scull and gave them their shirts. It was sad to see the bare-chested oarsmen heading toward the blue flag on shore. Then I remembered they were not dead.

18

Brook Trout Flies and a Lure

FLIES tied for trout were the sincerest and most logical connection between my early love of birds and my developing love for fish. Even before I fly fished I had begun to tie flies with a small kit my friend Stephen gave

me for my ninth birthday. Exercising my creativity with feathers, fur, and hooks occupied idle winter evenings. As I sipped my hot chocolate I examined the translucency of a fly under the lamplight, thinking that this would work for brookies come spring.

These are some flies people have given me when I was brook trout fishing with them. Back when L. L. Bean boasted that its products were postage paid, I used to treat myself to buying one fly every month. They would ship it in a cardboard box from Freeport, Maine, and inside, wrapped in newspaper, was a small clear hard plastic box with my one fly. Out of thousands, the flies on the following pages jumped out from my box to tell me something.

1. PARMACHENE BELLE

Invented by Henry P. Wells in the summer of 1880, the Parmachene Belle was inspired by the colors on the belly fin of a brook trout. It was Wells's favorite fly to fish with in the Rangeley Lakes of Maine. In his words: "Sunshine and in rain, at high noon and in the gloaming, I have tried it under all circumstances and conditions for years, and in every season it has gained my esteem."

2. MICKEY FINN

Until the 1930s, when it was titled the Mickey Finn by Gregory Clark, war correspondent for the *Toronto Star,* it was simply called the Red and Yellow. It continues to be one of the most effective flies for brook trout.

3. GRAY GHOST

The Gray Ghost, originated in Maine by Carrie Stevens, was most likely designed to imitate a smelt. I purchased the fly pictured here at a small fly shop on Lake Winnipesaukee, New Hampshire. For years I have admired the jungle cock feather on its cheek. It can be effective as a minnow imitation on lakes or stripped through frothy plunge pools on mountain streams.

4. ADAMS

If you talk to Catskill fly-fishing legend Ed Van Put, he will tell you that the Adams is the only trout fly you need. He raises his own roosters and hens for the hackle, tail, and wings of this fly. For brook trout fishing in early evenings I tie the Adams with big wings to resemble a moth. I like to watch small brook trout try to mouth the fly as it bobs down the currents.

5. YELLOW HAMMER

These flies were given to me by Gary Williams of Maryville, Tennessee, for fishing brookies in the Smoky Mountains. Traditionally, he tells me, they are tied with the underwing feathers of the yellow-shafted flicker. The body is peacock herl.

6. DEER-HAIR CADDIS

I use caddisflies everywhere and all the time.

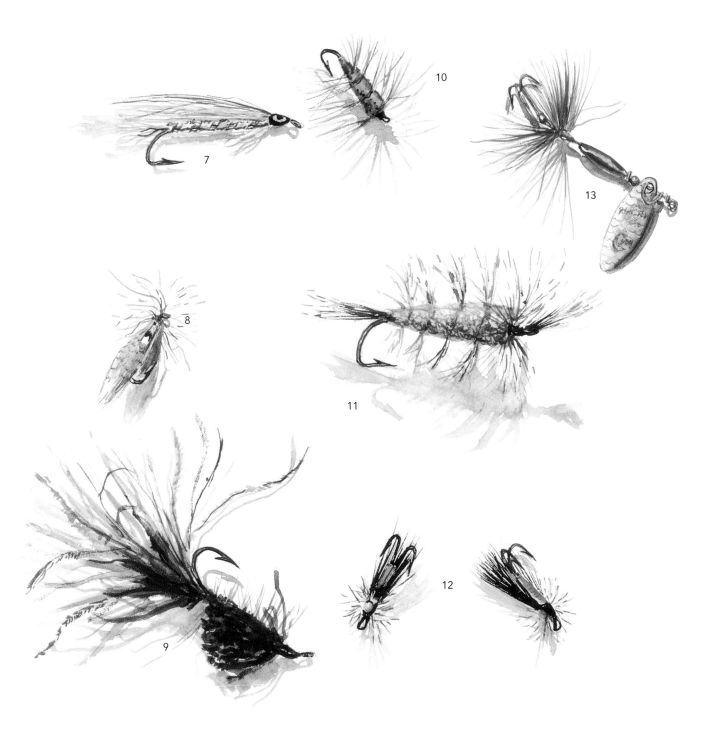

7. AMMONOOSUC FLY

While fishing the wild Ammonoosuc River in the White Mountains of New Hampshire an old man I met opened his box and gave me this fly. It was his favorite fly for fishing brook trout in the streams that tumble off Mounts Washington and Jefferson.

8. HORNBERG

I don't see many people with Hornbergs in their fly boxes these days. It was a favorite of a man who introduced me to many streams with wild brook trout. His name was Stanley and he was the cousin of my friend Stephen's mom. The Hornberg was the first fly I ever tied. Stanley said it was good used dry or wet.

9. JOE HAINES SPECIAL

My old friend Joe originated this fly to fish the Aspetuck River in our town. Haines fishes it downstream in April when the stream is running high. He weights the body with flat lead to get it to sink in the deep pools. Then he strips it slowly, pulling the line through his fingers. "Got one!" I have often heard him say when he hooks a fish on his fly.

10. GREEN MACHINE

11. BOMBER

12. GREEN STONE SALMON FLY

These are salmon flies on which I have caught sea-run brook trout while salmon fishing—the Green Machine, the Bomber, and the Green Stone, respectively.

13. ROOSTERTAIL

I want to say a bit more about the specific pleasure of wading upstream, casting a C. P. Swing, a Panther Martin, or a Roostertail spinner through openings in an overhanging forest. I like the push of the water against my legs and the small trout that dart out to hit the lure. Brook trout are suckers for a shiny spinner.

19

The Last Time

Off Pennsylvania Interstate 80, beyond the exit signs for Rosecrans and Loganton, Taylor and I stop to eat lunch at the Pit Stop Restaurant. It is marked by white, black, and red checkered racing flags. Here they sell black velvet art and Junior Mints. The specials today are meat loaf and

vegetable minestrone. The Coke is flat, which we can't understand because it's served in the can. We thought we were in the North until we heard the waitress's accent. Ours was the only nontruck vehicle in the lot. Route 477 will take us to what the map calls Booneville.

We had come to Pennsylvania to cast in Fishing Creek. The creek is fed by cold springs and along its course in summer it emerges and disappears in the ground several times, like a serpent in the sand, until it exhausts its flow into the Susquehanna.

At the service station outside of Booneville, Taylor and I had an argument over whose turn it was to pay for gas. Taylor insisted he'd filled up at the Delaware Water Gap. We argued it all the way to the Pit Stop. The argument continued over lunch. That's when it got personal.

"You think you're right at everything, don't you? You think you're the best person, period." He drinks from his stale Coke. "I don't know why you think you're such a great artist," Taylor says.

"What is this?" I return. "I never said that." The waitress brings our menus.

"But you think it."

"I don't know what this has to do with anything. But anyway. If I'm not going to like myself, who is?"

"See, you are conceited," he says. "There are other talented people."

"I never said there weren't."

"But you think you are greater."

I don't say anything.

"I don't think you give your father enough credit," Taylor adds.

"What do you mean? That's horrible. That's a horrible thing to say."

"Look how much he's done for you."

"No shit. What do you mean I don't give him credit?" I realized by the time I was twelve that my friends loved my father. He swore a lot—a consequence, he said, of his years in the merchant marine. He was the talkative Brazilian who coached my childhood soccer team.

"You wouldn't be anything without your father. If he died tomorrow would you be satisfied with how you've repaid him?"

"He doesn't want payment. I've been a good son. I've worked hard, I tell him I love him, I acknowledge his influence, that he introduced me to nature and birds, that he raised me some years as a single parent, that he has disciplined me, been shameful and proud. What can a son do for a father? He doesn't want presents, he's content with his life and what he has. I have no regrets. Can a son ever be satisfied when his father dies?"

"I don't know," Taylor says. He orders another Coke.

"Don't annoy me, Taylor." I watch a truck pull out of the parking lot and roll back onto I-80. "What have you ever done for *your* father?"

"I don't know," Taylor says. "I just don't think you give your father enough credit."

"But you have no reason. You can't just say something like that. Don't piss me off. You're just trying to piss me off." You idiot! I want to say.

We order and eat silently and split the bill. Before we stand up I throw fifty dollars in Taylor's face. "There, does that cover it?"

"Yes," he says, and puts the fifty dollars in his pocket.

"Fine. Then let's wrap up this bullshit and go fishing."

We drive up over the pleasant, green, rolling countryside north of I-80, passing barns and silos and an Amish man seated in his horse-drawn carriage with reins in his hand, his head drawn low under a tall black hat.

Taylor turns his head to watch the carriage behind us. "I tell you what this means," I say, trying to mend things. "We're in Booneville."

At first sight of moving water we pull off the road and park in the grass on the edge of a farm. Itching to get on the water and start fishing, we stand looking over a bridge into the clear water. It must be an arm of Fishing Creek, or Fishing Creek itself. A small trout darts in the shadow of the bridge. Out here it's nearly ninety degrees, July. Long green hairlike weeds swing lazily in the current. A milky haze hovers over the water. The water is cold and the air is thick and hot. A cow comes to the creek to drink.

Instead of our heavy waders we try fishing with just shorts and sneakers but the water is too cold to stand in for very long. We walk up the banks of the stream, searching for water to fish, and spook several large trout. Ahead is a big pool. The creek is developing into a gorgeous hidden world. We come alive with fever at the sight of this fertile stream and relief from the intense

Blueback trout on a nail

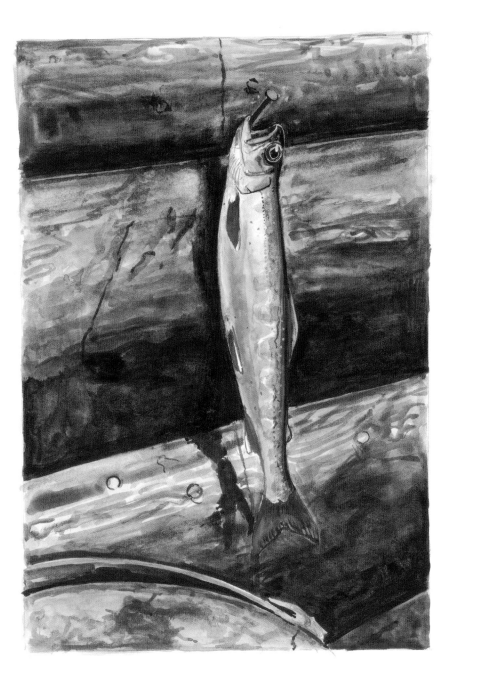

heat. I cast in the pool and raise a big trout but lose it. There will be more good water ahead, we think. But walking above the big pool we see that our river ends at a hillside. I've never seen a river end before. It comes up from a cavernous bowl, inside which we stand, relieved of the heat by a mossy and damp aqua-blue chill. Our first impulse is to throw stones into the source, but it's too dark to see where they go. A farmer junked an old tractor in the bowl. The water at the springhead pushes around the frame of the hood, its rusty hinges, and the front grille. We wonder how deep the spring is. It's the end of our fishing here, where an entire river bleeds from the ground.

In disbelief Taylor and I walk up out of the cool bowl, over the hill from which the river comes. There are only fields of corn, intense heat, and the deafening sound of cicadas in the trees. It makes me wish we didn't rush through all that lovely water. I led us up the creek at a brisk pace. And there is no fishing back down it now because we've spoiled it, we've spooked the fish. How could we have known the river would end when it did? We can come back tomorrow, but it won't be the same.

Taylor and I fish for a week elsewhere on Fishing Creek. We camp and talk to locals, who share some secrets. But we can't forget our first stop and the large fish and how the river ends.

Sometimes memories go bright and dim like a day does when clouds pass before the sun. Several years after my trip with Taylor to Fishing Creek and our discovery of the big spring, I was returning to college with

my girlfriend Mallorie after having spent spring break at her home in Winnetka, Illinois, when I realized I had been on this stretch of highway before. We were traveling in Mallie's car on I-80 in Pennsylvania and I saw signs for Route 477 and Booneville. I asked Mallorie if she wouldn't mind stopping. "I used to fish here," I said, and told her I knew a place called the Pit Stop where we could get lunch.

We sat across from each other at a little table by the window through which we could see the interstate and the eighteen-wheelers rolling by. I had pork chops for lunch and the meat was raw in the middle. I ate the crisp edges and left the rest. "There's a place I'd like to show you down the road," I said to her. What I wanted to show her was the sinkhole where the cold water bubbled up. On the way there I began to doubt whether seeing it had even been a dream; the creek and behind it a field.

"It's a whole river up from the ground at once," I told Mallie. It was March, the land was leafless, and she was pale and blond. I found the bridge in Tylersville where Taylor and I had parked.

We took to the yellow earth, the broken stalks of harvested corn, the brown soil heaved up from frost. We headed right for the source. The frozen ground was thawing under a warm sun. We came upon the head of the water where I had remembered it.

"There's where it ends," I said as we walked down the hill to the dark water and the busted tractor resting there.

"And begins," she said.

"It's more of a beginning, I guess, isn't it," I said.

The hole was black and from it was born a river. We left it and moved up over the hill.

"It's not too cold?" she said.

"I think it's fine." We searched for a spot, stretching our legs up the ochre hillside to the edge of a wood where the sun had dried the dead leaves.

"We don't have to take all our clothes off," I said.

There were incidental spots of snow still on the north side of stone walls. Below us was the bridge and the road and beyond it a small cottage that pushed blue wood smoke from the chimney. "That's the last wood burning for the season," I said.

That's the last time I saw Fishing Creek and the last time we made love.

20

The Flood

I HAD just been dumped again, this time by Mallorie. Why candy-coat it, that's what happened. She started liking another guy. If she knew I'd been

reading her journals she would have killed me. Because of them I knew even before she knew that I would be dumped.

His name was Craig. He ran the open 400 but was on the disabled list for the semester. Now he announced at her track meets. She did the long jump, the open 200, and was the anchor in the 4 × 400 relay. He wasn't attractive but he was fun to be with. Mallie's chief complaint was that I didn't listen to her. It is true I was not interested in the affairs of her roommates. I had graduated from college and she was still a sophomore. I suppose now she'll find out I had read her journals. Maybe she wanted me to. She left them out on tabletops in her dorm room and she left them on the stairs at her home in Winnetka, a suburb of Chicago. Some of the things I read surprised me. I had thought of her as innocent. She was blond and pure with great blue eyes. The hairs on her legs were so few and fine she didn't have to shave them. She wrote that she wished, that first time, that I had not been so gentle.

I admired Mallorie as a writer. Right now I imagined she was with Craig. She was beautiful when she ran. Her legs were strong. She was the best at the long jump. She'd written that he wore a camo army jacket. That's something she thought I would never wear. She wanted to publish and live a quiet life on her family's island off Stonington, Maine. As an incentive for her to move back to Illinois after graduation from Yale, her father, a surgeon, offered her the large house she'd grown up in. I saw this as scandalous and told her that with such offers her father was limiting her

opportunities. I also read in her journal that she did not think her father would be happy if she married me because I had not come from an affluent family. What bothered me about this, if it was true, was that he hadn't either. I had had a good year financially and told Mallie once because I was proud. "I made that in interest last year," she told me coolly. That is, on her trust fund. My insides turned. It was a skillful put-down. I once told her, I think it was an Easter Sunday walking near my home, that I thought her greatest tragedy was that she never had a tragedy. This made her cry.

Mallie also wrote about how she wanted to kiss Craig; she thought about it a lot. Once she thought she would marry me because her father's name was James, too. Now she was kissing Craig and I was in Maryville, Tennessee.

I was suffering. I had a book signing at a gallery and fly-fishing shop on the Little River in the valley of the Smoky Mountains. Mallorie and I would not be taking the trip we had planned cross-country. She didn't want me to come with her to her brother's wedding in Maine. I had liked the shirt I had bought for the occasion as well as the present I had painted for them. It hurt so badly sometimes I couldn't hear people. I liked it, though, not hearing people.

Cindy Williams paid my way to fly to Knoxville and split the cost of my lodging on the Little River with the owner of the fly shop. She was going to have a party in her little art gallery in Maryville.

The name Smoky Mountains conjured for me moonshine stills hidden in the laurel and acres of hillside covered with rhododendron blossoms. Mallie's grandmother was still alive in Chattanooga. I had been invited there for Thanksgiving. As a girl Mallie went to a camp in the Appalachians of Georgia and learned all the good folk songs that grew from that land. She considered herself an Appalachian girl and corrected me when I called them the *Appalashians.* It was Appalachia with a *ch,* like in "chore." What did I know? I was a Yankee.

I had met Mallorie through my guitar playing. She called me after she'd seen my roommate Etay and me performing at a coffee shop at school. I used to play her Woody Guthrie songs.

Cindy Williams was very kind. She brought me to her house and introduced me to her second husband, Gary. Her daughter, Jaime, was from her first marriage. When we passed Maryville College on the way from the airport Cindy said, "Her daddy gave her the choice of a college education or a new car and she took the car. He was a horrible man—not like Gary. I was so lucky to find Gary. I had married so young; you know I was only seventeen."

Cindy had started her own business, the Stone House Gallery. She phoned me one day and told me she'd fly me to Tennessee to sign books at the gallery; I should bring some paintings. "My husband, Gary, is a good trout fisherman," she told me over the phone in heavy Southern Appalachian. "He'll take you up in the mountains for native brook trout."

"I've never caught Southern Appalachian brook trout," I said.

"You'll like it here, James. We have lots of people who love trout."

Cindy had grown up in the stone house. It had been built by her father and on the first floor now she hung paintings and ran her framing business. Over the phone I could not picture what she looked like. Now I studied her. She had curly brown hair and a large round face and full cheeks. Her torso was ample and her waist was uncannily thin, almost boyish. She seemed at once vibrant and disturbed by a recent past; she was in her mid-forties and manicured.

Gary was a biologist working as a fisheries consultant for the Tennessee Valley Authority. He knew where the native brook trout were in the mountains. He said he would be happy to trade me one of the split-cane fly rods he made for a painting of a brookie. When he was done finishing the rod I chose I would return with the painting and we would fish the Smokies. I trusted his kind face and salt-and-pepper beard. After only five minutes we were already planning my return. He had so much to show me. There were photos of the native trout. These trout were different, he explained. "Look how the red spots go all the way up the back. Look how large the eye is and how large the jaw." There was much to discuss. For a while he helped me forget Mallorie.

In the evening we would have dinner at the local watering hole with Cindy's relatives. Now she would take me to where I was going to stay during my visit to Tennessee. I could rest there until seven.

During the drive down Route 73, passing the Little River, I wished Mallie could be here to see the early season in the hills, the first mid-April greens, the redbuds, the laurel leaves damp and shining with spring rain. When Cindy had first called to invite me down to Tennessee she asked if I wanted to bring my wife. "My wife?" I said. "I'm only twenty-two." Mallorie had thought of coming with me. Then we'd have visited her grandmother in Chattanooga and the great aquarium that people had always told me of. We drove through Walland, Townsend, and Wear.

The voice on the car radio posted tornado warnings for the area. Four people died from a tornado that touched down in Nashville that day. Here it was supposed to rain all week. "You'll love these cabins," said Cindy as we pulled off Route 73 and crossed a bridge over the Little River. "They're beautiful and Earl just built two new ones on the river."

The cabin they had rented for me was built on ten-foot stilts by the bank of the Little River. Earl, the tall gaunt proprietor in overalls, lived with his wife above the floodplain in a house of vermilion brick. When Cindy and I drove in he had been at work with his backhoe digging a small oxbow from the river, which he intended to line with cement and stock with rainbow trout. "I don't know if the water is cool enough down here in the summer," he said, "but I'll put in an aerator and hopefully that will be enough."

Cindy left Earl and me near the river and the tall thin maples and tupelos in the yard. She would return to get me for dinner. Earl left the key in

the tractor and walked me to my room. When I asked Earl why my room was ten feet above the ground on stilts he said, "Sometimes the river floods." He paused. "I built them ten years ago and I've never seen the water above the fourth step." I asked about construction. The four stilts were 1½-by-1½-foot-square beams of wood with iron poles going through them. Each stilt was braced in the ground by a six-foot-diameter and six-foot-deep cylinder of cement. The stream looked too tranquil for such precautions. I was satisfied.

"If you need anything, dial seven on the cabin phone," said Earl.

I carried my things up the steps to the cabin. Standing on the deck by myself in the canopy of new greens I thought of the time I'd spent in my treehouse back home. I liked the idea that tomorrow I would be fishing for native brook trout.

The cabin was well furnished in country style, with raw wood bedposts and paintings of the Smokies. Among the books on the nightstand was a biography of Dolly Parton, the local girl from Maryville who became known internationally for her voice and her breasts. There was also a year-old program for a folk music festival in Walland. Inside was an advertisement for a man in Townsend who made dulcimers, banjos, and mandolins. Until I lay down in bed and tried to nap, I did not remember Mallorie.

I was exhausted from traveling. I had been routed through innumerable southern cities to get here and soon fell asleep in the treehouse with all

my clothes on. When I woke up I was chilled. The sweat that had crept from me as I slept now cooled. It had begun to rain. I showered for dinner, thinking I would feel better.

At dinner I met Cindy's parents, a southern couple who had been married forty-four years and had five kids. I looked on this with admiration. Gary was there, and so was Jaime, Cindy's daughter. Also there was Cindy's cousin Mark and his wife. Ryan Roberts, a gastroneurologist fly fisherman who had bought some paintings of mine, had come from Nashville. I told him I was coming to Tennessee and he made the trip from Nashville that evening. It was our intention to get in a little fishing together for native brook trout. Dr. Roberts was staying across the river from my cabin at a bed-and-breakfast on the hills opposite the Smokies. Several times he excused himself from the table to telephone his wife. A tornado had cut a swath through their suburb earlier that day. Though we were on the other side of the state, the weather did not augur well for our fishing. There was still a tornado warning for the greater Knoxville area and the western Smokies. Gary apologized that he would not be fishing with us the next day. He had to take an assignment for the TVA in the central part of the state. He gave me a box of flies he had tied for our fishing. One of them was a beautiful fly called a Yellow Hammer; it was tied with the underwing feather of a yellow-shafted flicker. "It's a native Southern Appalachian fly," he said. "Hopefully the rain will hold off and you can fish."

As we were coming through Walland on the way back to my cabin, the sky bucked with loud bellows. "I'm real sorry about the weather, James," said Cindy. The Little River had risen a few inches, and it was discolored.

Alone in the cabin I tried to tell myself that there was no reason I should feel down. I was in a pleasant place near people who appreciated things I did. I suppose I had really liked Mallorie. I undressed. I lay in bed and listened to the rain on the tin roof of the cabin. I walked out on the terrace in bare feet because it was wet from rain. Somehow I found the darkness fearful and returned to bed. I propped up my pillow and felt the cover of a book that Dr. Roberts had given me at dinner. It was a first edition of *Our Southern Highlands,* by Horace Kephart. It had a beautiful green cover with gold lettering and inside were stories about the area we were going to fish. Dr. Roberts wanted me to have the book and to love the Smokies as he did. I could not be sad with such a new gift in my hands, but it reminded me of Mallorie. We had enjoyed frequenting secondhand bookshops together, poking into odd corners, finding the odd treasure. Would I find a girl like this again with whom to share a quiet moment?

The breath and strength of the rain increased. It pounded on the roof. My father called this kind of rain a tropical rain, one that burst the seams of all the living beings on the planet. I could not remember facing real fear in recent years, but now there was thunder so loud it cleaved my confidence. I felt like a sheltering animal. I was frightened by the stillness outside. Several times the lightning lifted me off my bed. I wondered how

serious a tornado warning was. I knew nothing of tornado etiquette. Wouldn't the mountains knock them down? There was no flat plain over which a tornado could pick up speed and debris. If there was a problem Earl would call. The phone was in the corner of the room. Dial seven. I wished the ceiling were lower; then it would not have so far to fall if it collapsed. Should I close the windows or leave them open? I wanted to respect the tornado if it came. Secretly I wanted to experience a tornado. I also wanted to survive it. The rain was especially loud on the tin roof.

To hell with it, I was going to sleep. I was in my underwear and when the lights were out, somehow being in bed did not seem safe enough. I'd never heard rain like this. I wanted to go outside to see if the river was up but was too afraid. Above the din of the rain the river was roaring. I did not want to know if it had already come under the cabin. Earl would phone if there was danger. If the phone was out he would fetch me. I did not live in Tennessee; I did not know the limits of things here. I got out of bed to dress myself and then got back into bed. I thought of sleeping under the bed. I felt safer sleeping in my jeans.

When morning came, the rain had slowed to only drizzle. Dr. Roberts picked me up at seven and it was more marvelous than fearful that the river had risen eight feet and taken the first step of the cabin. Still, after a big breakfast we would try to catch a few fish.

"Oh man," said Ryan. He had been born in Louisiana. "I've never seen anything like this." The river at this point was still rising. It was two feet

up the trunks of several trees in the yard, opaque and brown. There was no telling when the river would crest. It was still raining. As we headed up into the hills the laurels and rhododendrons were varnished with wetness. The Smokies were deep and cool. Ryan took me on a loop road through the park called Cades Cove. We passed over Abrams Creek where he had once fished. "James, I'm sorry, but that water's really high." The fly-fishing shop where I would sign books the next day had told us that everything was unfishable. On the Cades Cove loop we stopped at a pre–Civil War frontiersman's home. We saw many deer and turkey in the mist of the broad fields. Ryan told me there were fair numbers of bears in the park.

We tried to fish Jake's Creek near Elkmont, but there was too much water in it to fish well. The Yellow Hammers stayed dry. It was cool outside. We had the heat on in the car. Ryan had already decided he would leave early the next morning, two days earlier than planned. It was raining off and on. We put on our raincoats and walked with our fly rods forty-five minutes up a small tributary near Tremont. There were blooming trilliums underfoot and white and pink dogwood blossoms suspended in the wood.

"It's funny how it looks like snow," I said.

"I wish you could be here in May," he said. "You wouldn't believe what the woods look like when the rhododendrons bloom."

Old Civil War house on Cades Cove, Smoky Mountains

J PROSEK 93

"I'd like to see that."

"You really would? I'd love it if you'd come back to Tennessee. You can come to Nashville first. My wife, Cherie, would love to meet you. She'll cook you a good southern meal and then we can head off for native brook trout."

Ryan looked young but wore a full head of white hair. He was forty. His life as a gastroneurologist in Nashville had grown tedious. "I'd love to practice in Montana," he said. "At least for part of the year."

Coming out of the park and finishing up the large lunch that Cindy had packed for us the night before, Ryan asked how things were with "that girl from Winnetka" I'd talked about.

"It's kind of over," I said, trying not to show anything. "It was a year or so we dated. We sort of had different thoughts on things."

"I'm sure it's for the best," he said.

I'm glad he didn't say, "I'm sorry," a canned answer. I wondered if he could sense how hurt I was.

Ryan asked if I'd like to get a chocolate malt. The sun had shone for a few moments, warming the air and making it fragrant. We stopped at a roadside stand he'd said was good and were served by a cute redheaded girl with a precious southern accent. I liked the way she said "vanilla ice cream."

"I should quit my job and work at the malt shop," said Dr. Roberts. My malady for this moment had been cured.

"Yeah," I said, "and they'll ask you what your prior work experience was and you'll say 'gastroneurologist' and they won't have any idea what you're talking about." We laughed.

Ryan left for Nashville that evening. The rain continued on through the afternoon. I could still make it to the cabin without getting my feet wet, using a promontory of land that breached the third step. I sat in a chair with Kephart's *Highlands* and pulled a blanket over myself. It was cold in the cabin and dark. By ten-thirty the rain had stopped. When I closed my eyes in bed the woods were mossy green and damp and the streams were swollen. I saw white petals fall like snow through a stand of blooming dogwood.

My socks cushioned the first step from bed the next morning. I went out on the terrace of the cabin and looked down. The river was well up under the cabin. It seemed as though I was stranded here. It wasn't so much fear that struck me as awe. "Seven," I thought, "dial seven." I walked to the phone to call Earl. Just as I was about to pick up the receiver it rang.

"Unless you plan to stay a day or two longer I think we'd better get you out," he said. This was urgency, southern style, I thought. "I can just about get you in the bucket without getting you wet." I grabbed my book and left what I could do without in the cabin. The water was up pretty high. In the distance I could hear the tracks of the machine bracing mud and gravel. Earl's technique was to run his backhoe tractor up to the cabin and have me jump in the bucket. The water was up at least four steps on

the cabin. What I noticed then was the debris coming down the river and pausing by the pilings of the cabin. Behind the pilings, eddies had formed in the muddy roil.

"Still coming up," said Earl when we reached dry ground. His voice lacked its usual confidence. "It could be several hours until the river crests." My shoulders were wet with rain.

Gary had come to pick me up for my signing and the event at the Stone House Gallery but the road was flooded and he could not pass. The police had put up barricades. Someone tried to pass and lost his car in the water. My signings were canceled. I was relocated to a brick cabin on higher ground but still close to the river. Earl must be nervous now, I thought; they don't sell flood insurance for homes in Tennessee. If the water came up four more feet it would reach the cabin floor.

Earl and I watched the river all day. The water now was as high as the floods in 1994, which were the worst that anyone could remember. Here and there the sun peeked out. Even though the rain had stopped the river continued to rise. I had arrived for the Little River's hundred-year menstrual cycle.

The raging torrent brought a parade of objects past my window. I saw a picnic bench float by. A small suspension bridge of cable and wood rolled in a tangle down the river. Whole trees tumbled head-over-root with their early green leaves emerging and dunking like wet hair. It was all a testament to the power of moving water. The trees in the front yard were submerged eight feet up the trunks and were bent and straining to hold. A wave formed upstream of a stand of trees. Debris was collecting on

them. Broken limbs caught in the force of the water against them formed the foundation of a dam. Other things piled on: a mat of wet leaves, a tire, an empty oil drum, a road sign. The water backed up behind the dam and rose another foot or two in a looming crest above the gushing rage of the river. I knew what was going to happen when one tree in the stand began to whine and creak. Then all at once, with a loud *crack!* like a clap of thunder, the stand of trees snapped and tumbled head-over-root down the river. I exhaled. I wondered if Earl had seen this.

When you stop seeing large debris floating down the river it is safe to say the water has crested or reached its highest point. Once the river crests, it falls rapidly. The river crested an hour after lunch. Gary Williams called to say he might be able to get me in time for dinner. If he couldn't get me in time for my plane the next morning then I would walk by way of the large field around the road and across the bridge to Route 73. The river fell as they told me it would, several feet per hour. By early evening you could see a good portion of Earl's yard. I could not judge relief in his face, but he must have been pleased the river turned when it did.

Cindy's mother made a big home-cooked meal of breaded steak; collard, mustard, and turnip greens; mashed potatoes; coleslaw; biscuits; mushroom gravy; corn bread; beans; and, for dessert, peach cobbler with vanilla ice cream. There were also ripe Tennessee tomatoes raised in a hothouse. They tasted like summer garden tomatoes. Kenny Anderson, Cindy's father, told me stories about a wooden fishing lure he'd invented called the Reel Macoy. He had the whole neighborhood producing them by hand. "One

kid who bent the wire frame around the lure got a penny per wire and damn if he didn't make five dollars an hour." The old man also wrote country music songs. He took out the 1951 Martin he'd bought for two hundred dollars the year he got out of the navy and played a tune for us, working his arthritic hands across the ebony fretboard.

On our way back to my cabin I told Cindy I would pay my freight. Her event had failed to happen. I'd enjoyed the trip. The flood had gotten my mind off Mallorie and this and that, and I was thankful to know such good people and to have witnessed what I had on the Little River.

At home I painted a picture of a Southern Appalachian brook trout from photos Gary had given me. A month later I got an aluminum tube in the mail with one of Gary's split-cane fly rods. "Come back to the Smokies soon," the note said.

21

Boston Beans and Brook Trout

THREE men came from greater Boston who I associate with brook trout. I think of them when I see the sun set over a field of corn. I think of them when I eat warm corn bread grilled with butter. Emerson and Thoreau—

saltbox India—and Winslow Homer. No one ever painted a brook trout like Homer. I can think of red events—the revolution, the belly of a brook trout, apple picking, cranberry bogs—but not without a little green and always with some white and blue. Mink Pond in the Adirondacks, the streams that glide off Mount Washington, Ambajejus Lake near Mount Katahdin are all places where the mind touches water, and art nature. What is self-reliance but the brook trout in its fern-shaded pool? "The bended tree recovering itself from the strong wind," says Emerson, "the vital resources of every animal and vegetable, are demonstrations of the self-relying soul."

The sketches in word and paint, the images conjured for me when I recline in a chair with their work on my lap, pass through the same alembic of former times my thoughts of brook trout do. It's just a feeling I get from reading in Thoreau of "the hollow tree in the depth of a swamp, the cattle standing silent in their stalls, the woodhouse door faintly creaking on its hinge," on the eve of a winter walk.

I retire with them in the increased glow of thought and feeling and observe them in a flickering light of sturdy innocence and Puritan toughness. They knew the brooks intimately, the world about them and the world within them, the "submarine cottages of the caddisworm," the pumpkinseed sunfish, the white moth, the bullfrog.

Here on this page is the pickerel fisher, there the fly angler in a somber setting, the only light caught in the wake of his canoe and on his airborne

line. They captured worlds in the wood then only half discovered, transported there by horse, by foot, by boat, and by armchair.

To fish the north woods of Maine before "the tide of fashionable travel" you took the routes of the logger, by boat up the Penobscot River to Aroostook. Before the loggers there were trappers and in places the boats were still called *bateaux,* from when the trappers were Frenchmen. In the logging camps, baked beans from Boston and Portland could be smelled heating in cast-iron pots next to pans with fresh-caught brook trout frying in lard.

22

Entries from a Salmon Camp Journal

JULY 3: Bonaventure River, Gaspé Peninsula, Québec, Canada

The Bonaventure is fabled for the clarity of its water. Even in pools thirty feet deep you can see to the bottom. We saw fish but caught none. The water was low and there was not much current to make a good drift with the fly.

Jim Harter's grandfather

July 6

After the end of the third day on the Bonaventure Donn Byrne sat me down and said to me, "You're doing a lot of traveling and visiting with a lot of people who are wining and dining you. You are with a lot of people who are on holiday and when they're on holiday they drink. Now. I saw you with a drink in your hand—was that a drink?"

"Yes."

"And you put it away pretty quick."

"I guess."

"If I can give you one piece of advice it's don't drink alcohol to quench thirst, drink water. Alcohol has destroyed a lot of people and I don't want you to end up one of them. You have too many talents, too much in front of you. And you have a great sense of humor. You had us laughing last night when we were reading your book. I read it out loud to Jack."

"I'm a little embarrassed by it now," I said. "It's a little overzealous."

"That's ridiculous," he bellowed. "That's what makes it great."

It was good to be around people who encouraged.

July 7

The eighteen-pound salmon I caught was the biggest in camp that week and the only fish I caught in four days on the water. It was a beautiful fish that took me up one pool and then down two, covering a quarter mile of river.

I caught several brook trout, too, fish that were silvery, fresh from the sea. Their spots were a creamy lemon yellow. Their bellies were white. On their backs was a cool umber that bled to cobalt blue. The brook trout's eyes were dark and their fins were purple-black, lined with blue-white rims. On the gill plates were hints of brick red and violet.

The rain was heavy last night and we knew this would bring the river up. New bright fish were approaching the mouth of the Bonaventure and ascending the river in the rising water. At one in the morning while I was dreaming of the salmon, a thunderclap nearly knocked me out of bed, it was so close and loud. The lightning had struck a tree in camp. In the morning a small crowd of us gathered to see the fresh white splinters of wood scattered about the split trunk.

July 8

Today was my last day of fishing. I shared it with Jack Upton and Mario. Last night we celebrated Jack's ninetieth birthday. After breakfast we drove through mist rising over the fields and wet ground to the Bonaventure above a *fausse* called Baker. Baker Pool had about a hundred salmon resting in it. Mostly the sun was out and mostly it was strong. We played at several bright fresh fish the whole day, tossing wet and dry flies at them. I had one take on a Green Machine and a good rise to a Bomber but the salmon refused it. Every guide has very different views on why salmon take flies, why they take certain flies, and when they take flies.

Sea-run brook trout in a canoe bottom

Often they will shrug their shoulders at questions that are unanswered and simply say, "That's salmon fishing."

Some have superstitions. There is a cow pasture on the way to our fishing. Mario says that if the cows are all lying down in the meadow then no salmon will take. "It has something to do with barometric pressure." A few were standing today. He maintains this will be a decent day.

We put in at Baker Pool and there was a boat in it. It was John and his dad and John was fighting a good salmon. Mario said he was happy for the boy.

"Now let's go find our own fucking salmon." He motored up the riffle and into the next pool. Through the pool he moved the canoe with a dried spruce trunk honed and straight. I could hear when the pole hit the gravel. Like most guides, who fish from canoes they've built themselves, Mario built this one. The water was clear and the colors of the world swirled in its reflections.

Jack made quiet casts off the big canoe, his hands unsteady. None of us knows when a trip to any river will be our last. Jack seemed casual with the knowledge that in as few as ten years, when he reached a hundred, he'd no longer be able to make the trip to the Bonaventure. "I've had some good years," he said.

I was excited by the big brook trout we saw in the river among some grilse. One of the brookies must have been four pounds. We could not get

any of them to take. Jack told me about early years with his first wife and some brook trout fishing they'd discovered in Nova Scotia. "The guides were excellent," he said. "They made a hot lunch on the stream and then a hot dinner."

We never argued when the guide decided it was time for lunch. Lunch was packed by the ladies back at camp. We pulled into a bar and ate sandwiches by the river.

Among the Bonaventure guides, Mario was perhaps the most notorious, mostly for his enthusiasm and colorful language. "Holy shitover" and "cocksucker" were among his favorite expressions. He loved brook trout, too, and told me that when they are running in the Bonaventure he has seen as many as seven hundred fish in Baker.

He is of the school that says: There is one fly a salmon will take at a given time. We were fishing dry flies, watching twelve-pound fish rush up like trout from the bottom to swirl and inspect them. This is something you might hear from Mario if you are casting off his canoe: "No, not that way, you'll spook the fish. Holy shitover, that is one hell of a salmon. Look, the fish will take if you cast to him right. Too short, Jack. Too long. Too long again, Jack. I think Jack forgot his glasses, ho ho ho. Jack, that is the worst cast anyone has ever made. That's it, Jack. You did it, and you see when you put it in the spot I told you, he looked at it. There's hope for you yet, Jack. One more cast and we'll let James at it. Look, you see, I'm right, when you put it right on top of his head he will take. You have seen the salmon move for the fly. Look at that salmon. Is that a beautiful

salmon? What a salmon. You may be the worst caster ever in my canoe but I will make you the best."

Mario has a mat of thick brown hair, droopy eyes, and a bushy droopy mustache. He is weathered under the mustache. When I see people like Mario I think of moose hunts and brook trout in ponds beyond thick pine forests. There is an appeal for me in this authenticity of character. I had seen it in the legendary guide Richard Adams on the Matapédia. If I liked salmon fishing—I'll admit a partial affection for it now—my joy would derive from the fragrance of its rich history; for on the heels of this history I smell the sweet flanks of the rust-bellied brook trout ever present in the salmon's rivers.

I am staring into the currents of the Bonaventure over a flat of brightly colored stones and gravel.

23

Eating Brook Trout

THERE is a specific pleasure and remorse in killing a brook trout to eat. In death the brook trout retains a certain elegance. It is splayed and cleaned for eating. The innards are removed. The swim bladder of a brook trout allows

Study of a dead brook trout from the Mill River

the fish to regulate its depth in the water like the buoyancy compensator used by scuba divers. The angler who is interested in stream entomology should examine the fish's stomach contents. When cleaned, the line of dark blood along the spine, the kidney, can be removed with a movement of the thumbnail top, from tail to head. Anglers have practiced this action for a long time. At the discretion of the chef, the head can be cut off. The flesh of the brook trout ranges from pearl white to salmon pink.

When camping, I have stuck the trout through with a forked green willow stick sharpened at the ends; then I sprinkle lemon pepper on the fish and roast it in the coals of a wood fire until it is crispy. A small fish fried fast in butter or olive oil can be eaten spines and all. The tail, dusted with flour, can be especially good. Adding a bit of soy sauce to the oil in

which the trout is fried gives it a beautiful golden color, a particular flavor, and removes the need to salt it.

A small brook trout cooked within the hour of its capture will curl in a hot skillet to the shape of a crescent moon. The meat flakes from the spine and melts over your tongue. The flavor is as gentle as the tongue of a butterfly licking nectar from the palm of your hand.

24

———

Two in a Million

"I THINK it's time you take me fishing for trout," my sister Jennifer announces. She has never trout fished before. I make better friends with cats when I let them make the initial approach; I fished for twelve years before Jennifer showed curiosity. I tell her that she should never expect much from a day of fishing.

"My trout fishing is not the same as what others like," I say. "As much as catching the fish, my joy is seeing the fish and holding it. I prefer small streams. Often the trout are small, too, relative to what most fishermen consider large. Casting is difficult because the trees grow close to the

water. But this is trout fishing the way I want you to see it. The trout were born in the stream. They hatched from eggs buried in the gravel. Isn't it remarkable that they emerge from stones? The fins of the wild fish are perfectly formed and lacy, their colors are bright and pure, and if you choose to eat them their meat is as delicate as a canary's song. In spring the leaves of the beech and swamp maple are a light transparent green. In summer the greens grow dense. This is my favorite time on the little streams—when the leaves are full but not yet dark."

We set out together and stop at a little general store. "When I fish We-waka Brook I like to stop here," I tell her.

The boards creak in the Newtown general store and sometimes there is a woman playing on the old piano. We order sandwiches first and look at all the salads in the deli case.

"I always get a pickle with my turkey sandwich," I tell Jennifer. "Get anything you want. My treat." The crispness of the dollar bills seems strange. The cold metal of the coins fall into my pocket. "Oh, I forgot my cream soda. I get it with the screw top so I don't have to drink it all at once."

My sister claims, though it is before I can remember, that she was the first to take me fishing. This may well be, for she is six years older but always included me in activities with her friends.

"The trout face upstream into the current," I say. I take her to cast where the brook falls into Lake Lillinonah. There are white perch here that come deep into the cove in schools. We can count on these fish to be Jennifer's first on the fly. "You approach trout slowly, and the only fishing

in these brooks is from downstream up. You could call it stalking. If you present the fly well, they'll take it."

The water is colder in the brook than in the lake. It's clear over the ledge. There is no denying that my sister is beautiful.

"Feel the water here," I say.

"Ooh," she says, "it's cold."

They don't stock any trout here. It's too small. Most people don't notice the brook.

"This is the only brook in Connecticut where I have caught three kinds of wild trout: brooks, browns, and rainbows. The rainbows jump. The brown trout have black and red spots. The brook trout are native. I hope I can show you a brook trout. If you can hit the water here I think you'll catch one," I say. It's not easy to hit the water with a fly. There are spicebush and beech and maple. There are dogwoods. There is a whole world and there is the water in the pool. When I'm alone I fish from the lake up to an old red mill and a waterwheel, about a half mile. I don't think we'll make it that far today. This first pool is one of the better ones.

"You hooked a fish," I say. "You've done well, Jenny. It's a beautiful brook trout."

"Oh my gosh oh my gosh oh my gosh," she says. There's light in her face. "Oh! Let it go let it go let it go."

"He's okay," I say. "The water is cold, so just hold him in the water till I get my camera ready and I'll take his picture with you." She smiles and lets him go.

"Jen Jen is a good fishergirl," she says. We often speak like children when something good happens. "Let's catch more."

Some of the other pools are more difficult. In places the brook is mossy and strange. In places it is fine gravel and a big sycamore breaches land and sky.

"If you can loop the line tight with the rod you can send it through narrow holes in the trees," I say. "It's been a very good day so far. You've caught your first trout." Jennifer is distracted by the water. I move up the stream between the green branches and am alone. Secretly I wanted this pool for myself. I knew there were many trout in it. Not only is it a deep pool for this brook, but there are innumerable crevices in which the trout can hide. When the water was low in late summer I came to fish with my hands, but in this pool the trout were hidden under stones beyond arm's length. With its depth, trout can grow larger in this pool.

I wade up the left bank as I always have. I place my feet as I've seen herons do. I cast and hook a trout. Then my line loops over a branch but I get it off and slide the fish up on the sand of the bank. "Oh my gosh," I say to myself and call to Jennifer.

"You won't understand how strange this is," I tell her, holding him up. "It's a tiger trout. But he was hatched in the stream." I tell her that this happens very, very rarely. I've fished trout in these little brooks for more than twelve years and have never seen a wild tiger trout. I think Scott Loecher said he caught one once. "Isn't it remarkable to look at?" I ask. "They raise these artificially in hatcheries by fertilizing brown trout eggs

Wild tiger trout from Wewaka Brook

with the milt of a male brook trout. Even so, very seldom is the fertiliza-
tion successful. The hybrids, like mules, are sterile. They call them tiger
trout because of the tiger markings on the sides. For this to happen in the
wild is just short of a miracle. It must be one in a million."

I put the fish into the stream, wait for him to regain his balance, then
let him swim away.

Though Jennifer shares my enthusiasm I think I have confused her. I've
always wanted to catch a wild tiger trout. He had a pink belly and red fins
and green and yellow sides. "This is an extraordinary day," I tell my sister.
I do not want her to think every day of fishing is like this. "Why don't
you fish up a bit, Jenny."

Most of the next stretch of water is flat, without pools deep enough to
hold fish. Above us there is a pool I like that's deceptively deep and always

holds fish. Jenny casts the fly into the pool and a small trout chases it to the chute at the tail. "See how voracious they can be?" I say. "They're like little tigers when they want to eat. I've had a trout come up onto the bank to chase a streamer."

She puts the fly in the pool a second time and hooks a fish. She brings it to my hand and I cradle it. We're at least two hundred yards upstream from the pool where we caught the last fish. "I don't believe it. It's another tiger trout." I unhook it and give it to Jennifer to let go. She wets her hand and cradles the fish. I am dumbfounded.

"Two in a million," she says.

25

———

Spawning

BULLET Hill became the place I'd go in autumn when I wanted to paint a glorious male brook trout in spawning colors. They had splendid long lacy pectoral and ventral fins with sharp points that almost looked like wings. The males had ripe black bellies with crimson red seeping out, oozing a brilliant cadmium red up the sides and then the yellow of buttercups and spots bright like lampposts. Their eyes looked down when they were caught; sometimes their pupils sat back. When their eyes pointed back toward their

Autumn leaves

tail they looked worried, but they always looked noble. Then there were these almost unbelievable things going on with reds and blues along the midsection of the flanks. You couldn't really believe it when you noticed finally how strong the jaw and sparring teeth were on the most handsome males. Some were so ripe that sperm melted in pearlescent curls around their anal fins, dripping and coalescing in the frigid water of the pools. It was amazing how they mimicked the fall colors and how this whole world was all at once a dizzy reverie and I could no longer hear the cars whizzing on the road nearby and my knees were in ochre-colored dry grass and the pool was full of brook trout.

After several visits to its banks, Bullet Hill spoiled me for brook trout. Isn't it always like that? This was the attainment of what I dreamed about, a secret place filled with fish.

26

Getting There

I HAD last seen Yannid in Normandy. She had shed the Old World and Paris now. Up here in Québec it was still frontiersman's land, in the forests north of the Laurentides and Lac St-Jean.

It surprised me when Yannid put on her bathing suit and swam in Lac Ratel. I had been irritable all day and now that we had settled in the cabin on the island I was eager to transform my frustrations into a pleasant fiction.

The cabins of the *pourvoirie* had appeared on Lac Ratel as we came in on the dirt road. Moose antlers were nailed to the wall of the *propriétaire*'s cabin. Though Yannid was halfway across the lake from *l'île* now, it was so quiet I could hear her breathing. The only other sound was the distant high-pitched drone of swarming flies.

"This little book on brook trout will be your *jeu de l'esprit,*" she had said the evening before at dinner.

"That's right," I said. *"C'est ça."* *Jeu de l'esprit* is literally "game for the mind," though in a way it means something you do for your own spirit.

The sun now was orange and purple over the *lac.* The spruce were black, and above, the sky was still blue. This was twilight. As Yannid swam back to the dock two loons in silhouette moved out from the black spruce along the quiet margin of the lake.

I had met Yannid some months earlier in Connecticut. Her bright eyes, cute short-cropped hair, and the small mole on her neck had first drawn me to her. We became acquainted, I visited her in France, and then I lived with her in her apartment in Rouen and observed her life as a student of medicine.

"I don't know about our relationship," said Yannid late that spring.

"What is it you don't know?" I said.

"I'm not sure."

"How do you feel?"

"I feel like I'm being used for a story," she said.

We were in the Norman countryside staying at Yannid's aunt's home between Paris and Rouen. I could not deny that I wanted to write about us. I had come to look at my life now as a story. This was difficult in some ways. But it was only because fiction to me was more palatable than reality.

Under the spring sun, Yannid and I played tennis on her aunt's courts. We picked gooseberries barefoot in her aunt's garden and then went to the *poissonerie* to buy dinner. I bought some *calamar* and grilled it with garlic and olive oil. We had been that day to Monet's *maison et jardin* at Giverny and Yannid had spotted a trout in the little spring creek of the Epte that was diverted to supply water to his lily pond.

I knew I wanted to write about Yannid and when I left Rouen for Paris, watching the poplars tossed by gentle breezes from Le Havre, I was horrified by myself. But I could not help it. All I could try to do was make it beautiful. I had to write about her and that was fine with her. My journals were a sacred well. Publishing us was a different matter. Maybe she'd be all right if I published us in my *jeu de l'esprit*.

After that late-spring weekend our relationship dissolved. She had sensed an indifference in me toward her and I had felt the same in her. I turned sometimes when she kissed. She was not always eager to see me.

The cabin on Lac Ratel

For the summer Yannid had been hoping to arrange an exchange between her hospital in Rouen and a French-speaking hospital in Montréal. For some months through the late winter we had been planning a trip north of Montréal to go trout fishing. We had talked about it so much that although we were no longer together, when the time came neither of us could deny the obligation to take such a trip.

The summer exchange went through and by June Yannid was in Montréal on the St. Lawrence River. She was in her third year of medical school in France and though she had exams in September she planned to take several days off at the end of August for our trip. She had said early on that she wanted to learn to fish. From its genesis the trip was to be a fishing trip. We decided to explore the region of Lac St-Jean, a vast round lake six hundred kilometers north of Montréal.

It had been nine weeks since I had seen her when I drove into Montréal from my home in Connecticut. Yannid had rented a flat on Rue Milton near the McGill campus and walked to the hospital every day for her rounds. In France her flamboyance had seemed natural to me. Here there was a falseness in her short black hair and her enthusiastic brown eyes.

She had lived the first ten years of her life in Connecticut and when her parents divorced she moved with her Norman mother back to France. At twenty-three she was more French than American but she had begun to realize that America suited her better.

I had been working well at home and felt as though this trip had disturbed something. I had just driven eight hours and it irked me when Yannid was so eager to leave town without offering me a drink. I sat on the couch in her flat and folded my arms across my chest. Then we loaded her rucksack in my car and left. It was heavy with her medical books.

I drove out of Montréal over Pont Jacques-Cartier and stopped for gas a bit north on Route 20. "I can drive," she said when I filled up the tank. I was road-weary. But before I had a chance to say, "That would be nice," she said "but I'd rather not." Ten kilometers down the road she was marking her *urologie* text with a highlighting pen. It angered me when people got work done when I couldn't.

North of La Tuque I was too tired to continue driving. When Yannid began to drive I was reminded of my experience in her Citroën through the countryside of Normandy. To say the least, she had a lead foot. Then I hadn't said anything. Now I told her to slow down. When she did not I asked her again and added, "It's my car. I can go fast in it but I'm uncomfortable when you do!" Again she did not listen but only said "sorry" every time I raised the issue. I hated when she said "sorry."

I did not want to drive and I did not want to hear "I'm sorry" so I fell asleep to Yannid telling me of the stubbornness of Québecois separatists. In France at least, though reluctantly, they called a hot dog a "hot dog" and a submarine sandwich a "sandwich." For "weekend" they simply said "week-end." In Québec there was no shred of English. Everything

was a literal translation—a hot dog was *"chien chaud,"* a submarine sandwich *"sous-marin,"* and weekend was *"fin de semaine."* If English appeared printed above French on a storefront sign in Montréal the owner was fined.

When I woke up I took the wheel again. By now we had reached the lake. We stayed at an inn on the north end of Lac St-Jean in the town of Péribonka. I was angry when at last I lay down in bed and was too tired to read. I felt as if a day of my life had been stolen.

The next morning after breakfast, we began asking local people about *truite sauvage:* wild trout. Almost every convenience store had signs that boasted *articles de pêche.* These articles were usually no more than a few trolling spoons, lead weights, and hooks, and if you were lucky some locally tied flies for *ouananiche,* what they called the landlocked salmon of the *lac.* After talking with several reluctant clerks who refused to speak English we learned that in order to catch trout we had to drive at least two hundred kilometers north of Dolbeau on logging roads, that it was a bad time of year to fish for trout because it was warm, and that all the fishing to be had was in small lakes— "Oh, you have no canoe?" No one here fished in streams. Dissatisfied with this information we made inquiries at the *département de conservation de faune* in Mistassini. We talked to a ranger there over the phone. He told us to stop by before noon when he left to take his *casse-croûte.*

He was a friendly, green-uniformed man. He stood us before a large green map of the region with all its topography. With a pen, someone had

indicated the maze of logging roads that traverse the *forêt* north of Lac St-Jean. Lac St-Jean was an enormous expanse of water. I said that I wanted to catch brook trout. The ranger was about to become our first credible source for the existence of trout north of Lac St-Jean. He called them *truite mouchetée*—or "speckled trout."

In the time of Louis XIV it was fashionable for French women to wear fake moles to bring the attention of a gazer's spirit to certain parts of their bodies. This fake mole was called a *mouche.* The trout had many natural *mouche,* or "spots"—so they were *mouchetée. Mouche,* more commonly, is the word for "fly."

I could not say why I felt bitter toward Yannid.

"Isn't this so beautiful," she said of our inn. "I can't tell you how long it's been since I've relaxed. I haven't taken a vacation like this since our skiing at Antoine's."

We had had some happy moments. When Yannid reminded me of them I smiled. But then the bitterness crept up like acid from the stomach. It was horrible of me to feel this way.

It was on a main logging road out of Mistassini, unmarked on the map, that we would access the north woods. The ranger warned that it was easy to get lost on side roads. He advised we bring a small tank of extra gas. I did not want the smell of gas in the car so I disregarded this. I felt uncomfortable traveling in new country without maps so we bought some at a sporting goods store in town. Still, the maps did not show the logging roads either.

At the entrance to the logging road there was an enormous sign warning that those who wished to use these roads did so at their own risk. The roads were owned by the logging trucks. Any vehicle that dared pass in the path of a truck barreling at a hundred kilometers per hour carrying a hundred tons of lumber might as well step in front of a freight train. The trail of dust pushed up behind the trucks took minutes to settle and you had to pull over and wait when you saw one coming. The dust clouds were almost beautiful but they settled white and suffocated the leaves of the trees on the side of the road.

The forest off the roads was thick and impenetrable. The undergrowth was a weave of horizontal spruce boughs. The streams I had imagined we could fish for trout were boggy with unstable banks. You had two choices for fishing: You could fish off a bridge or from a boat. The water was motor-oil amber. Where the loggers had cut, the sun reached the ground and there were acres of wild blueberries and raspberries. Already in August the leaves were yellowing and filling with red. I did not want Yannid driving on the logging road.

The washboard road, progressively worse as we drove north, nearly knocked every fixture loose from the undercarriage of my car. Yannid was still reading her medical books. I was impatient with her when we stopped to fish a small stream by the side of the road. I could not understand why it was so difficult for her to follow my instructions. All she had to do was turn the bail on the reel and lob the worm into the pool. Instead she tried

to cast without listening, playing with the handle and the drag mechanism on the reel. It was clear to me that her mind was not here.

"Is it like this?" she said. "I can't figure this out."

"There aren't any fish here anyway," I said finally. "Let's go on up and find a place to spend the night."

"Oh, let's try a bit more, James," she said. "It looks good up there. If I could only get it. . . ."

Why don't you leave me alone and go read your books, I wanted to say.

As we followed the road deeper into the forest we were guided by small signs for *Pourvoirie la Jeannoise.* I was encouraged by the signs because the *J* in *Jeannoise* was drawn like a fishhook. A *pourvoirie* was a kind of camp with cabins and sometimes boat rentals. This kind of thing would suit us well.

As we began to take smaller unmarked logging roads off the main one, I asked Yannid to record on a piece of paper the mileage on the odometer. After several turns I looked over to her. I did not like the way she was drawing our map. If she was not precise we could get lost. It was easy to get lost in this maze of logging roads. Getting lost here was serious. I told her to mark the distances to the tenth of a mile and to indicate the direction of our turn *à la droite* or *à la gauche.* She made our map with a yellow highlighting pen that I could barely read, and it was sloppy. "You'd better make sure you understand that thing," I said, looking over to her in the passenger seat, "because I don't. And if you don't, we're not getting out of here." What I said did not faze her. She continued to make a sloppy map

and read her *urologie* text as if I had said nothing. What bothered me most was that her irreverence was not spiteful; she simply did not care.

Nowhere on the side of the road did I see a place to pitch a tent. Yannid was no help in this search. I knew that when the sun went down the flies would be ferocious. We stood to lose quarts of blood. I could not remember if the tent I'd brought was the one with the hole in the screen. The thought of flies in my tent was enough to keep me tense. I mistrusted Yannid for her boyish alertness; her short hair swung too happily. She made me nervous. I did not like her in this setting. I wished I were traveling with Taylor.

We continued looking for and following the signs for *Pourvoirie la Jeannoise.* We had taken so many turns that Yannid's map was all yellow from the highlighting pen. I was furious. Our only hope was to find the *pourvoirie.*

It stood at the limit of my car's ability to get there, a row of red log cabins with white trim on a spruce-lined lake. I recognized this as a place I'd seen on other lakes at other times. I felt comfortable to meet the white-haired proprietor with the blue eyes. I breathed easily. In his right eye the black of his pupil ran like a leaky egg yolk, north up through the blue of the eyeball. He was a moose hunter. I imagined he sighted with his left eye.

"Another month," he said, "the moose season begins." This was north country: *orignal* and *truite mouchetée.* "The only vacant cabin is on the island," he told us. For a modest sum we could have the use of a boat to ferry us to the cabin—and "Monsieur likes *pêche à la mouche*? Well, here

are some dry flies you will want to have. Near sundown the *truite* should be rising, *beaucoup gobage près de l'île*."

By the main cabins on Lac Ratel a man, woman, and boy were cleaning their day's catch from nearby Lac Doigt d'Or—about four dozen brook trout averaging in size the span of a man's hand. Tomorrow we would go there and catch our meals for the next three days. We carried our things from my dust-covered car to the boat. When the boat was loaded Yannid jumped in near the outboard engine and started playing with the choke. "Have you ever started one of those before?" I asked.

"No," she said. What was she doing? Why did she immediately assume that she could do anything?

I remembered now when I had first begun to sour on Yannid. I was tying flies in her apartment in Rouen for fishing the Jura. She asked if I could show her how to tie a fly. She sat down before the vise and began to fumble with the bobbin and my materials, snipping and cutting with my scissors here and there with complete disregard for my knowledge, my things, and my eagerness to instruct her.

"Let me drive the boat," I said, trying to show in my face how little patience I had left. "Please, Yannid."

The sun was low in the sky as we pulled away from the dock. A small chill reminded us that nights up here would be cool. The evenings would be cold enough for me to put on a flannel shirt and my wool jacket—the first fibers of the season on my summer skin.

As we made our way across the lake, I breathed the cool air and pretended I was alone. We landed and docked the boat on our island in the twilight. Our cabin was at the other end of a wooden-plank walk over spongy ground. In high and drier spots were wild blueberries and raspberries. We settled in the cabin and went about doing our own things. I took out my paperback copy of *The Razor's Edge,* by Maugham. Yannid put on her bathing suit and had a swim. She went out in the last light nearly to the other side of a little bay. Lac Ratel began to grow dim, its surface black.

I was sitting on a bench outside the cabin when Yannid came back up the planks on the wood walk. "You hear that?" I said to her. "Loons." Their whinnying was uncanny. When she was through drying her ears and hair with her towel she sat down in a chair beside me and looked at me through her brown eyes.

"I won't say it again, James, but I'm still very fond of you."

"I don't know why you say that," I said. We watched the loons. "Maybe we'll catch some fish tomorrow," I said.

At night in our cabin the gas lamp gave enough light and heat to read by comfortably. Yannid went to sleep in her bunk and left me alone with my Somerset Maugham paperback.

The morning brought cold. Someone needed to get out of their warm sleeping bag to light the woodstove. That someone was me. The sun was not up yet but the dawn was slowly editing stars. The loons were still un-

canny. Some dry bark clung to my wool jacket as I cradled the wood into the cabin. I watched my breath in the air for the first time this season. I promoted embers with some kindling and wood smoke rose up the pipe. I sat on a stool by the open stove and felt the warm glow of the fire on my face, thinking of the trout I'd catch later that day. Yannid was still asleep.

27

The Moose Hunt

I'M not much of a hunter, but something about a moose hunt makes me think of brook trout. During a moose hunt latent instincts come into play. Following tracks in the snow, and the pursuit of game, satisfies something. As does the glow of campfire coals. Perhaps I've breathed the smoke from a hundred campfires.

Beneath the tall legs and massive body of the bull moose is the brook with its small trout. Here the moose comes to drink and I come to fish. The guides who move canoes across north woods ponds in summer take men into the woods in fall to hunt moose. They bring guns to shoot the moose. Sometimes they see one stepping carefully over fallen timber or

The moose hunt

moving like a black mass over drifted snow. Then they raise their guns and shoot it and watch it kick snow angels in the snow until it dies.

28

Langsee

THE rain came early to the roof of Lastenstrasse 25. It wet the *brezel* and the Franz Schöffmann initials twisted in cipher on the wall of the bakery. The sweet confection smells curled and rose between the droplets and leaked into the open window on the floor above where the men were at work. When first light came, Johannes was dusting the flour off his blue-and-white-checkered uniform, pulling trays of fresh baked goods out of the ovens. Two hours after the sun was up his workday was over. He shed his white clogs and uniform in the shower room. He decided not to shave and walked upstairs to his office by the rooms where his wife and two children were still asleep. He laid out the maps and studied them, brushing his gray mustache with the thumb and forefinger of his left hand.

Over breakfast—a good wurst, cheese, and bread from the bakery—we studied the route that would take us from Johannes's home in Sankt Veit

to Trieste, where we'd take the ferry to Igoumenitsa, ride through Greece, Turkey, and back through the Balkans overland to Austria. We took two cars to the garage; the Land Rover would stay for the day to be serviced. Maybe we would cover ten thousand kilometers on this trip in search of trout. We drove the small Fiat to the lake to go swimming.

Sankt Veit was filled with narrow cobbled streets between stone and plaster buildings. Some leaned from age into the streets and almost touched at the tops. Before the inner walls of the central square were flowers in all colors.

Outside Sankt Veit you could see hills with castles on them, and there was green countryside planted with corn. In summer they cut a labyrinth in the corn and set a *bier garten* beside it. The people of Sankt Veit liked to drink beer in the sun and get lost in the maize.

By the time we got to Langsee, Long Lake, the sun was out and it was warm. Johannes was visibly exhausted, as he had been working in the bakery since two that morning. We enjoyed two beers and a plate of prosciutto with bread and cheese under umbrellas by the lake and then went down to the docks for a swim. The water was warm, but not clear enough for diving. There were no trout to see anyway. Johannes was going to swim across the lake but I didn't think I could make it. We were far off from the docks as it was. The water was dark and I disliked the uncertainty of its depths. Maybe that's why I liked small clear streams. There were many people lying out on the docks. I was embarrassed to lie there among the topless women.

The docks were dry and warm and we found a spot to lie in the sun. The wood turned dark when we sat on it wet. There were sailboats out across Langsee. We both fell asleep with our faces to the sun. When I woke up two young women were beside me where there had been none. They were asleep or pretending to be and the straps of their bathing suits lay coiled beside their untanned breasts. I caught one smiling when I looked at her; I could see the blue veins under her skin.

When Johannes woke up, we slid like seals back into Langsee and swam to shore and the Fiat. We were going hand fishing in a small stream in the hills above Sankt Veit. This stream was cold, clear, and blue. It was called Mühle Bach, or Mill Creek, like the stream where I caught my first brook trout. It is above the village and castle called Frauenstein. It was small and ran through farms beside cows in tall grass and wood frame homes with steep sloping roofs. It was like June back home but strange. We parked at the end of the road where an old farmhouse was being refurbished by a friend of Johannes's, Peter, who lived in Munich and came to Carinthia for weekends in summer. Together they had built pools in the little stream and channeled a division to feed a small pond. In the pond they introduced marble trout from the Soca River in Slovenia and lake trout from Walchensee in Germany. The sound of the brook rushing through broad-leafed butterburr was like rain. This small stream drained the Black Sea, farther east than I had ever been; in the coming days we too were headed there.

Sometimes Johannes caught fish; at other times the fish swam in too far under the rocks for him to reach. Ever since I saw a snapping turtle come

Langsee

out from a rock where I'd been groping for trout I have been reluctant to put my hands in places I can't see. But this place was new and there were no turtles in the creeks here.

Johannes caught trout with his hands like I did at home in summers when the brooks went low. He snuck up to pools and watched where they hid, slid his hand under the moss until he felt the quivering body. He felt the smooth body of a trout in the dark beneath the rock, wetting his shirt to the shoulders. The trout he caught were what we call brown trout, but here they are known as *bach forelle,* or brook trout. They were little golden fish with cerulean blue parr marks and bright red spots. The fins beneath the ivory belly were the solid yellow of buttercups.

"We call them brook trout," says Johannes, "but they are not your *Salvelinus fontinalis.* Yes, of course, we call them brook trout because they live in brooks."

29

It's Strange to Go Back There

BETWEEN Route 8 and Interstate 91 in Connecticut there are places on little back roads that resemble the lean underdeveloped Appalachia of Kentucky.

Though Connecticut is small and places are never far apart, I don't understand where the people who live here work. It's too far from Waterbury, too long to Hartford, and beyond the county of New York City commuter towns where I live. It seems the people here don't work anywhere and I get to thinking they live off the meat of whatever travelers happen by. Some homes I've seen look like little more than lean-tos, with corrugated metal for roofs. On some streams I fish these days, often with Taylor, sometimes alone, small tributaries of the Naugatuck River, the smell of abandoned industry hangs heavy in the November air before a snowstorm.

I am fearful of this shack by the brook. It's up in the woods a quarter mile from the little road where I parked my car. It's the dogs I don't hear that make the "Beware of Dog" sign more fearful. Scattered around the shack are the cracked remnants of a living man—the rusted pickup with three flat tires, the Pepsi bottle half filled with rainwater and algae, the pail with the bottom rusted out, the mark of an ax on a felled tree.

Every time I think of this brook and the posted signs and warnings tacked on the trees I think that it is strange to go back there.

I've never seen who lives here, I've never seen anyone stir, but I notice now that one of the posted signs has been replaced, and once I saw wood smoke rising from the chimney. I've stepped on someone's property, that is the fact of it, and they may not like me being here.

My heart is racing when I pass in view of the little windows of the shack. It's strange to go back there knowing what I do about this place, its mystery, but I do it anyway. There's a pool upstream that is the largest on the brook.

30

Going Back

JUST a week ago I was traveling in New Hampshire and Vermont with a friend. We are old friends, newly reacquainted after seven years apart. I was taking her to see some places that I loved. We hiked Mount Washington in a day and the next day fished for native trout in a tiny brook that comes off Mount Jefferson.

Whitney was attentive coming up the creek. It was the smile I remembered—the smile I had loved. I recognized it as we were setting up the tent at the state campground. Labor Day was past and the campground looked abandoned. We had things mostly to ourselves. We browsed antiques stores and secondhand bookshops. I bought a pair of Faber snowshoes. I was glad to be with her again. Somehow I had known that I could not refuse her if she came back.

Whitney and I bathed together early one morning in the wild Ammonoosuc River. Beside the river was the small highway where we had parked and made our breakfast. Here up north the smell of autumn was more distinct than back at home in Connecticut. The tips of the leaves on

Trout hanging from a burnt tree

Whitney

the swamp maples and spicebush showed their first signs of summer's end. The first frost had killed the mosquitoes. The river was clear and cold, with big round boulders. Tiny brook trout, elusive as early love, darted at the foot of our naked bodies.

THE
AMERICAN
FAMILY FARM

Hans Halberstadt

Motorbooks International
Publishers & Wholesalers

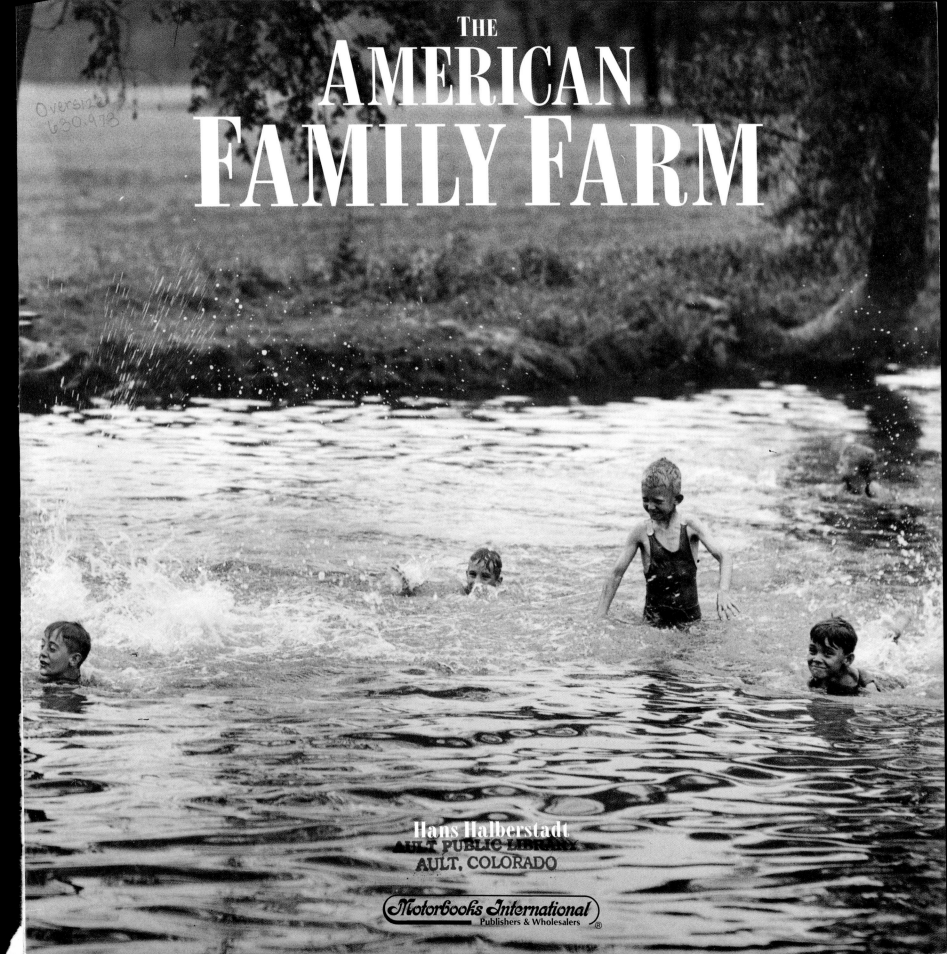

Dedication

For my friend and mentor of 30 years, Bill Garnett—
photographer, farmer, educator, visionary.

First published in 1996 by Motorbooks International Publishers & Wholesalers, 729 Prospect Avenue, PO Box 1, Osceola, WI 54020-0001 USA

Motorbooks International books are also available at discounts in bulk quantity for industrial or sales-promotional use. For details write to Special Sales Manager at the Publisher's address

Library of Congress Cataloging-in-Publication Data Available

ISBN 0-7603-0284-7

On the front cover: The venerable Farmall 560 pulling a John Deere planter. *J.C. Allen*

On the frontispiece: These two Benton County, Indiana lads are scrubbing up in the kitchen sink. Photo taken in 1915. *J.C. Allen*

On the title page: What better way to spend a hot July day than down at the swimming hole? *J.C. Allen*

On the back cover: (Top) A mighty Case International 9230 plows corn stubble. (Bottom) Loading corn for silage was a bit more labor-intensive in the early days of farming.

Printed in Hong Kong

Contents

chapter one
Spring

Explore plowing and planting with horses and the evolution to power farming. Take a spring visit to farms on the Iowa plains, a river valley in Kentucky, California mountains, and the rolling hills of Ohio. Also includes a bit on the farm mechanic, an essay on horse farming by David Nickell, and spring livestock.

chapter two
Summer

Glimpse how making hay and cultivating have changed over the past 100 years and spend some time with threshing crews from today and yesterday. Take a dip down at the swimming hole, shell some pink-eye purple-hull peas, and travel with photographer Walker Evans to the Depression-era home of an Alabama sharecropper's family.

chapter three
Fall

Sample the harvest across the country, from shelling corn by hand in the mountains of western Virginia to harvesting tons of soybeans and corn on a farm in central Iowa. Follow the evolution of fruit co-ops, visit the Wild West with cowboys of the past and present, put up food for winter, and take a roll in the hay mow.

chapter four
Winter

Skate through the icy chill of winter by doing chores, cutting ice, and looking at the ups and downs of one-room schools. Take to the woods to gather sap and make maple syrup or visit the shed to mix and case fresh sausage. Learn how to milk a cow by hand, attend a dance of the past, and harvest winter crops in warmer climates.

Acknowledgments

I'm extremely grateful for the help and hospitality of many American family farmers—a generous, charming breed—who have hosted, educated, fed, and sometimes housed us during the years we've worked on this book. It has been a process of discovery and delight, a process that sometimes worked in two directions. All these folks played an essential role in developing this story, for which we are most grateful:

Cliff and Onalee Koster, their son Billy and wife Celeste, and the new triplets—the sixth generation of Kosters on that same good ground;

Wayne and Mary Wengerd—and all their twelve children—we thank for their help, hospitality, and guidance;

Milton and Ruth Good, for all their "baby-sitting" and instruction;

Jacob and Anna Yoder, plus Merlin and his family;

Dave Rogers, the J. I. Case Company photographer. The Case Company has been a friend of the farmer for almost 160 years, and Dave's maintained the tradition by his very generous help on this and other books;

William Garnett, known as one of America's greatest landscape photographers, has contributed some of his spectacular images to this story. Bill is a farmer, author, Guggenheim Fellow, teacher, and the former Chairman of the Department of Design, University of California at Berkeley. He exerts a strong and friendly influence on many Americans with a love of the land;

A special salute recognizes Mr. John Bird, a charming and perky gentleman of eighty-something, who helped this book in two important ways. His superb reporting in *The Country Gentleman* half a century ago still charms and delights the reader, is still full of wisdom, considered perspective, and gentle advice. One of his articles that appeared in 1942, a defense of the interned Japanese-American citizens, went against the popular mood of the time and doubtless cost *The Country Gent* some subscriptions. And John's recollections about his own blessed boyhood in Kansas in the 1920s and 1930s added a lot to this report, too.

Preface

When I was in high school, I spent time on Lloyd Jensen's ranch up in remote Shasta County, California. That was back in the 1950s, and the legend and lore of the rural life was very attractive.

The Jensen place was primarily a livestock operation, running cattle and sheep and bagging the occasional coyote. While all three provided a cash crop, only the first two paid much. The bounty for coyotes wasn't much back then, hardly enough to cover the ammo for Lloyd's rifle and certainly not enough to replace the ewes and lambs the coyotes killed. The alarm clock on the Jensen ranch was often the boom of a Winchester 30-30 directed at some predator in the sheep pen by the house, normally too late to save a lamb or two. In fact, the approximate score for the game during my tenure was, as I recall, Coyotes 100, Sheep 0.

But the primitive little ranch was a kind of heaven on earth if you liked the rural life. To the north, 12,000-foot Mt. Shasta loomed theatrically with its perpetual snow cap. The deep, crystalline Fall River flowed through the property, packed with large, well-educated trout. Fields of fragrant alfalfa grew along the banks of the river, often with trophy mule deer grazing at the margins.

In this idyllic setting, I spent my days stringing fence and helping with branding, dehorning, inoculating, and castrating calves. Looking back, I realize that it was a privilege to participate in the annual roundup. I liked the land and the people, the tempo of the life, the smell of alfalfa, and independence of the people in the Fall River Valley.

Later I had a part-time job (tearing down old barns, unfortunately) on George Wheelwright's wild, windswept, magnificent Green Gulch Ranch on the Northern California coast. Green Gulch Ranch was too steep for anything but livestock and almost too steep for coyotes, but still an adventurous place to work—a craggy place in perpetual fog, with its western fence lining the sheer cliffs above the crashing Pacific Ocean. It was another delicious taste of the farming life.

But Wheelwright wasn't born to Green Gulch Ranch; he made his fortune as a mathematician with Polaroid. Wheelwright and others like him made me realize that it took big bucks to break into ranching, or fortunate breeding; I guess I came up short in both departments.

I moved on to other things, often at the edge of agriculture, playing a supporting role rather than center stage. But I have never lost my reverence for the great American landscape, a productive thing of beauty, well worthy of admiration and careful husbandry. I've been watching farm life from across the fence for 30 years.

During the 30 years since my summers in the Fall River Valley and on the Green Gulch Ranch, I've worked primarily as a documentary film maker and photographer, but was never far from the farm. I've photographed and filmed the farms and families of the Pennsylvania Amish, Texas ranchers, the Hopi of Northern Arizona, and people on farms all over the United States. I have never lost my reverence for the great American landscape, a productive thing of beauty, well worthy of admiration and careful husbandry. In effect, this book project began 30 years ago, on the banks of the Fall River.

You'll see a lot of Amish influence in this book, for several reasons. One is that the Amish preserve traditional practices common 150 years ago—watching them is seeing our history come literally to life. My German ancestors, alive in 1860, would have recognized the language, customs, clothing, and beliefs of these American farmers of 1996. Another reason is that the Amish use very traditional American farming philosophy from the past in an extremely successful way in an alien, modern world; they use "obsolete" ideas about technology, family, religion, and community and prosper while their modern neighbors go broke. Finally, I admire and enjoy these good people—they represent a past and a future. We have a lot to learn from them and the old ways they use so well.

We hear a lot about the family farm and the families on the farm—but not much *from* them. So I decided to let them speak for themselves here, voices from the past and present of American farming. Despite all the predictions of gloom and doom, the story they tell is a rather hopeful one. The idea of just what a family farm is, and how it should be run, is an idea getting a lot of attention within the farm community. There is a solid commitment to traditional family farm values, right down to horse farming, still alive in America. People like David Nickell, Bill Toms, Milton Good, and the Kosters are all right out of the traditional mold—thrifty people, workers of the land, with a strong sense of past, present, and future.

Introduction

The family farm has become an American icon, first because of the political power of numbers, then because of tradition and legend. This part of the book provides a little perspective on the subject; while the numbers are smaller than in the past, the family farm is alive and well and likely to remain so despite various threats and problems. Folks were distressed about the problems with this institution before World War I, and they'll still be fussing about it a century from now.

The farm is cyclical in nature. It must be, because a farmer's daily routines are built around dealing with and betting on what Mother Nature is going to hand out. The organization of this book reflects the farmer's close ties to the seasons. We'll follow the American farmer from spring to summer to fall to winter. The American farmer comprises an incredibly diverse mix of people and places, and we'll take a look at a wide variety of them to present a snapshot of the American family farm.

Early in the century, more than half of all Americans were farmers. In modern times, less than 5 percent farm. This book is designed to take you out to the farm, to meet the farmers, the farm families, and to see what happens at the business end of a cow. Rather than try to provide a textbook explanation of the details of farm operations with every crop and every corner of the country, we are going to visit a few representative farmers of the past and present. They are the Yoders, who farm with horses in Ohio, the Boyds in Iowa, and the Kosters in California; Bill Toms has his family's old place in Virginia and David Nickell does the same in Kentucky. But the idea of *family* and the *family farm* suggests continuity and tradition, so we will do a bit of time travel, too, back to earlier generations. All these American family farmers, living and dead, have something to

Her name is Lucille Burrows and she's the oldest child of Floyd and Allie Mae Burrows, sharecroppers in Hale County, Alabama. This photo was taken during the summer of 1936, which was a tough year for American farm families and their children, especially on a little cotton farm in the deep South. *Walker Evans/Farm Security Administration Collection—Library of Congress*

tell us about this beloved institution and they speak directly, in their own words. But just who were, and are, America's farm families?

The people who carved homesteads and farms from the wilderness were a mixed lot: English, of course, at the beginning, but Spanish colonists on the West Coast almost as early. There were some Russians, and lots of French. They found people farming here already. The Hopi in the southwest, and many tribes in New England and across the continent cultivated corn and other plants. These early settlers were followed by more from Ireland, Scotland, Germany, then a flood from Sweden, Finland, Denmark and a dozen little European nations that don't exist anymore. Japanese farmers colonized the West Coast, and are still producing our fresh flowers, winter vegetables, and tree fruit.

Part of the tradition is a strong ethnic identity among communities. Bill Vavak, for example, is third-generation American, but he went to school speaking only Czech. The Yoders speak German although their families have been here for many generations. That kind of cultural tradition is one part of the story of the American family farm.

But what about the family itself? What kind of family do you find on the farm? The family on the successful farm is a team, with at least two members and, if those two were good breeding stock, quite a lot more. Traditionally, each member of the family team has a firmly fixed role and set of responsibilities. Dad did the heavy lifting, the plowing, cultivating, and the threshing. Mom kept house, chickens, the garden, and put food up in jars or crocks. The small children helped Mom around the house when very young, then went to the field with Dad by age seven or so. Everyone worked to the limit of their age and ability; all hands were needed to keep a farm operating smoothly.

But there is more to the farm family than just mom, dad, and the kids. It is a network of kinships, typically including parents, brothers and sisters, grandchildren, cousins, all of whom can contribute when there's work to be done.

Then there are the neighbors. Part of the equation that made the whole thing work so well in the past was a much bigger extended family, usually linked by both church and ethnic origin. Your real family was, and sometimes still is, the folks who live nearby, who attend the same church, and whose family went to the same schools. They were (and sometimes still are) part of your threshing ring, sewing circle, supper club, or Sunday school. If your mower broke, if your sow got loose, or your horse went visiting, you could count on a neighbor to lend a hand. If your barn burned, your neighbors would pitch in to build you a new one. They still will, if you're Amish in Holmes County, Ohio. Working together is part of the tradition of the family farm, a custom that is alive and well in many places in America.

If there is any big change in family farm practices over the years, it is the trend toward production farming. While the family farm of even a half-century ago tried to be somewhat self-sufficient, most of today's family farmers do not meet all of the family needs with homegrown product. The cash crop is the number one priority; families keep livestock or a garden as time permits. And on a few family farms, including some of the Amish farms, a secondary business brings in income that supports the farm.

So some farmers work in town at the local implement dealer, feed mill, or propane delivery business. Many of the self-sufficient Amish operate a harness shop, buggy repair, or carpentry business. Sometimes it's the farm wife who works outside the home as a teacher, nurse, bookkeeper, or any of the dozens of occupations that employ non-farmers. As one woman stated, "There is no difference between what I do and the folks in town do. I just have a bigger yard to mow."

American family farmers can be men or women, but they are usually a team. They can have lots of kids, or none, but the tradition is a large flock of youngsters. The American family farmer can work two acres (and make big money doing it) or 20,000 acres (and go broke). Some families farm full time, like Leland Boyd in Iowa, and others, like David Nickell in Kentucky, have jobs in town. Some farmers own (with the bank) huge combines and expensive tractors, and others use horses or old tractors and don't owe a dime to anybody. Some, like the Amish, are deeply religious and their farming is part of their sense of place in the world; the Hopi Indian farmers and the Amish are kindred spirits in this attitude. But there are others who don't seem to think about the spiritual aspects of agriculture—a minority, in my experience.

Some farmers drive Cadillacs, have airplanes, hot tubs, and vacation homes; others think running water and indoor plumbing is just about all the luxury anybody ought to have. They grow corn in a dozen varieties, wheat, barley, oats, rice, asparagus, tomatoes (canned whole, as sauce, paste, fresh, and dried), lettuce by the carload, citrus (lemons, limes, oranges in five varieties, grapefruit, and even kumquats), avocados, Brussels sprouts, walnuts, and plums…Herefords, Holsteins, Durocs, and Percherons…and, well, it's a big country and a big subject. No wonder they're a diversified bunch.

The farming life can be hard or gentle, profitable or a financial black hole. You sometimes hear it called a "gamble," but that's misleading. Farmers are *speculators*, or *investors*, but not gamblers—they all can count and most calculate odds better than a blackjack dealer. If everything goes right and the corn makes 190 bushels to the acre, if your production costs are low and the market is high, you can make a bundle; if not, you lose money. It is a business full of risks and potential, of investments and payoffs. It was the same way 100 years ago.

No farmer can control the amount or timing of the year's rainfall; none knows what the price of wheat, raisins, soybeans, feeder cattle, or any of the other commodities farmers produce will be on the day the crop comes in from the field. The farmer does know with precision how many acres are available for production, what the yield of each acre normally is, the costs of tractor fuel, herbicide, fertilizer—and all the taxes, installment debt (for tractors, combines, tillage tools, barns, grain bins, silos, pickup trucks), compound interest, and other expenses required by modern farmers to operate modern family farms. A farmer usually knows pretty well how much rain fell last year, and when…and the year before, and the year before that. All the costs of production are one side of an equation; the farmer solves for X only on the day the crop goes to the co-op elevator. In Iowa alone, at this writing, there are still 100,000 farms in operation; those farms are, at this writing, about $145,000,000,000 in debt. With the mortgage riding on the result, it is not a business for the inexperienced, the undisciplined, the lazy, or the faint-of-heart.

The actual return on investment for the American farmer has been falling for years; the cost of all our agricultural products (in constant dollars) is far less than 50 or 100 years ago. The price of

That's Mr. And Mrs. J. E. Vohland, and their new baby, way out on the prairie near Gibbon, in Buffalo County, Nebraska. The year is 1903, and a lot has happened in the 20 years or so since this land was first homesteaded. The old "soddy" house has been replaced by a frame structure, although nobody's bothered to paint it yet. But the Vohlands are happy and proud— you can see it in her smile. There's a good stand of corn in the field behind the house, four solid mules for plowing and planting, and a nice buggy and carriage horse for going to town. *Solomon D. Butcher Collection—Nebraska State Historical Society*

wheat, for example, is now about the same as it was many years ago, around the First World War. That makes food and fiber and all the other products much more affordable for more people now. That also makes business much harder for the farmer. A lot of growers who, through strong co-operative marketing, are doing extremely well on rather small plots of land. But many farmers have been sucked into the notion that bigger is better—bigger tractors, bigger acreage, bigger debt. Sometimes it pays off, sometimes not. It is part of the farmer's calculated guess every year.

The response has been a trend toward bigger farms, bigger tractors, more high-tech solutions, each offering a little more *potential* efficiency. But the tractors cost $100,000 and up, instead of $1,000. The hybrid seeds, crop-dusting aircraft rental, the broad spectrum herbicide, the $25,000 pickup truck with the cellular phone are each a calculated part of the risk. That's been the trend in American agriculture. A lot of farmers, ranchers, and growers have invested wisely and luckily; they have big houses, hot tubs, and winter at second homes in Florida every year. And then there are the other farmers who've quit and either sold their land or rent it to others.

But there's another trend, an ancient and traditional one. Cliff Koster's favorite tractor was built during World War II and some of his implements were built in the 1930s; both work well and have no installment payments attached. Jacob Yoder's hilly 80 acres support a large Amish family with abundance and security. Bill Garnett's two acres of premium wine grapes—tilled with an old Caterpillar D2 and hand-pruned by Bill—return a substantial annual profit. A lot of farmers succeed by keeping expenses to a minimum, avoiding debt as much as possible, using machines until the wheels fall off, and doing the bulk of the labor around the place. The Amish, in particular, prove the point—they generally thrive with old-fashioned values, virtues, and technology…where their modern neighbors struggle along with huge plots of land, air-conditioned tractors, and mountains of debt. You hear a lot about the demise of the family farm. While there are problems for some family farmers, reports of their demise is, as Mark Twain said, premature.

The first American family farmers homesteaded the Four Corners area of Arizona sometime around 1000 AD, and they're still there. They still practice a fairly extreme form of dry land farming but produce enough corn and other crops to survive. Hopis are as crabby and crusty as your typical Vermont farmer—pig-headed sometimes, contentious, conservative in the extreme, qualities they have in common with many other American farmers. But nobody—including the Spanish, the Mexicans, or the U. S. Cavalry—has much modified them or their way of life. They have defeated their enemies, mostly by living in a place nobody else really wants and by keeping storehouses filled with enough corn and dried mutton to keep a family alive for a year or two.

There are some real problems on the farm today. Urban encroachment is one of the worst—the growth of cities and their suburbs into agricultural areas. The town and the city don't coexist very well. Most of the farmers portrayed in this book are having problems with the rapid growth of nearby communities.

Another problem is the de-population of our rural areas. The acreage being worked remains huge but the number of people working the land is shrinking. Three members of the Boyd family in central Iowa work 1,200 acres with the help of one hired man; 100 years ago those acres would have supported perhaps 60 people. So what's the problem? The problem is a lack of community, the death of rural towns, the disappearance of shops and services across rural America. Bigger farms and fewer people have slowly eliminated a lot of the rich social life that was once a joy for people on the farm—the shucking bees, church socials, threshing rings, and harvest dinners. In the past, if you needed help butchering a hog, your neighbors could be counted on to pitch in and help; today they will probably be too busy.

But the real problem on the farm is what you might call "dumb economics." Entirely too many people have been seduced by the lure of borrowed money for bigger machines and larger plots of land. Debt load, more than anything else, seems to be the real enemy of the family farm; it averages $145,000 per farm in Iowa today. A dependence on crop subsidies, too, distort the financial picture. During the recent, well-publicized farm crisis, when the news media lamented the death and destruction of the family farm, some American family farmers were having profitable years. Those farmers were the Amish who keep debt to a minimum, who still trade labor in the old, friendly way, who work small spreads, and who don't spend more than they make. There's a lesson in that.

Despite the problems and hazards, an awful lot of good things are happening today on the farm. Lots of families are staying on the "home place" and some are finding ways to get back on the land. There is tremendous interest in the traditions of the family farm. You'll see it at any farm show across the country, and in the rising demand and high prices for draft horses suitable for farm work. Although the horse-farming idea has its advocates, American farmers will never junk the tractors and combines in large numbers in favor of the horse.

God Bless Our Happy Home, even if we have to use butcher paper to cover the walls and we live in a little shack in Minnesota cut-over stump land. John Vashon took this photograph of a farm family in 1940, part of the Farm Security Administration's documentation of American agriculture during the Dust Bowl years when things were so bad that many thousands of farms were abandoned. This family didn't have a lot—but they had each other, and that's a start. *John Vashon/Farm Security Administration Collection—Library of Congress*

And we can't become Amish, as attractive as that life may be for some. But we can learn a lot from the successes of the past, and modern ways are not always better ways.

With less than 2 percent of the American population now growing the food for the other 98, it's even more important to continually remind American consumers where their bread and butter is produced. More important than just raw land, American family farmers provide a special conscience, continuity, and stewardship of the farm land. American farmers learned the hard way that once good soil has been destroyed, all the water and fertilizer in the world will not produce a satisfactory crop. So family farmers have an important advantage over corporate conglomerates...families have a personal heritage.

The heritage of the farm lives on in the memories of those who grew up there. Although growing up on a farm is usually recalled warmly, there are some things that get left out of the usual farm cliché—outdoor plumbing, for example, and the endless labor required of adults and children. John Slauter survived the "good old days," and remembers them with fondness.

"It's what I call the 'good old days,' however, I wouldn't care to live them again! My dad worked from daylight till dark, winter and summer. It was pretty tough, although we didn't know it at the time. We didn't have electricity, no indoor plumbing. The water came from a well out in the yard that you pumped by hand. The toilet was a privy outside—and as long as I owned that farm, up until 1990—we used that same old outhouse that I had inhabited as a child! I don't remember that outhouse being particularly bad back then, but I didn't know any better. But it was COLD, I can tell you, in the middle of an Iowa winter. We didn't buy toilet tissue—that's what the Sears and Monkey Wards catalogues were for...and corn cobs, of course." 🍏

John's recollection brings us to the start of our exploration of the farm, and the season in which the growing season begins. He also reminds us that, on the farm, there were lots of reasons to look forward to the arrival of spring.

Spring

Out on the backbone of America, in the middle of the Great Plains, the sun breaks across the eastern horizon about quarter past six on March 21. It won't set until about 6:30 P.M. and will heat the land and air for over twelve hours before setting in the west. Slowly, the sun pulls a trigger that fires spring suddenly into motion. One day the air is cold, damp, overcast—wintry. The next is warmer, drier and the air smells different. Suddenly, you can sense things growing all over America. The grape vines in their orderly rows, the peach and apple trees in their regimental order, all have a little color to them that wasn't there yesterday. Close inspection shows that the trees are in "red bud" stage, with swelling that will produce blossoms in a week or ten days. Weeds suddenly grow like crazy and everything is green. The chickens start pumping out eggs, the fruit trees explode into blossom, the horses start to loose their shaggy winter coats. Tractors that have been sitting idle roar to life. Spring planting can now begin—and it does, on many thousands of family farms across the continent.

Spring is the season of renewal, for people, for animals, for all of the crops that farmers grow. Calves, colts, chicks, lambs are all naturally

❦

March Is the Time To:
Pay taxes.
Review your will.
Scour rusted tools.
Order windbreak trees.
Get after lice on animals.
Help Junior make a kite.
Get fuel ready for sugaring.
Unlock plant food with lime.
Disk, fertilize, reseed pastures.
Make sure your farm title is clear.
Include a legume in your rotation.
Check farm water supply for purity.
Pep up wheat with nitrogen dressing.
Farm Journal, March 1949

born in early spring. The year for American family farmers really begins in March, rather than in January, when the serious work of the year starts on most farms. Tractors and horses get pushed as hard and long as they can go, hurrying the plants into the ground. The major work of springtime is plowing and planting across the nation, and the major crop is corn. But there are hundreds of other crops, too, plus livestock and orchards. Spring is the critical time for nearly every crop and commodity. While the corn farmers are plowing and planting in Nebraska and Illinois, apple growers in Oregon start the annual spraying program, and cattle ranchers get ready for spring roundup and branding the new calves. Spring is a busy time for everybody in the farm family. There is plenty to do on most farms, and not enough people to do the work. Farm kids learn to pitch in early, driving tractors, milking cows, feeding lambs and piglets.

Although spring begins precisely on March 21, the vernal equinox, the farmer's work will begin according to Mother Nature's schedule. Spring starts whenever she wants it to start, normally anytime between February and June. One thing is predictable, and that is that the sun will rise higher in the sky each day, and the hours of sunlight will increase, minute by daily minute; the ground will warm, the sap will flow, the seeds will get the mysterious chemical message. Eventually, the snow will melt away and the ground will soften so that the first big task of spring can begin.

An acre a day is all a man with a walking plow can manage, and it is hard work for him and the team, too. *J. C. Allen & Son*

Spring in central Washington state back in the early years of the twentieth century produced scenes like this one. Huge "bonanza" farms with 10,000 and more acres under cultivation were common in Washington, the Dakota Territory, Montana, and California. Wheat, barley, and oats were grown on a grand scale and it took a lot of men and horses to plow and plant those big farms. The horses were a special breed, the Palouse, a combination of draft horse for strength bred to a hardy Indian pony. The lead team, a 12-horse hitch, pulls a three-bottom plow cutting a swath about four feet wide.

Breaking Ground

Springtime is plowing time, normally as early as you can get in the field. While we think of this as strictly tractor work today, it was done with hand tools on many American farms—and sometimes still is. You can still buy unpowered, push-type cultivators that look like a garden tractor without an engine, and some folks cultivate gardens with them. But regardless of what kind of tool is used, the priority job on the American farm in spring is plowing and cultivation—in the fields, in the orchards, and in the family garden.

Farmers plow the soil for several reasons. First, plowing buries the weeds and "trash" from the previous crop, returning organic material to the soil. That also buries weed seeds and insect eggs, providing some (but never complete) control. Plowing in the fall opens the ground to receive moisture over the winter, water that would tend to run off otherwise; that moisture will be available to the crop in spring and summer. And plowing loosens the soil, aerates it, prepares the seedbed to receive the corn, wheat, oats, soybeans, milo, kafir, safflower, barley, and all the other crops American farmers plant in their fields.

The traditional technique, during the days of the walking plow and two-horse team, was a clean, straight furrow from one end of the field to the other. The soil should be turned smoothly over, upside down, and pulverized. Many designs of walking plows were available for different soil conditions—breaking virgin prairie, working around stumpy cleared forest land, or the difficult sticky gumbo soils common to parts of the South.

Typically, a single "bottom" (the whole cutting assembly of the plow, including the share, frog, and moldboard) general-purpose plow would turn a 12-inch strip of ground on every trip up the field, slicing the soil on the landside (normally to the left) and cutting about six inches deep, depending on the specific design. If the share was brightly polished, the hitch adjusted perfectly, and the horses cooperative, the plow man could spend a fairly stress-free morning or afternoon, walking in the country. While an acre doesn't seem like much ground, it represents over eight miles of 12-inch furrow, a job that takes about five hours if everything works as advertised.

These plows are *heavy* tools, made of cast iron and steel. Most tip the scales at around 100 pounds, the big prairie and brush-breakers going up to nearly 200 pounds. The plow man shouldn't have to do much steering or other course corrections once the first furrow is cut, until the end of the field. Let the horses rest and recover from the pull. Then a push down on the handles will bring the share up out of the ground for the turn. You generally dump the plow over on its side, to the landside (left) while you drive the team over to the return furrow on the

far side of the field. Then, with the plow properly aligned, lift on the handles and signal the team to pull—*Dixie! UP!*—and they'll lean into their collars, the tugs will strain, and the share will slice into the ground. The lead horse, normally on the off side, walks in the furrow. That provides a kind of self-steering system that (when it works) makes for a dull morning and a neatly plowed field.

Plowing With Horses

A team of two horses was the standard source of motive power for American farmers for hundreds of years, and is still in fairly common use. There are many virtues to the horse on the farm and some prefer them over tractors. You can plow two acres a day with an experienced team (and experienced teamster, too) and that's a lot more than anybody can do by hand. Here's a short course in how to do it:

First, you've got to catch the horses. This isn't too much of a problem if they've been stabled overnight, but if you've pastured them (a good idea, generally) they must be enticed within range with a bucket of grain, or you've got to chase them down. Good draft horses, though, often like to work and are quite placid and friendly—particularly if they're of the Suffolk Punch breed—and are likely to cooperate. A draft horse that plays hard-to-get in Amish country is a candidate for a new career in the pet food industry.

Then you've got to harness them. The safe place to do this is NOT in the stall, but outside. Jacob Yoder harnesses his team inside the barn, adjacent to the stalls. If a horse spooks, you can get out of the way; but that is hard to do in a box stall. You secure the horse with a lead, the snap-link attached to the horses' halter, the other tied to a hitching ring secured to the barn wall. The collar goes on first, then the "hames," the curved metal components that actually carry the load; the collar goes between the horse's shoulder and the hames, providing some padding and spreading out the strain. Then comes the back pad, hip-drop, and britchen. The hames are adjusted to fit into the grove on the collar, secured, and then the harness is pulled back into position. Watch the hooves, and talk to the horse while you're moving around. The

Early spring in cotton country. You can get a second crop from one cotton planting if the winter is warm and frost doesn't kill the plants, as this farmer well knows. His cotton survived the winter and he's cultivating last year's plants on a crisp March morning in 1936. Frost may kill them yet, but every farmer is an optimist in the springtime. *Walker Evans/Farm Security Administration Collection—Library of Congress*

The Plow That Broke the Plains

It would probably not be fair or accurate to call any one invention the most important in American history; the steam engine and the railroad would be candidates, but John Deere's simple, elegant plow perhaps had as much to do with our national development as anything else.

When the prairie territories were opened to settlement in the 1830s, the full potential of American society was fully unleashed. Rich, fertile farmland in seemly limitless amounts became available, almost for the taking. Waves of immigrants, including your ancestors and mine, arrived to help exploit, directly or indirectly, this potential bounty.

While the prairie soil was rich and deep, the first settlers discovered it was also almost impossible to plow. Prairie grasses formed a solid mat that broke conventional plows. The soil stuck to the cast iron shares of the walking plows that had worked well enough in eastern soils. John Deere was a blacksmith who built and repaired plows for pioneer Illinois farmers. His customers implored him to make a plow that would "scour" in these difficult soils, and Deere set to work.

He used (the legend goes) a section of broken saw blade as the basis for a new design, forging it in a graceful, progressive curve and adding a sharp point and leading edge. Unlike the traditional share's rough surface, the Deere blade was polished to reduce friction. Trials proved that it sliced through the sod, turning the tough grass over and preparing the virgin prairie for its first planting. If you broke the prairie in the fall, let it weather and the roots disintegrate over the winter, the soil was ripe for planting in the spring.

Not only did the plow scour properly, the draft (as the resistance for the horses is called) was far less than with the traditional plow. Without this invention the Great Plains could never have been brought under cultivation. Millions of single bottom walking plows, designed for use with one or two horses, have been made over the years since, all based on John Deere's design.

Single bottom horse-drawn walking plows are still manufactured, very much like the Deere design, primarily for use by Amish farmers, but also for a rather numerous congregation of people who still prefer working with horses instead of tractors. Demand for the old horse-drawn plow is so great that the Amish-owned Pioneer Equipment Company has recently opened a large, new factory to produce these plows and other tillage tools for horse-powered farms in the United States and Canada.

Plowing this way, with a horse and single-bottom plow, was and sometimes still is an annual rite of spring for farmers all over the United States. If the plow turns a 12-inch furrow, as this one probably does, the horse and plowman will walk over eight miles for every acre. But this plow is an elegant, important tool that changed the American landscape in very real ways. It broke the plains and opened the West and fed the nation, one acre at a time. *John Deere*

britchen goes around the horses' tail, the belly band is brought around and secured, then pull the pole strap over the belly band. Snap the quarter straps to the end of the pole straps. Now, wasn't that easy?

Okay, now for the bit and bridle. Be sure, on those freezing March mornings, to warm the metal bit before putting it in the horses' mouth. A good horse might protest a bit at this point, but most cooperate readily by opening up. Hold the upper end of the bridle in your right hand, spread it to fit the horse's head, with the bit in your left. It should be a simple matter to slip the bit into the mouth, and don't let him use his tongue to play with it! Adjust the bridle and buckle it. Everything should fit neatly. Attach the driving lines to the bit, snaps on the outside. Now do the same for the other horse.

Okay, they are harnessed, but not yet hitched. Walk the horses to where your plow is waiting at the edge of the field. You put the horses in gear by talking to them—*Matt! Mike! Up!* And Matt and Mike will move off together. Steering is with the lines, obviously, but with a gentle touch. You hold the lines so there is always slight tension on them; that lets the horse know you're still back there and not under a tree taking a siesta. Slight pressure on one side or another is all the clue they usually need. And they generally are smart enough to know what's on the program, too, if they are mature and experienced work horses. The tugs attach to the doubletrees and the evener equalizes the effort of the two, and pulls the plow. It has only taken about 15 minutes and you are now ready to go to work.

It takes a while to harness the horses—longer than it takes to start a tractor, certainly. But, as David Nickell says, "I've been around a lot of old farmers. When you get to know them, they always have some story about a favorite horse they had. I have never heard anybody tell a story about a favorite tractor."

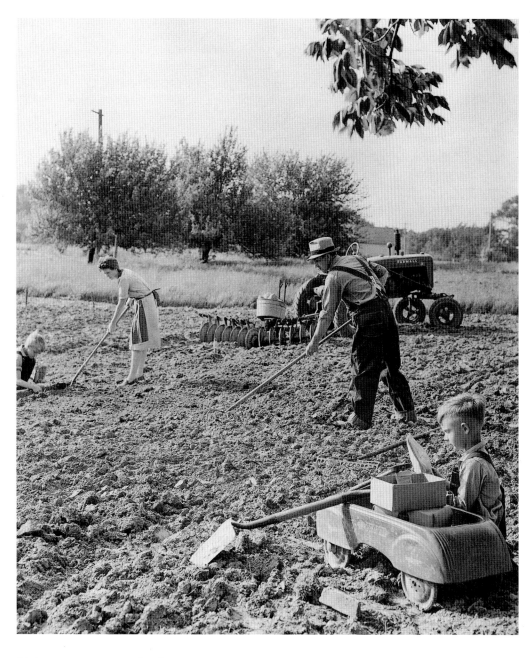

Cash crops went to market but produce from the vegetable garden fed the family until harvest. This farm looks prosperous. Junior has his sporty little Zephyr pedal car and Pop drives a Farmall A tractor. *J. C. Allen & Son*

Plowing with horses is a skill that takes plenty of experience to master. A farmer of 70 or 100 years ago would be expected to be able to cut a clean, sharp, arrow-straight furrow. That is a lot harder than you might think. It starts with the first furrow, which happens to be the most difficult. That's because the horses have no guideline as they will once the first furrow is cut. Then the "off-side" horse (on the right) will walk in the furrow, the "near-side" horse will walk on the unplowed "landside." When a green, inexperienced team is matched up with a beginning teamster, that furrow can wander all over the map—and the teamster will be turning the air blue with unkind remarks about the horses' motives, breeding, and education. What the horses think about the teamster is not recorded.

It is important, too, that the plow be set up and adjusted properly. The center of the "draft" or pulling force from the team must intersect with the exact center of the resistance of the plow in the ground. If not, the plow will try to wander off one way or another, or pop out of the ground, or dig down to China. If you find a rock or a root, the plow will flip and try to launch you into space. Ah, weren't those the good old days—when things were much simpler than today?

Plowing is just the first step in the normal tillage process. You can't plant in a field that has simply been plowed—the soil is too uneven to provide a reasonable seedbed. The next step in the process is *harrowing,* with disks or spikes. This pulverizes the soil, aerates it, and levels the surface. Several passes may be required, but you can almost always ride a harrow, and the swath is much wider so it goes faster.

Over the past forty years or so an alternative to plowing has become generally accepted, a tillage system called "no-till" or "minimum tillage." The basic idea is that it makes no sense to cut a 12-inch hole for a half-inch seed; instead, a narrow strip of soil is cultivated with special tools. That makes the tillage and planting go faster and reduces erosion. It also means the weeds that would otherwise be destroyed need to be suppressed with herbicides and cultivation. No-till works for some farmers and not for others.

The Good Family's Dairy Farm

One American farm family that is ready for spring are the Goods of Dalton, Ohio. They are pretty typical of modern dairy farmers anywhere in the country: Milton and Ruth, their seven kids, 100 cows, 425 acres, a couple of tractors. They live a couple of miles north of Dalton in rolling terrain, near the Pennsylvania state line, in the northern section of Holmes County. There's a lot of dairy operations in the vicinity, the "milk shed" for the industrial cities like Cleveland to the north. Drive out of the center of the Dalton village on Dalton-Fox Road and you'll wind through a lush countryside of old, well-maintained dairy farms. The Goods have been dairy farmers for many generations, and are part of a large and thriving Mennonite community in Eastern Ohio. They own 250 acres outright, and rent another 175 acres nearby. These acres all support a herd of about 100 Holstein cows, 75 of which are normally producing milk at any one time.

The first day of spring on the Good family farm is the first day you can get the tractor out in the field without getting bogged down in the mud. That's an important day for anybody who grows corn, and that includes most farmers in the eastern part of Ohio. The Goods grow a lot of corn, fodder for their dairy operation.

The Good family's roots are deep in this Ohio soil. Milton's grandfather once owned the farm to the north, but he and Ruth bought their home place about 20 years ago, not long after they married. Two of the older girls have married and moved away, but five children remain. All help with the milking, dishes, and routine chores. All children can run a tractor and the older kids, both boys and girls, help with the hay and corn harvest. The girls, though, help Ruth with meal preparation and the

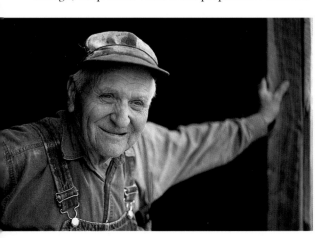

boys help maintain the extensive machinery required by any dairy farm. Their conservative Mennonite faith has the same historic foundation of the Amish and—in the strong tradition of American farmers—is a central focus of daily life. Their congregation includes a large, extended family of relatives, neighbors, and friends in and around Dalton. As American farmers have done for hundreds of years, members socialize together and pitch in to help each other with labor and loans of machinery when something breaks down.

Although it is the first day of spring plowing, the day will begin with the same ritual of every other day in every other dairy farm household, milking the cows. Young Irvin is now old enough to help with this chore but his primary job (typical of the youngest child in dairy farm families) is bottle feeding the youngest calves. He's a sturdy lad of 10 and the job of milking the whole herd is a little more than he can handle yet, but he will often pitch in to help.

Jacob and Anna Yoder's 80 Acres

Down the road a few miles, over in Dundee, live Jacob and Anna Yoder, their son Merlin, his wife and children—all eagerly anticipating spring, too. The Yoders are also typical American family farmers, although they use horses and methods of the past. They are Old Order Amish and members of a large and thriving community in Holmes County, Ohio. They have only 80 acres and

Paul Reno is the beloved grand old man of traditional farming in the far West, a kind of horse-farming guru for people trying to learn how to plow and plant with horses and mules. Originally from a small Oklahoma farm, Paul knows just about everything there is to know about the southern end of a northbound mule—and about plowing, planting, and harvesting with single-bottom walking plows, grain binders, and threshing machines. His advice is offered in a thick Oklahoma drawl, but it's free, accurate, and valuable. There are a lot of old guys like Paul around, and a lot of interest in the old ways and old wisdom.

their primary cash crop is veal, some of which is shipped to Israel. Like most Amish people, the Yoder's rely on horses for transportation as well as farming. They drive to town in a buggy pulled by a handsome thoroughbred, a failed racehorse. Five big Belgian horses do the plowing and planting as well as pull the binder and the hay baler. They thresh the oats for their horses with an old Dion threshing machine. Although the Yoders, like many Amish, keep the old practice of threshing alive, the thresher is driven by a modern diesel tractor used as a stationary power source, and the binder and hay baler both use small supplementary gasoline engines to relieve the horses of some of the work.

Jacob and Anna's children are grown now and in Amish tradition they've moved out of their big old farmhouse where the kids were raised and relinquished it to son Merlin, his wife, and their children. Jacob and Anna now live in a smaller home across the yard, called a "doody house" by the Amish.

The Amish have a reputation for aloofness and reserve around the "English," (an Amish reference to non-Amish Americans) but the Yoders are open and friendly. Jacob greets you with a joke: "Ya' know what would happen if they took all us Yoders out of Holmes County? It'd be *de-Yoderized!*" But that's not likely to happen here; there are hundreds of Yoder in this community.

You won't find many of them in the phone book, though. They don't have telephones, radios, televisions, electric light, automobiles, or many other devices the rest of us consider necessities. The Yoders, like most of their neighbors, use kerosene lamps for light. But while the Yoders use many of the tools and techniques of the distant past, they do so by choice. It is part of a considered deci-

sion by the bishops of their congregation, and a lot of their decisions make sense if you understand their foundations.

The Koster Home Place

Spring in the far western part of the United States comes a little earlier but is celebrated with as much enthusiasm as in the east. That is particularly true on the old homestead owned by Cliff and Onalee Koster, tucked up against the Coast Range of mountains that forms the western boundary of the great Sacramento-San Joaquin Valley of California. The principal commodity on the Koster place now is tree fruits—apricots, walnuts, almonds—although it was

once planted with wheat, oats, and barley. This ground has been in Cliff's family since his great-grandfather homesteaded the place in 1880. Cliff and Onalee's son, Billy, his wife, Celeste, and their new triplets all live on the place. Chores on this spring morning are different here, 2,000 miles to the west of the Yoders and the Goods, but the setup is just about the same. Check the weather, listen to the market reports, and feed whatever livestock is currently in residence. Then it's time for breakfast.

Cliff Koster is like many American family farmers, a guy with a reverence for traditional ways, for traditional tools, manners, and values. Cliff's dad sold off the mules and horses in 1914. He bought himself a Best 25 tractor, a big one, and a huge Harris harvester, too. But since he wasn't all that sure about the reliability of the new rig, he kept the hitch and harness for the mules. They are still there, on the same nails, where he hung them 80-plus years ago—just in case.

There are a couple of buggies in that barn, alongside the big Best tractor, plus that Harris har-vester designed to cut a 24-foot swath of standing grain. Cliff worked on the harvesting crew as a boy in the 1920s, a young man in the 1930s, as its owner after World War II. And he still gets it out every couple of years and (with the help of some friends) cuts some grain with the old machine. A few years ago they pulled together every horse and mule they could find, hitched them all together with the old Shandowny equalizing hitch, and were about to try to attack some oats with the rig when some of the horses spooked. That's called a "runaway" and what usually follows is called a "bust-up." But somebody maneuvered a pickup truck to cut off the leaders and the old Harris (and the horses) survived. They've hitched it to one of the big old tractors ever since.

The barns on the Koster place look pretty much just the way they did when they were built, back around the turn of the century, and some still wear their original redwood shingles. The hitching post is still outside the house, just where it has always been, ready if somebody should arrive in a

It's a fine spring day, "shirt-sleeve weather" we call it, and the danger of a late frost is past. So it's time to fire up the old Avery and haul the spring-tooth harrow around the field, preparing the seedbed for planting. *J.C. Allen & Son*

buggy or with a wagon and team. The Koster com-
bine is a John Deere 55, 40 years old and still cut-
ting. Cliff plows with an International tractor
bought at government surplus; it (like Cliff himself)
is a veteran of World War II. Cliff doesn't believe in
debt, doesn't tolerate waste. He honors tradition,
cherishes the hard, dry California ground, and loves
farming. He and the Yoders have more in common
than you might suspect.

David and Stacey Nickell's
Old Kentucky Home

Spring finds the Nickell family ready to
start another year in a long tradition of Kentucky
farming. David Nickell's family has farmed the
western Kentucky soil for better than 210 years,
ever since Jerimiah Nickell headed down the river
to the western wilderness after the Revolutionary
War. Jerimiah fought in the war as a private.
Afterward he and many other veterans moved
into Kentucky, looking for a place to start fresh.
Jerimiah found it where the Cumberland and
Tennessee rivers unite. The Indians were friendly,
the ground level and fertile, and the price was
right. He and his wife built a cabin, had their chil-
dren, lived a life, then passed on.

David's great-great-grandfather, James,
was the next custodian of the farm and he had his
own children, improved the farm and built a house;
he passed it along to his son Madison, and he
passed it yet again to son Shelly Nickell. Then it
went to David's father, Bill. Each succeeding gener-
ation born in the same house, adding a room or two
with each fresh crop of youngsters. The maternal
side of the family has been here since 1850, farming
pretty much the same ground, too.

David and Stacey now own his maternal
grandfather's old place, 109 acres, that has been in
the family for at least 100 years. The house goes back
to the 1830s, is solid oak from top to bottom, and the
foundation is the simple creek rock construction
once common to farm buildings. The ground is a
sequence of rolling hills, low at the front, along the
road, then climbing toward the back and a ridge.
Behind the ridge the land slopes back down toward
the Ohio river below. That land back toward the river
is timbered, and likely to stay that way for a while.

The farm is a place full of ghosts and links
from the past to the present. A web of relationships
between people living and dead connects David and
Stacey to their ancestors who worked this same
ground and their neighbors, down through the
years and the generations. "Anywhere I go on this
farm I have been before, as a child, with my grand-
parents," said David," They told me stories about
things that happened here and there on the place.

One of the earliest and most important chores in spring is putting in seed. This horse-drawn contraption is a corn planter, an example of high technology when it was introduced after the Civil War. It opens a furrow with the curved blade, drops a kernel from the small canister, adds a portion of fertilizer from the larger canister and then covers them over with soil. *J. C. Allen & Son*

Rural roads were once a major political issue, and here's why. Getting stuck in the mud was part of getting to town. *J. C. Allen & Son*

"Mr. Herbert, my neighbor across the road, is 95; he and my grandfather grew up across the road from each other—they were best friends. Their fathers had been best friends before them. Mr. Herbert's daughter and my mother grew up as neighbors, across that same old road, and were best friends, too. Now, Lyle lives over there—we're fourth-generation neighbors and friends!"

That old road is VERY old. It has been moved a bit, and the asphalt county road runs a bit farther from the old house than in the past. The old road bed was, and still is, right in front of the house. Countless carts and wagons have left their mark on the ground where people passed by. The ancient bridge still crosses the creek, too, although it no longer serves highway traffic. "I don't know how old the bridge is," David says, "but my mother's cousin, who lives a quarter-mile up the road, told me that his grandmother remembers sitting on the porch of my house as a little girl, watching the Confederate and Union troops pass by on that road, across that bridge."

The Nickell farm is a mixed operation—in several ways. David likes working with horses but

Early spring in cattle country, when the hay fields turn emerald green.

owns and uses a tractor, too. David's first draft horse, Dixie, is a "grade" (meaning of common or mixed parentage) Belgian. He started out with Belgians and Percherons, then got into Suffolks. Actually, he started out working on conventional farms, the conventional way. David explains,

"I used to—by myself—cut, rake, bale, and stack over a thousand acres of hay every year. I saw right away that the farmer's biggest expense was in equipment. I saw how tremendously costly it was to buy and maintain these machines, and how quickly they wore out. I knew there was no way I could ever get into that on my own—it was impossible to afford.

"Well, I looked around and noticed the Amish guys were doing pretty well. I thought, well, maybe that makes sense. Then I did some work for a guy who needed some help and didn't have the cash to pay for it; he offered to trade the work he needed for some of the twenty Belgian horses he owned. I ended up with two

Belgians, one of whom was Dixie, then a two-year-old. I started using the horses...and it all kinda fit together. I'm still a beginner, still collecting equipment, still trying to learn—still no good with the plow! I never have managed to plow a straight furrow with a horse! That's something I am still working on. My grandmother used to tell me, 'You'll know you're a real farmer when you can plow with a team!'

"My grandmother taught me a lot. Her number one rule was, If You Live On A Farm, Make Sure You Always Have Something To Sell! "That turned out to be excellent advice," said David." 🐦

David and Stacey are slowly rebuilding the old home place. Although the farm had been in the family for generations, it was sold about 20 years ago to someone else. This farmer depleted the soil with successive corn crops, polluted it with indiscriminate use of pesticides and herbicides. When David and Stacey finally bought it back almost nothing would grow. In the years

since they've rebuilt the soil with careful tillage, frequent applications of manure, and a good rotation plan.

Spring At the Boyd Farm

Leland Boyd's family on both sides has been farming the black, level land west of Charles City, Iowa, for generations. His father, Duane, grew up on a farm nearby, a typical diversified operation of the time, with dairy cattle, some corn and wheat. When it was time for Leland to start farming on his own, he had to earn his acres the hard way, starting as a frugal tenant farmer after World War II. He worked 320 of somebody else's acres, growing corn and soybeans, and feeding cattle. That lasted a few years. Then in 1950 he took his pennies, a loan from the bank, and some high hopes and bought 150 acres of his own. He continued the same kind of feeder operation, buying cattle and putting meat on them, and farrowing pigs and getting them in shape for the bacon industry.

Charles City is the birthplace of the farm tractor, and it's been quite a while since the Boyds walked a furrow, studying the southern end of a northbound horse. Duane wanted a large, efficient, manageable place for the family, and he built it with tractors and machine power. He bought ground when he could afford it, rented some as well, slowly adding to his acreage. Today the family operation owns 550 acres but farms a total of about 1,200 acres, all focused on the feeding operation. They farrow ("breed") and finish 2,000 hogs (Large Whites, Durocs, and Hampshires) a year, plus about 450 head of cattle (anything available, typically Herefords, Blacks, Charollais). The whole operation is managed by just Leland, his father, Duane, now in his 70s, and uncle Glen who is about 85, plus one hired man. That kind of operation is typical of this part of Iowa, small family units with acreages in the 1,000 to 2,000 range. This is tractor country, big time, although there is still extensive horse farming nearby, and the biggest draft horse auction in the entire country is held annually at Waverly, down the road.

How do three or four people manage all that acreage and livestock? Automated feeders and BIG tractors and combines. That is another form of American family farm, and it is probably the most typical form today. But the cycle of the seasons starts the same way, with the first day of spring, when the tractors can finally get into the field. The Boyd's primary tractor, the big one, is a Ford 946. It's two years old, has four-wheel drive, and with 300 horsepower, does the heavy lifting. It does the spring plowing and fall tillage.

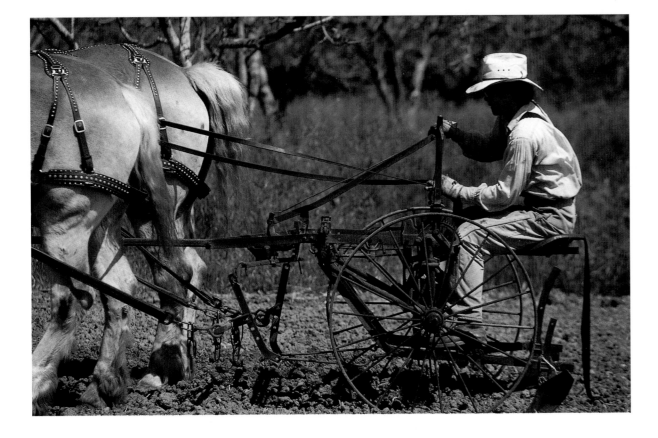

Nobody has bothered to restore this old cultivator but it is headed off to the fields for another of spring's chores, cultivating the young potatoes and corn with Dave Cook at the helm. Corn and potatoes both need plenty of early attention to keep the weeds down; once the crop has grown for a month or so they'll be too big for the machines, so get the weeds early, while you can.

Planting the traditional way near Lafayette, Indiana. This is tedious, back-breaking labor, sowing seed by hand from an old lard bucket. It was difficult to keep the seeds evenly spaced and consistent. *J. C. Allen & Son*

FAR RIGHT
Grandpa is planting potatoes; cutting a potato into quarters and making sure that each quarter has an "eye" that will sprout into a new plant. Both of these spring planters are outfitted in coveralls, a one-piece denim suit that was frequently worn over other work clothing. *J. C. Allen & Son*

To market, to market, to buy a fat pig...it's Thursday at the Kidron, Ohio, market and these Amish lads are doing some business at the weekly auction. You'd have seen just about the same scene 150 years ago, when most American farmers used wagons and teams like this one, and generally dressed about the same way, too.

OPPOSITE
Near Phillipsburg, Kansas. Farmers once prided themselves on arrow-straight furrows. Now, spring plowing follows the contour of the terrain, with watercourses left uncultivated to catch erosion. That change is part of the modern farmer's careful husbandry of the land, a big improvement over the "good old days" when the soil was taken for granted—until much of it blew and washed away in the 1930s. *William Garnett*

On the Boyd Farm in Springtime

The growing season's work for the Boyd family begins with a specialty crop, registered oat seed. "We start thawing out in early April," Leland says. "We might get some oats in by the 15th, some years, on about forty acres. We need the oat straw for bedding the animals, and we just sell the grain as registered-quality seed oats. On this good ground we'll get 100 bushels of oats from an acre, plus close to 3,000 bales of oat straw. That's pretty

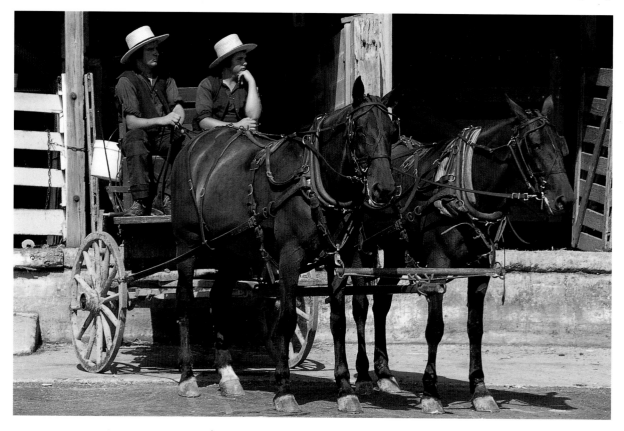

good." They'll drill alfalfa at the same time, a slow growing hay crop that will share the ground with the oats for a couple of months, then have the field to itself for another year or two.

As soon as the oats are in, preparation for planting corn begins. Normally the Boyds apply anhydrous ammonia in the fall, but sometimes that doesn't happen before the weather closes in, so it then becomes a springtime chore. Around the third week in April, they'll apply anhydrous ammonia during the preparation of the seedbed. The big tractor gets hitched to a 28-foot wide One-Pass Krause implement, a combination tool with two rows of disks and four rows of 12-inch shovels, followed by a leveling tool with 12-inch spring harrow tines, and finally a wide rolling basket. These tools together open up the soil, break up the clods, and leave it ready to receive the seed. The tractor also mounts a 600-gallon tank and sprayer system to apply a wide-spectrum herbicide to further control any weeds that escape the tillage tools. With the big Ford 946 doing the pulling, Leland or the hired man can cover 25 acres an hour, roughly 100 times faster than a farmer doing the same basic job with a walking plow and two horses.

An hour or two after the One-Pass goes over the ground, leaving it all soft and fluffy, one of the Boyd family team comes along with the planter, a 12-row White machine, behind one of the other tractors cruising along at a brisk six miles per hour. "When you're not stopped, filling the boxes with seed, you can plant 20 acres an hour," Leland says. They apply liquid fertilizer at the same time to get the plants started, about 100 pounds to the acre.

Soybeans go in next, in the row instead of drilled with a no-till system as some of the neighbors are doing. But the Boyds' yields with the old methods have been good, the no-till seed drill costs better than $20,000, and the old planter still works. "It's kind of a trade-off," Leland says of the two contrasting methods used by the neighbors and his family, "some years they get an extra bushel, some years I get one." By the last week of April or the first week of May, planting is done on the Boyd family farm.

Livestock in Spring

Spring is a busy time for all farmers, especially those like the Boyds who have to care for hundreds of animals. Spring is the natural time for most animals to give birth, allowing the young to develop and mature before winter closes in. This is when chickens pump out eggs by the dozen, when lambs

The Practicality of Using Horses

by David Nickell Excerpted from *Small Farmer's Journal*, Summer 1995

The practicality of using horses is seldom considered by the majority of Americans, yet it is a question some of us are continually examining. I found myself thinking about this while disking the small field between the house and the road. Basically, whether or not horses are efficient depends on what level of technology you take as the starting point of reference—disking with a team sure beats the heck out of using a roto-tiller on this three-and-a-half-acre creek bottom. And in terms of sheer cost, it is difficult to believe my little disc and these two pregnant mares aren't more cost effective than a fuel-guzzling tractor pulling a disc that could hardly be turned around in this small field. As we all know, using the horses *increases* their worth. Using a tractor decreases its worth—as does letting it sit idle. The older colts will get their first work here, raising their own fuel.

"Dagnabit! You hitched the wrong horses!" Well, they *always* show the wrong horses in the old advertisements—wimpy lightweight racers instead of good, muscular "drafters." But the "sulky" plow was a big advance for the family farmer, speeding the job of spring plowing. That allowed larger acreages, and that in turn generally improved the farmer's profitability. *John Deere*

Resting the horses at the end of the field I look around me in an unhurried manner generally not available. I watch the bluebirds inspecting the house I nailed to the pole at the west edge of the field. At the north end I see a white breasted nuthatch working in the hollow knot-hole of the pecan tree. Looking back to the disc and the soil beneath it I decide, on a whim, to try a different adjustment to see what effect it has on the quality of the work being done. These rests allow room for such curiosity-driven experiments—occasionally the results are a pleasing advance in my understanding of what I am doing.

As I bid the mares go, I observe the communication between them. I know that even though both are experienced farm horses these two are still learning to work together. So I give them ample time after the command rather than responding with impatience. They look at each other with purpose. The lead mare bobs her head down and up. The off mare begins to bob her head in unison, and they step into their collars together. The load eases into motion and they pick up their stride.

I am but the foreman of the good work crew. By careful observation I am continually learning when to let them decide how to proceed and when to intervene. The lead mare, Dixie, is a particularly honest worker. When they have had enough time to blow during their rest, she will raise her head and snort softly. If I do not respond she will turn her head full around to look at me. Why am I not paying attention?

As we move down the field, the disc centered on the edge of the path created by the last round, I hear last year's corn stalks under the disc blades, I feel and see the good soil open, turn, and crumble. I smell the richness of the freshly opened spring soil. I attend to how the mares move, looking for adjustments that might make their work easier. I notice the red-winged blackbirds nesting in the saplings along the creek which borders the field on two sides. And I notice with satisfaction the improved tilth of the soil. This field has been long productive. My ninety-four-year-old neighbor has told me—many times—how he and my grandfather worked this field as boys. It yields almost as much now as it did then, back when the century was as young as they were.

Gene Hilty with a pair of big Belgians, ready for spring plowing. Skill with horses was once an essential part of farming everywhere in America. Although horses nearly disappeared from the farm during the 1950s and 1960s, interest has grown over the last couple of decades and the market for "drafters" is currently quite good.

A well-worn Centennial plow in action, hitched to a glittering old Massy-Harris 101 tractor. Farmers certainly loved their horses, but it was love at first sight when models like this started appearing at the dealers in town half a century ago. They still love them, as you can see from the wonderful restoration job lavished on this tractor, about to take a bite out of the great plains near Waverly, Nebraska.

Sitting down to plow was for sissies, even after the tractor was introduced. On the early machines, the farmer needed to stand up to see over the front wheels. This early tractor has metal cleats on its wheels to improve traction when pulling this "two-bottom" plow. *J.C. Allen & Son*

and pigs and colts and calves all magically appear. Most require a lot of attention—if the farmer expects good survival rates, anyway. And that means lots of time out in the barn, helping sows farrow and cows drop calves.

Cattle on the Farm

Range cattle give birth in early spring, normally without any attention from the rancher who owns the herd. If anybody is going to help with the process it is likely to be a coyote or mountain lion. If the cow has a problem delivering, both the cow and the calf rather quickly become fodder for the new crop of coyote pups or lion kittens. If a cow rejects her calf, it dies and feeds coyotes, lions, and vultures. That's just the way it works on big ranches.

Late in the spring—which can be anytime from February to June, depending on the altitude—is roundup time across the west. That's when, today as in frontier days, neighbors and family members and anybody who can stay on a horse and stay out of trouble will be recruited for a weekend or a week of 15-hour days in the saddle. The idea of the roundup is to collect all the new calves, count them and mark them. Western

It must be Monday because Mom's doing the wash. Rural electrification made this seem a luxury. The lady is feeding wet wash through a wringer, cranking the handle to operate rollers which squeeze out all the excess water. A hazard in any family of boys was the occasional frog in the pocket of somebody's jeans. *J. C. Allen & Son*

cattle often graze on public land and herds get mixed. The branding iron is each steer's license plate and registration, applied at the first opportunity in springtime.

After roundup, the herds are still driven to summer pastures. That is often in the high mountain meadows of the west, up at 8,000 feet quite often. While many herds are moved most of the way by truck today, you'll still find plenty of cattle drives in eastern Oregon that last a week or more, moving a herd of several hundred animals 25 miles up into the mountains.

Horses on the Farm

It's hard to appreciate just how important horses once were to the American farm. Before World War I, about 20 million draft horses and mules provided motive power on just about every farm in the country. The horse has a lot of virtues for the farmer, some real advantages over the tractor. In fact, it wasn't the tractor that really killed off the horse on the farm—in a way, it was World War I. When the U. S. Army went to war in 1917, a large portion of the draft animal population was drafted into the service. Many went to France but not many came back. The American farmer still had to plow and plant and harvest, and the infant gasoline-pow-

Homemade Raised Doughnuts

3/4 cup softened oleo
2/3 cup sugar
3 eggs
about 10 cups flour separated
3 pkg. dry yeast
2 tsp. salt
3 cups lukewarm water

Cream oleo, sugar, and eggs. Add 2 cups flour. Add yeast. Then add the rest of ingredients. Add flour as needed. Knead 100 strokes. Let stand in warm place for 1 hour. Knead again. Let stand for another 1/2 hour.

Roll out to 3/8-in. thickness. Cut out doughnuts. Place on floured surface. Let raise until double in bulk.

Fry in hot shortening. Drain on brown paper. Enjoy!
Makes about 6 doz. doughnuts.
Courtesy of Frieda Klancher

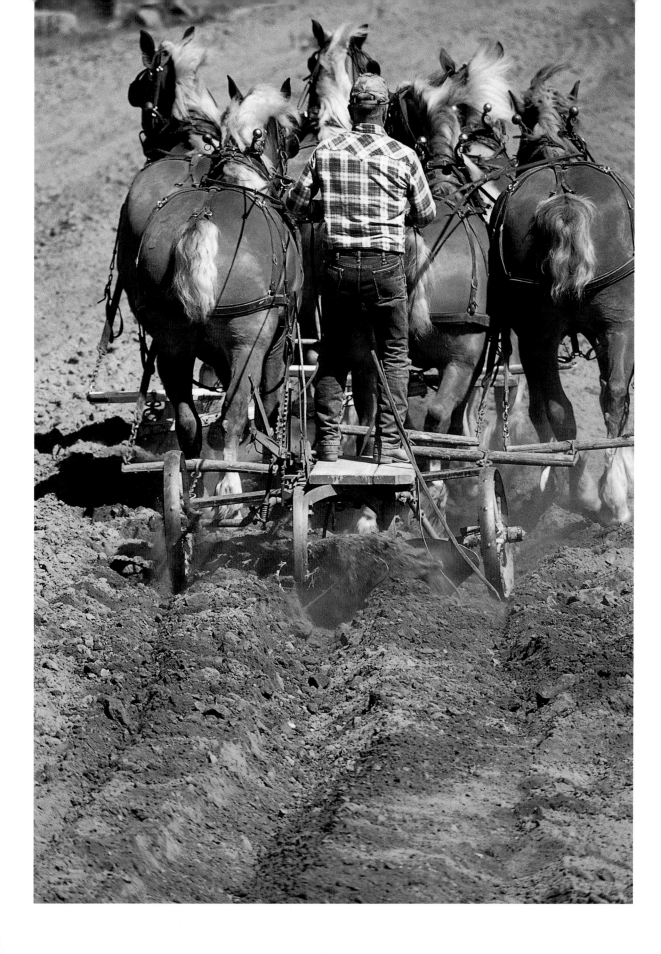

Gene Hilty plows at Red Top Farm with a six-up hitch of Belgians. The big hitches—and they get bigger than this—take a skilled teamster to manage; turning the horses at the end of the field is like watching a chorus line finale, with legs flashing in unison.

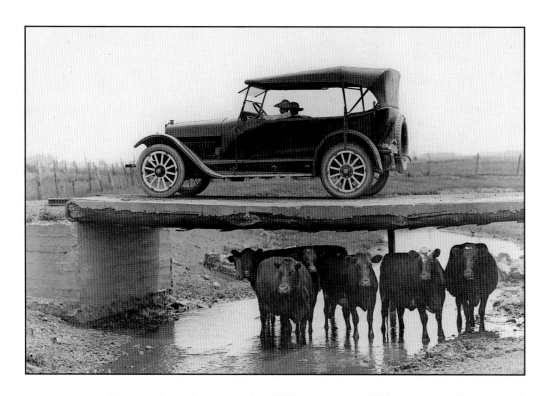

ered tractor was available to help. Once the farmer mechanized the farm there wasn't much incentive to go back to horses. It took about 30 years for the whole country to convert to tractors, a process that was essentially complete by about 1955. Currently, though, horses are making a comeback and prices for draft animals are excellent.

John Slauter's folks farmed with horses in the 1920s and 1930s, and springtime on the Slauter farm back then was a time he remembers with special affection:

"I always delighted in being allowed to tag along and watch Dad do the plowing, planting, and cultivating in the springtime! What a thrill it was the first time Dad put me up on the sulky plow and taught me how to drive the team! It was an eighteen-inch, single-bottom sulky plow, and Dad used three horses on it. That was an important moment to be big enough to be able to use it. Then we graduated to a two-bottom gang plow, with a four-horse hitch.

Farm youngsters frequently learned to operate the family tractor as soon as their feet could reach the pedals. And they drove the family car as soon as they could see over the steering wheel. The cows are wisely taking cover. *J. C. Allen & Son*

Dave Cook harnesses Charlotte, one of Ardenwood Historic Farm's Belgians, before a day cultivating young potato plants. She is a fairly young horse, still learning the routine, but she likes to work and enjoys a chummy relationship with Dave.

"In the spring of the year we always had a couple of colts to break. You start that process by tying the colt to one of the outside horses, just to give it the experience of being part of the team. That was a new experience for the colt who would usually jump and rear and squirm around at first. It took a while to get them settled down.

"Then Dad finally put me on the mowing machine, pulled by two good horses—a very special and memorable day! I can still smell that good clover hay as the mower laid it down.

"We stacked all the hay loose in those days. No bales for us. My dad prided himself on being a good hay stacker. A man who knew how to make a good haystack in those days could just about name his own price—the neighbors would hire him to do the job, and paid well for the service.

"We always sowed some oats every year, and about the end of June or the beginning of July it would be time to cut and bind them. We owned a binder, and four horses. A neighbor helped, and he brought four horses, too. It was awful hot that time of year, so one team would work while the other rested, and we changed teams every two hours or so. My job was to shock the bundles of oats, gathering them up and stacking them in shocks. It was a big thrill when I was old enough to help with this job." 🌿

The Draft Horse

The focus of the Nickell farm in Kentucky is draft horses; they breed, train, board, and sell Suffolks to the growing market for working horses in the southeast. The Suffolks are an English breed, properly known as the *Suffolk Punch*. That has been a fairly rare breed in America, but one rapidly growing in popularity, and the Nickells have pretty much cornered the market for them in this part of the country. It is a rather short horse, much closer to the ground than, say, a Shire or Clydesdale. They

The self-sufficient farmer needed a wide range of skills: carpentry, veterinary medicine, and then tractor repair. Such machinery as the gas-powered tractor changed the farm and the farmer forever. *J. C. Allen & Son*

Rice fields near Sacramento, California. California was once, in the 1880s, the leading wheat producer in America, and this land once was planted to that crop. Since then cotton, rice, grapes, and tree fruit have displaced the old crops, thanks to a network of irrigation canals.
Bill Garnett

It was one-stop shopping from necessity, not from choice. The General Store sold nearly everything needed on the farm. Candy bars are displayed in the glass case on the right, Mason jars are next to the cash register and the Fly Tox is behind the counter. If you don't see it, just ask...it's here somewhere.
J. C. Allen & Son

have massive barrel-shaped, muscular torsos, and a roan color. Of all the draft horse breeds, the Suffolk Punch is probably the most affectionate, willing helpmate.

David Nickell didn't intend to build the operation up that way, it just happened. They discovered a market for the breed and gradually have begun to fill it, selling horses to people primarily in Kentucky and Missouri. There are fourteen on the place now, two stallions, several brood mares, some colts and yearlings, and a boarder or two. Five of the Suffolks are leased from another breeder; in exchange for their keep, the Nickell's get to keep any colts from the mares. Stacey's got a pair of quarter-horses in the barn, but they don't pull plows. Three of the draft horses are Belgians, the rest Suffolks. They're on pasture, most of the time. There is only one piece of farm machinery on this farm. The resident tractor is a faithful 1954 Farmall Super H, but it sits in the barn most of the time.

If you haven't worked with draft horses the idea might seem entirely daffy but, as David explains, working with some horses is like having a friend come along to help with the field work. You can develop a relationship that makes the work

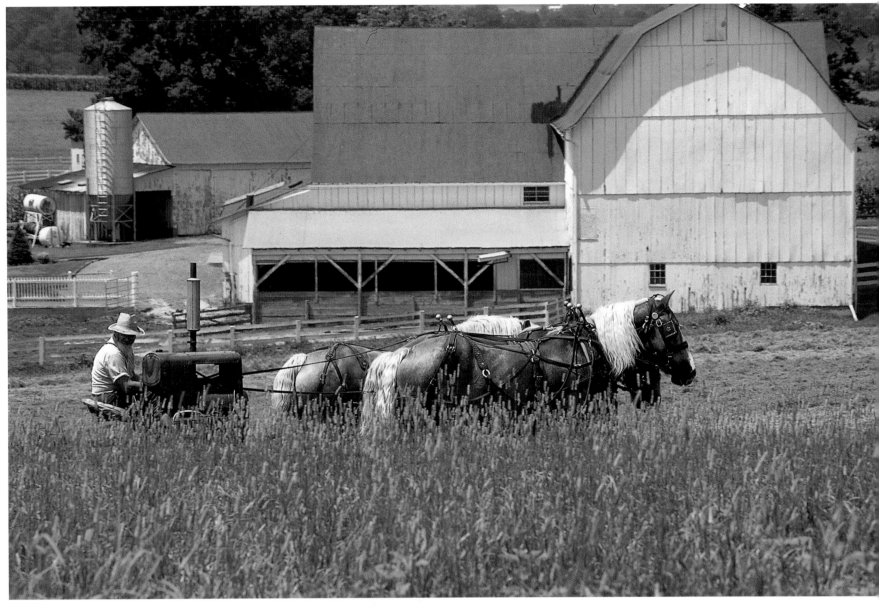

rewarding in ways not possible with a tractor. David explains it best:

"I've been around a lot of old farmers. When you get to know them, they always have some story about a favorite horse they had. I have never heard anybody tell a story about a favorite tractor. Dixie is the first horse I ever owned, and she and I have been through a lot together. Dixie is the kind of horse that, if I take another pair out to the field to work, she will run the fence, trying to join us. She has a quality that you can't train into a horse—intelligence. When I make a turn at the end of the field, she'll be looking at where she thinks she's supposed to go, without any guidance from me.

If I change the pattern, she'll stop and seem to say, that's not right! A good horse, most folks will tell you, is one that does what you TELL it to do; this horse is always thinking, always trying to stay a step ahead of me—working WITH me. Working with a horse is radically different from working with a machine; it's like having a partner in the work! In fact, I don't do the work, the horses do." ❦

The Farm and the Tractor

Despite David's attachment to horses, the bulk of American farmers took to the tractor like the proverbial duck to water. In the years just before World War I, tractors were all people could talk about. During

Haying on the Yoder family farm finds Jacob making a circuit of the hay field. The mower is powered by a gasoline engine, easing the draft on the horses.

April Is the Time To:
Sing.
Fix fences.
Haul manure.
Dehorn calves.
Plow for corn.
Build terraces.
Read Psalm 147.
Oil all machinery.
Get your hat cleaned.
Face the bee hives South.
Try out the corn planter.
Let Sister April Fool you.
Put up bird houses—last call.
Overhaul grain drills for spring rush.
Pick some wild flowers for Mom.
Show Shorty how to sharpen a saw.
Adjust the carburetor on the truck.
Protect grass from too-early grazing.
Spray cattle for grubs.
Put down pipe to the hog pasture.
Earmark gilts from the biggest and best
litters for future motherhood.
Reduce the mortgage; tell the banker
that you still appreciate that first loan
that got you started.
Farm Journal, April 1952

This Roxbury, Connecticut, farm is green and gorgeous in spring. *Howard Ande*

Ralph Wettschurack and his son David are taking soil samples with a small boring tool. The local county agent will analyze the sample and advise the farmer on suitable crops and the kinds of fertilizer needed for this particular soil. *J. C. Allen & Son*

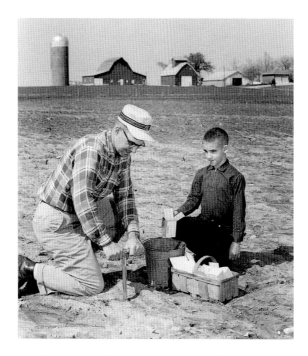

This little cutie is discovering springtime in Oregon. She's a Suffolk Punch, an English breed rapidly gaining popularity with American horse farmers. Horses have both virtues and vices for farmers; it will be a couple of years before she's ready to work, but her "fuel" can be produced on the farm where she lives, at small cost.

this time, enterprising businesses started up new tractor companies at the drop of a dime. Some of these manufacturers assembled decent equipment, while others tried to sell anything that vaguely resembled a tractor. The worst of the lot ran ads and hoped enough money would come in to build a tractor to sell.

Part of the frenzy was based on pure, undiluted bunkum. Manufacturers made what turned out to be outrageous claims for their products—that anybody could run one, that they were durable, inexpensive to operate, and so on. Sales were enough to fuel the fly-by-night manufacturer's dreams, but only a tiny fraction of American farmers actually bought a tractor. The early ones were delicate, balky, and often underpowered. And the farmers didn't know how to maintain them, either, so many were destroyed by poor operation and maintenance.

In fact, for some farmers, horses were a better solution. Some tractors went through oil almost as fast as the horses went through oats; one quart every 500 miles was considered extremely good, back around 1919. While you didn't have to stop every few minutes to let the horses recover from the work, you might have to stop because the machine was overheating. And you could yell *WHOA* as loud as you wanted, the thing would keep going (through fences, the barn wall, the pig wallow, the chicken coop, and maybe the side of the house) until you remembered how to work the clutch. It might have been love at first sight, but it took a while for the marriage between the tractor and the farmer to reach a workable accommodation.

And a horse might be a little headstrong sometimes, but you could usually catch him and get him harnessed and working. The tractor was easy enough to catch, but getting one started was often impossible for farmers with no experience with gasoline engines.

First—open the fuel shut-off; this is VERY important. Then, apply full choke, set the throttle to the one-third setting, the spark lever to the START position. Make sure the transmission is in NEUTRAL. Now, go up front and grasp the crank handle; keep your thumb under the crank, not in the natural position on top. Keep your head out of the arc of the crank. Push the crank in and rotate the engine by pulling up with a good, strong pull—if you can, because the resistance can be very strong. Repeat the cranking process as required until the engine starts or *you* run out of gas.

Some refused to start, even after hours of cranking…because the tank was dry or the shut-off valve was closed. Others started and promptly ran right over the farmer who neglected to take it out of gear. Many early farmers received broken thumbs, arms, and jaws from the crank. Many farmers were injured or killed when their tractors rolled over on them. But after a bit, improved machines came along, designs farmers grew to love as much as their favorite horses.

While the earliest tractors might have been as balky and stubborn as a green mule sometimes, it was obvious that the designers and manufacturers could be trained. And it is a little difficult to convey just why farmers were so excited about these new, rather small, quite noisy machines, but here is a summary:

Before the REA (Rural Electrification Administration) strung power lines to the farm, Mom did the wash by hand, then later with a modern gasoline-powered rig like this one. *J. C. Allen & Son*

Farmers began to use machines and engines long before World War I, starting about 1850. With the acceptance of steam engines and steam tractors, the American farmer became a mechanic and an advocate of power farming. You just couldn't work the big farms without a lot of horses and almost as many teamsters to care for them.

But the steam engines, while powerful, were physically too big, too slow, and too demanding for many farms and farmers. The little gas tractor wasn't as powerful but one man, woman, or child could often start and run it—alone! That was a tremendous advance. The tractor's light weight and small size allowed it to get into places much too small for a steam tractor, and across flimsy bridges that would stop a steamer cold. With an affordable little tractor, a farmer could start doing a lot of things previously contracted out—like the threshing. Then, about the

May Is the Time To

Plant corn.

Spray weeds.

Vaccinate pigs.

Keep eggs cool.

Side-dress cotton.

Read Proverbs 22.

Buy a new straw hat.

Watch the lamb market.

Buy new cultivator shovels.

Say good-bye to Shorty's teacher.

Help your sister deliver may baskets.

Ask Mom if she'd like to have an electric drier to go with the automatic washing machine.

Farm Journal, May 1940

same time, you could buy a combine, that amazing combination of mower and threshing machine, and harvest your grain crops in a couple of days—all by yourself if necessary. It was as if somebody had opened a window for the American farmer, revealing a new way of farming that was physically easier and financially far more profitable.

Farmers were impressed by demonstrations and reports of trials like the one at Purdue University on October 14, 1911, when three Rumely Oil-Pull tractors hitched to 50 plows set a world's record for plowing speed. This lash-up turned over an acre of grain stubble every 4 minutes, 15 seconds, and turned a strip of soil 60 feet wide, at a rate of seven acres to the mile. The implications for American farmers were dramatic and well-publicized. Many started thinking about replacing horses with tractors and it wasn't long before the

A Penny for a Pound

Going to town was a big deal on the farm, especially in earlier times when just getting to town was an ordeal. William Vavak remembers exchanging eggs for supplies when his family loaded up and went to town:

"My grandparents homesteaded near Weston, Nebraska, and the place is still in the family—four generations we've had it. They came from Czechoslovakia, and we only spoke Czech at home when I was little. It was a different life back then; few people had cars, roads were bad, and we didn't travel far from home. Visiting Wahoo, the county seat, only happened once or twice a year and was a big deal! We did all our trading in the little village store there in Weston, exchanging eggs or chickens for tokens you could use like money at that country store. They paid us one cent over market, but you had to spend all the money in their store! But it worked out okay; a penny would buy a pound of sugar in those days—and then some!" 🍇

Going to town on Saturday, an event that combined shopping with socializing. The stores that formed a ring around the town square could be found in nearly every town: the drug store, the hardware store, a shoe shop and the office of the local newspaper. How many of these wonderful little downtowns are still in business today? *J. C. Allen & Son*

farm magazines were full of ads for tractors of all shapes and sizes.

By the early 1920s, really dependable, powerful machines became available, including the first models from the John Deere & Company. Deere, of course, had been a major force in the implement market for almost 100 years by that time. It was, and is, a pretty careful, conservative company—just like the market it serves. Deere stayed out of the tractor business until the company was pretty sure they had something to offer.

John Deere's president at the time, Leon Clausen, said to the board of directors in 1923,

"There is a national demand for tractors. We do not have to create it. And when a suitable tractor is built, at a reasonable price to the consumer, it can be sold." He was right, and from modestly successful beginnings, the John Deere company slowly but steadily increased its standing as a tractor manufacturer. When they finally abandoned the much-loved two-cylinder engine in 1960, John Deere was on top.

Despite a crash in farm commodity prices in the early 1920s, farmers started converting to tractors in large numbers. Magazines such as *The Country Gentleman* and *Capper's Farmer* published

Spring plowing today is done on a grand scale, at a fast pace. This big John Deere is preparing a corn field near La Fox, Illinois, in air-conditioned comfort. Such machines allow a family to farm 10 or more times the acreage that would have been manageable in the old horse-powered days. *Howard Ande*

Early June finds corn farmers busy cultivating crops, just as they've always done. But powerful tractors like this John Deere allow the job to be done quite rapidly and effectively, as this farmer is doing near Sycamore, Illinois. *Howard Ande*

reports and testimonials on the machines from time to time. This letter from Ralph Hanson of Iowa is just one of many that appeared in a report in *Capper's*—all highly favorable.

"We purchased a tractor in 1926. It is in good condition today. We use it for plowing, disking, hauling, grinding feed, for cutting oats, and other farm work. We always were the last ones in the neighborhood with our field work in the spring until we got our tractor. Now we keep up with the best of them. I can plow from thir-

teen to fifteen acres in a ten-hour day with fifteen gallons of kerosene at a cost of $1.50 a day. I sure like a tractor and would never be without one." ❦

The 1920s were a sorting-out time for the tractor industry. Small companies with good products were sucked up by the big boys, one after another. Big companies with poor products evaporated, one after another.

By the 1930s, the remaining manufacturers were building high-quality, useful machines,

and the farmer was turning to the tractor in unprecedented numbers. William Vavak recalls his family's first tractor:

"My dad was a horse farmer until 1932 when he bought his first tractor. It was a used Fordson, a 1925 model, and cost $325; new ones were going for about $575 to $625 at the time. It had been only used for running a corn sheller and belt work and was still like new. Dad used that Fordson only for plowing, and it was really nice because you could just keep going all day. When you plow with horses you've got to stop and let them rest pretty often, especially on a hot day." 🐞

John Deere's major competition at the time was the International Harvester Company, another old-time giant in the farm machinery business. With the financial muscle to develop new products and the dealer network to get them sold, IHC was a dominant force in the market. Their tractor was the Farmall, the first successful general purpose tractor. The Farmall could cultivate row crops, turn a belt, and pull a plow, and it left the rest of the market scrambling to catch up. International Harvester sold over 25,000 a year in the late 1920s, and built over 130,000 of them over its life span. Deere's response was the GP, a tractor designed to plow, cultivate, and do belt work…and take some of the market away from the Farmall.

Over the years, tractors evolved into one of America's most interesting forms of industrial design, a part of the American farm landscape that is cherished by many. You can see that affection in the long rows of restored tractors at every farm show in the country, glittering in fresh paint and running better than new. These machines turned out to be so durable that most farmers know that almost any ancient derelict machine, even the ones sitting in the open for years, may very well start if you slosh a little fresh gas in the tank and crank the engine over. Those tractors are tough!

In the end, a handful of manufacturers provided tractor power to the American farmer:

Deere, International Harvester, Case, Allis-Chalmers, Oliver, Minneapolis-Moline, and a few others. And while horse-power enthusiasts will argue, tractor builders delivered on their basic promise. The inexpensive little tractor—with all its attachments for plowing, planting, cultivating, mowing, and spraying—really did improve the life and lot of the American farmer and farm family. The tractor is one reason food and fiber are more affordable than ever before.

The Modern Tractor

Tractors today have generally become much larger and more powerful than in the past, although some smaller machines are still sold. The size of the tractor, its power, and the many power-drive attachments offered as accessories, are all a result of the larger size of the American farm today. It is also a reflection of the smaller work force available for labor. Engines are 10 or more times as powerful as earlier models, up to about 300 horsepower. Diesel engines are standard, in all classes. So is roll-over protection, after many deaths from tractor accidents. It is easy to spend well over $100,000 for the larger models, and close to $200,000 for a big machine with all the bells and whistles.

But the power available today is tremendous. Tomato grower Augie Scoto uses a big Case four-wheel tractor to chisel-plow to a 24-inch depth every season—and he does it at 4.5 miles per hour! Deep plowing to that depth wasn't an option for many farmers of the past—they used dynamite instead. It is part of a soil improvement program that the Scoto brothers have followed since they started farming about 15 years ago, on their dad's 300 acres. Their tractors all get a workout in spring, plowing and pulling the planting machines.

Crawlers often have the power for deep cultivation like that, but you can't drive one on the county road, from one field to the next, as you can with a rubber-tired tractor. The Scotos lease their big tractors, rather than buy them out-

Irrigation has changed farming, and farmers, too. Once a family would only grow a few rows of lettuce, selling the crop door-to-door in nearby towns or villages, and only for a few months of the year. Today's lettuce likely comes from a family farm, but it is grown and harvested in huge quantities, chilled and shipped by the truckload to buyers around the country. This field was raw, useless desert until just a few years ago when a canal brought water from mountains a hundred miles away.

right, and turn them back in every year—but they own and lease 2,000 acres of diversified farm land. Lots of other farmers do the same thing.

Augie Scoto's hired hands each get a safety briefing before using the big tractors and are required to follow the same procedures expected of aircraft pilots: a walk-around inspection of the tractor and the tillage tool before getting in the cab, including a look at the oil and coolant levels, tire pressures, and mechanical condition of the tool and the tractor.

Children's Farm Life in Spring

Despite the incredible changes brought to the farm by the tractor, many things remain the same. As the tempo of farm life accelerates in April and May, as the mud dries and the work of the year goes into high gear, the children of the family have plenty of work to do before and after school. In the

past, that often included feeding the stock before school, normally around 5:00 A.M., and milking the family cow. After school, the boys would be expected to muck out the stalls and the barn's cleaning alley. Both boys and girls learn to operate a tractor at an early age; with a team or tractor, a kid's responsibilities often include spreading the manure on the fields periodically.

Nearly every farm had a flock of chickens, and many still do; kids learn how to sneak the eggs away from broody hens, and find the eggs around the yard and barn where mischievous hens sometimes stash them. The kids help out in the garden, although that has traditionally been Mom's territory; the kids can weed, and when they're big enough, run the roto-tiller. They can help pick the strawberries that bring delight in springtime, one of the first rewards of the new season.

The Farm Mechanic

It may be that there are successful farmers and ranchers around who aren't skilled mechanics, but I haven't met one yet. Even in the most basic and simple operation, even among the Amish with their horse-powered equipment, you will find all kinds of machines that need regular adjustment, sharpening, and repair and farmers with the skills to maintain them. In fact, a conventional dairy operation like Milton Good's, with 60 or so milking cows, will have about as much money invested in machinery as in land. That typically means a tractor, mower, gang plow, disk harrow, corn planter, mower, wagons for hay and grain, manure spreader, milking parlor systems, and more—each costing thousands or tens of thousands of dollars. Even the Amish own and maintain sicklebar mowers (the John Deere No. 4 from the 1940s is a favorite), sulky plows, grain binders, corn binders, and threshers. Some, like Jacob Yoder, even own tractors, although for use as stationary power sources rather than as a replacement for the horses. Each of these machines are tools; without at least some of them it is virtually impossible to farm at any more than the most basic subsistence level. The farm literature of America, going back to the Revolution, is full of reports on such tools. In large measure, they've built the nation.

Spring ends in June, all across America. The plowing and planting for spring crops is complete, most years, and by June the family farm is a place of hectic growth—calves, colts, and corn all filling out and up so fast you can almost watch it happen. Weeds are up, and bugs, too. The snow is long gone on most places, most years. The first tomatoes are ready to pick and ship to market, the first hay has been cut, and the strawberry harvest is over. Soon the kids will be out of school, available to help, just as they always have—and play in the creek and the hay mow, just as they always have, too. Mom tends the garden, picks the early string beans and lettuce and squash. The new colts frolic and the mares are back in condition. It is a season for picking cherries, and putting the surplus in the freezer or in jars for winter. But winter is six months away. It's time for summer to begin.

Summer

Summer on the farm begins officially in the third week of June. Out in Nebraska, the sun will rise at about five-thirty in the morning, most likely in a transparent sky, and up in the northeastern quadrant of the compass. The sun will pump heat and light into the land for over 15 long, hot hours on the twenty-first day of June, the longest day of the year.

Summer in the heartland is a time of hope, heat, and waiting. Across Kansas, out in Oregon, or back in New Hampshire, July and August can be scorching. The cattle will stand in the creek to escape it, the hens stop laying, and Mother does all the cooking outside in the summer kitchen. But the corn grows so fast you can almost hear it; you certainly see its progress day by day. The farmers who are serious about their yields get out and cultivate the row crops before it is too late—they know weeds steal nutrients and moisture, that stirred soil catches the rain. The farm boys and girls are sent to the fields to pick off the potato bugs and the tomato worms. The early vegetables get picked,

June Is the Time To:

Plant limas.

Cultivate corn.

Vaccinate pigs.

Make an egg cooler.

Worm the early pigs.

Sell turkey breeders.

Obsquashgulate flies.

Fumigate the granary.

Set out some late cabbages.

Go to your nephew's wedding,
and kiss the bride.

Build a shade for the cows—
and watch the milk check rise.

Farm Journal, June 1950

and some get canned and preserved. The grain bins get cleaned and disinfected before the harvest. Hay gets its second cutting. Summer is the time that Mother culls her chickens, selecting the weak and worn out, sending them to market. The extra cockerels will soon be broilers. The good layers get extra attention, plus plenty of fresh water served by the youngest children. Summer is picnic time on the farm, and that's when the men of the family are supposed to do all the serving and the women are waited upon in style. Summer is the time to harvest the small grains—oats, wheat, barley—and the traditional time for threshing. Threshing is still a center-stage event at all the farm shows in the American heartland during summer today, and some farmers still thresh with stationary machines, just as in the past.

Summer is a time to cut oats and small grain, to cultivate the growing corn, to go fishing, pick cotton in the South, have a picnic. But for most American family farmers, it is and always has been a time to make hay.

Making Hay

Farming is a business that encourages its practitioners in two directions, one conservative, the other radical. Farmers like to stick with what they know, what tends to work on an average year. Farmers

Near Waitsford, Vermont. The roof is new but the barn is old, and typical of Vermont stock barns of the Civil War era. The cupola has an important function, helping ventilate the structure—a real problem when you've got a small herd of dairy cows cooped up on the lower level all winter. *Howard Ande*

hedge their bets. But when an opportunity for profit appears, they'll try it on a few acres and watch what happens.

That's what happened with alfalfa back in the 1850s. Farmers have always made hay for fodder. Hay, by definition, is dried plant material. It can be one or more varieties of grasses or legumes. Clover was, and is, one variety. But the introduction of alfalfa in 1853 really got the attention of farmers across the country, from New England to California and the Oregon Territory. The great farm paper of the time, Ambrose Wright's *Prairie Farmer*, reported the characteristics of the plant soon after seed was introduced, from California by way of Chile, in the August 1853 issue:

"The alfalfa is a species of lucerne, greatly in use as forage for animals in the mining district of Chile. It is a vigorous grower, requires little labor, and furnishes two crops a year of most nutritious food for stock of all kinds…The plant is remarkably prolific and possessed of…extraordinary nutritious properties. With the addition of a little barley, it is found to keep mules in the best working condition. In its green state, cattle feed upon it with the utmost avidity and gain flesh so rapidly that it is the practice in Chile to drive cattle hundreds of miles to obtain the benefits of its use. The land is prepared for the seed of this plant in the same manner as for clover, it being in truth of the same family as the latter." ❧

The U. S. Patent Office distributed sample seeds to every state and within a fairly short time alfalfa became an important forage crop. It still is.

Corn

You can talk about your wheat fields—
you can call 'em golden seas,
And your cotton and your taters
and your berries and your trees;
But a hundred tasseled acres in the
summer or the fall,
When the ears is standin' on 'em—
oh, well, anytime at all!
If you got no soul you get one,
when you walk between the rows,
And you want to reach and fondle
every big stalk that grows;
And when all them leaves is rustlin'
in the breeze of dewy morn—
Say—there's jist one thing that's farmin'—
that's real farmin'—and it's corn!

J. W. Foley, *The Country Gentleman*, July 27, 1918.

Farmers around the country rely on it, alone or in combination with other crops, to provide pasture and silage. You'll find it on the Yoder's place, where they cut it with an old John Deere Number Four mower, then bale it with a fairly modern New Holland machine drawn by horses. The Goods and the Boyd family use somewhat newer machines and put the material into the silo, where it keeps a bit more of its substantial protein and other nutrients.

Alfalfa is a particularly important crop for several reasons: it is hardy, produces a crop about every 40 days, and that crop is typically abundant and nutritious. It produces about twice as much hay tonnage per acre as timothy and clover. The rich protein content, farmers discovered, could produce excellent weight gain on hogs pastured on alfalfa, as much as 776 pounds per acre over 180 days. And alfalfa's deep roots help the plant survive when other plants dry up and blow away. But alfalfa has been particularly important on the family farm for use in hay.

Hay is a much more important crop than you'd think when somebody uses the cliché expression, *that ain't hay*. There is nothing trivial about it. It is one of the top three or four American field crops in dollar value, year after year, traditionally the feed that sustains animals for six or more months of the year in our northern latitudes. It is a crop that has even had a large influence on American architecture; the standard American stock barn is designed and built around the crop. The tall form of the classic barn is simply a place to store large volumes of loose hay, normally above the stalls where it was fed to cows and horses. And when the

and horses. And when the silo, with its ability to preserve hay as silage, became popular around 1900, the shape of barns changed to reflect a new way of storing the hay crop.

Cultivating

Wayne Vinson grew up on a farm in central Illinois, on a little 48-acre place with the usual combination of corn, soybeans, alfalfa, a few pigs, and a huge kitchen garden. The house had no running water, indoor plumbing, or electric lights—and didn't until after Wayne left home in 1959.

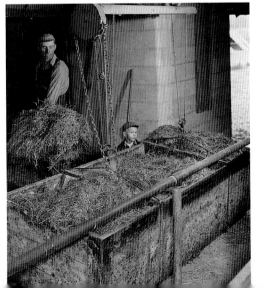

Horses are a part of farming that old farmers have mixed feelings about. Some truly miss the rapport that was established between horse and man, while others are more content working the fields to the smell of diesel fuel and hydraulic fluid.

There's more than one way to clean a barn and this system, with a litter box on the overhead track, made this chore a lot easier. Dirty straw, full of manure would be transferred from the litter carrier to a waiting manure spreader parked just outside. Then it would be deposited on the fields, an important soil amendment. *J. C. Allen & Son*

Summer haying, 1930. This John Deere hay loader is modern technology to these two guys. They probably have loaded hay by hand, pitching it with a hay fork from the ground to the wagon and appreciate this labor-saving device. *John Deere*

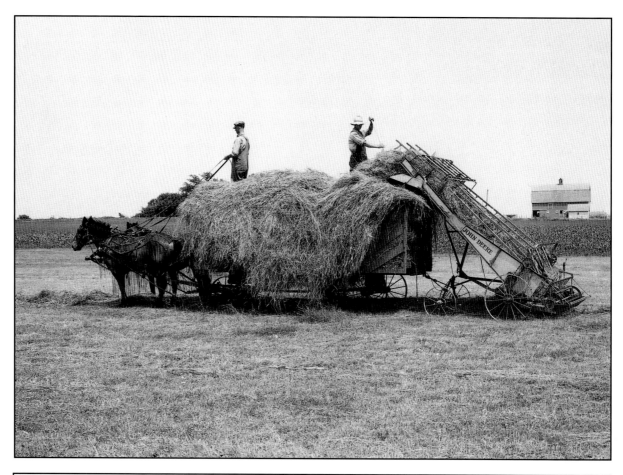

Bringing in the hay, the old way, in spring.

Wayne's dad had a job in town that took most of the daylight hours, so from the tender age of 11 he did all the plowing, planting, and cultivating. The senior Vinson had farmed with horses pretty much all his life, by choice, but surrendered to the tractor in the middle 1950s along with everybody else, when horse gear became hard to buy. The tractor was a Farmall F-20, hand cranked, and cost him $600 with a Model 214 plow and a cultivator.

"My dad told me what I was supposed to plow or plant, then I did all the work while he was at his job. Actually, I loved it! When you're eleven and you get to drive the tractor—that's a lot of responsibility, and it never lost its appeal for me! I learned to drive by watching my friends' fathers, and by running around the yard a bit." 🐦

Corn farming has changed a lot over the years. The rows are closer together today, hybrid seed makes for bigger, more bug- and drought-resistant ears, and herbicides and no-till planting have made life easier for the farmer. But in Wayne Vinson's young days in the 1950s, everybody cultivated the corn two or three times to keep the weeds down and to help rainfall soak into the ground. You could cultivate one row at a time, with a simple horse-drawn cultivator as Wayne's dad had always done, or you could do it with a tractor-mounted contraption that could do two rows at a time.

The cultivator is a complicated implement, with lots of little shovels that scrape just below the surface, cutting the weeds like a hoe without hurting the roots of the corn plant. The cultivator can't

That's Colonel Brown and his pride and joy, a flock of purebred chickens. They are just outside Kearny, Nebraska, on a sunny summer day in 1907. The chicken flock was a major part of almost every family farm before World War II when eggs and fryers could pay the mortgage. *Solomon D. Butcher Collection—Nebraska State Historical Society*

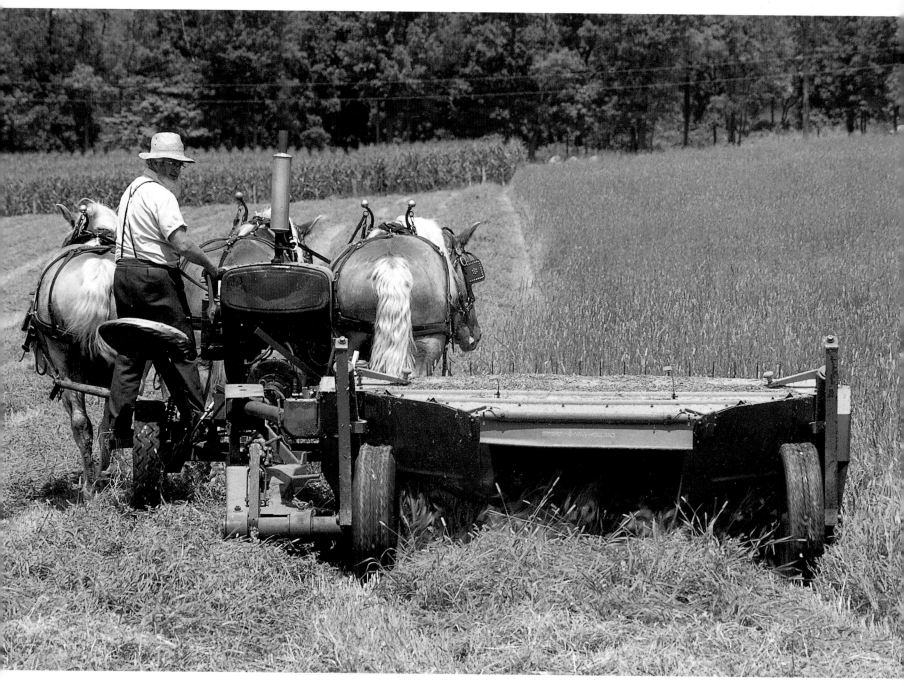

While some Amish insist on ground-powered mowers like the old John Deere model 1 or 4 (both very popular 50 years after they went out of production), the Yoders use powered mowers like this modern New Holland because it is easier on the horses.

between the plants in the row so it is adjusted to toss some dirt over on the row, smothering new weeds while they're still small. It is a complicated business, done with a complicated machine. It was a major project to just get the cultivator's components bolted to the tractor, and it took Superman to adjust the mechanical lifts at the end of each pass down the row. But even a scrawny 11-year-old can do it if he wants to:

"The first thing you had to do was to get the cultivators on the F-20, and that wasn't easy because those things were heavy! We cultivated both the corn and beans—nobody sprayed back then. At the beginning of the growing season, in late May when the plants are just a couple of inches high, you had to set the 'fenders' that shield the plant very low to the ground and drive very slowly, in first gear. You'd just creep up and down the rows as slow

It's been quite a while since these lads from the Nebraska State Industrial School For Boys weeded that beet field in 1914, and a lot has changed. For one thing, you don't see many boys wearing ties while working in the field. There aren't as many orphans, either, a pretty common condition for a farm boy or girl in the days before medical attention was available in an emergency. *Solomon D. Butcher Collection—Nebraska State Historical Society*

Cutting grain with a scythe or cradle (shown here) was hot, slow, hard work. Although the grain binder, the threshing machine, and then the combine have replaced the cradle now, many farmers still remember harvesting this way during the 1930s and even later. *J. C. Allen & Son*

Down at the Swimmin' Hole

The swimming hole was a favorite place for kids in the summer, and most rural children have fond memories of hot afternoons splashing around a wide spot in the creek or at a local lake or pond. Charles Irwin tells this story of mischief in Hunter Creek:

"I was a freshman in high school, in the spring of 1954, in the little rural town of Ava, Missouri. A group of us, boys and girls, cut school to go swimming in Hunter Creek. This creek had nice clear water and a nice pool that we all used to cool off. Well, the boys were over on one side of the swimming hole, and the girls on the other, giggling and playing.

"One girl in particular filled out her swim suit in a way that really got our attention. Well, I noticed a nice big crawdad in the water and swam down and caught it. I tossed it at the girls—and it went right down the front of her suit!

"The water started frothing. There was squealing and yelling and pandemonium. The girl just about (but not quite) came out of that suit! The other girls went in after the crawdad. We gawked in amazement, until they ordered us to turn around. The poor girl was screaming bloody murder!

"We had been friends up until that day—but she hasn't spoken to me since!" ❦

Second Creek Memories

David Holcombe hails from the northwest corner of Alabama, where his family has lived in the same small valley (known as a "holler") for three generations. The farms there are small, with few if any large plots of workable ground. The area was peppered with David's family, and he spent much of his time with his cousins. In summer, the swimming hole in Second Creek, a mile from David's home, was a favored destination.

"Every day in summer I'd do my chores in the morning, then ride my bike over to my cousins, Terry and Dwayne's place. We'd ride down the lane, then across the pastures to the creek. We'd be sweating from a combination of Alabama summer heat and humidity, from mowing the yard and our other chores, and from the bike ride. About three-quarters of the way to the Big Rock (the name of the swimming hole) there was a dense pine thicket that was always about five to ten degrees cooler than the field where there were no trees. You could almost

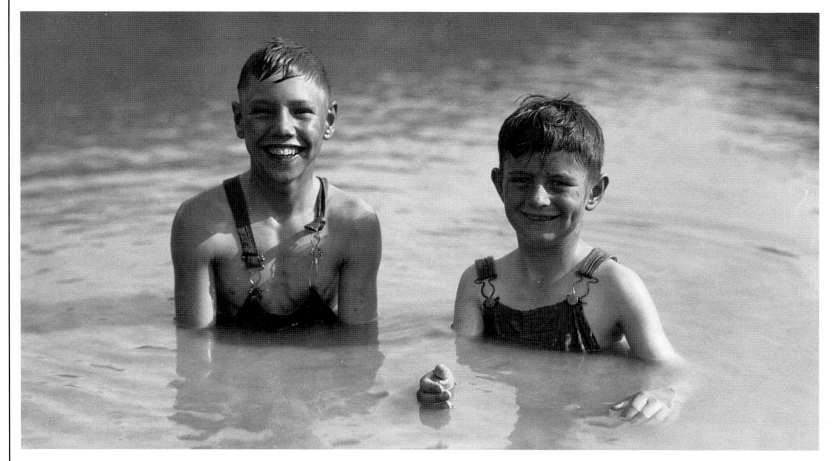

Many farm kids, then and now, delight in a jump into the creek at the bottom of the "lower 40." *J. C. Allen & Son*

smell the creek when you reached the pine thicket. The creek runs due west and makes a sharp left hand turn when it runs into the hill—this is where the water gets deep and where three big rocks in the edge of the water make a perfect place for diving. It is in the shade of the hill, and deep in the woods, so it was always much cooler there. All my relatives would come down there—seven or eight of us—to cool off and swim.

"We'd dive off the biggest rock, which was about twenty-five by twenty-five feet in diameter, and stuck about eight feet out of the water. The middle rock was about fifteen by fifteen feet, and stuck about four feet out of the water, the smallest rock was about ten by ten feet actually at water level. The biggest rock had a large oak about 10 feet long that we used to dive from or do cannon balls or sometimes accidental belly busters. Even on the hottest day the fast moving water was cold! It came from springs somewhere on the hill. Sometimes the spring rains would wash the banks away from the trees and cause one to lean out over the creek, making a perfect place to jump into the creek.

"The bottom of the creek is gravel, and every now and then someone would get a handful of gravel, throw it up in the air, and yell, 'All heads under water!' If you didn't make it in, your back and head would be pelted pretty hard. I have one cousin that still has a chipped tooth from the rocks. We'd race home on our bikes, across the pastures, and come back just as hot and sweaty as when we left!

"We usually had a certain time we were to be home, some days we let the time get away. If we heard a tractor coming down the lane we knew we had stayed too long. It would be my mother or Terry's mother driving the tractor coming to check on us. They would usually act like we were in real trouble, but looking back I can see how much they really enjoyed taking a break from their canning and gardening chores. My mother is gone now but the guidance and good things she taught will never go away. That swimming hole is still there, and I still take my two boys across the pasture to swim in that cold, cold water!" 🍎

as possible, maybe one-and-a-half miles per hour on that first time over the ground. The next cultivation, though, you could pull the fenders up and go in fourth gear sometimes, four or five miles per hour. I became really strong as a kid, partly because these cultivators were very heavy. There were no power lifts then—it took sheer muscle power to get these things up and down at the end of every row. A strong man could do it from the seat, but as an eleven-year-old kid I had to stop the tractor, brace my feet against the seat, and push down forward with all my strength to get them up or down. " 🍎

Plowing

Wayne Vinson also recalls plowing with the Farmall:

"The first thing I ever did on the tractor was plow. Well, a tractor's steering is very responsive and it took me a while to get the hang of it. I went zigging and zagging down the field. But you pick it up pretty quick, and then I did all the plowing. Those were the longest days I spent on a tractor. I'd get up at first light on a summer day, and be plowing soon after—from six in the morning till seven at night. I might get ten acres done in the whole day. That Farmall F-20 would pull two plows in our ground only in second gear, about two miles per hour; there were a few spots where you could get up to third, and a few others where you'd have to go down to first gear and just hammer it!" 🍎

Summer at the Boyd Farm

Summer at the Boyd family farm in central Iowa keeps everybody pretty busy. The first cutting of the hay will be needed in late May or early June, repeated three more times about once a month. The corn will get one pass with the cultivator, cleaning up some of the weeds. It will get another band-spraying of herbicide to get any weeds missed on the first pass or by the cultivator…a crop duster might make one application of insecticide to control corn borer…and that's all the field work the corn will need until harvest.

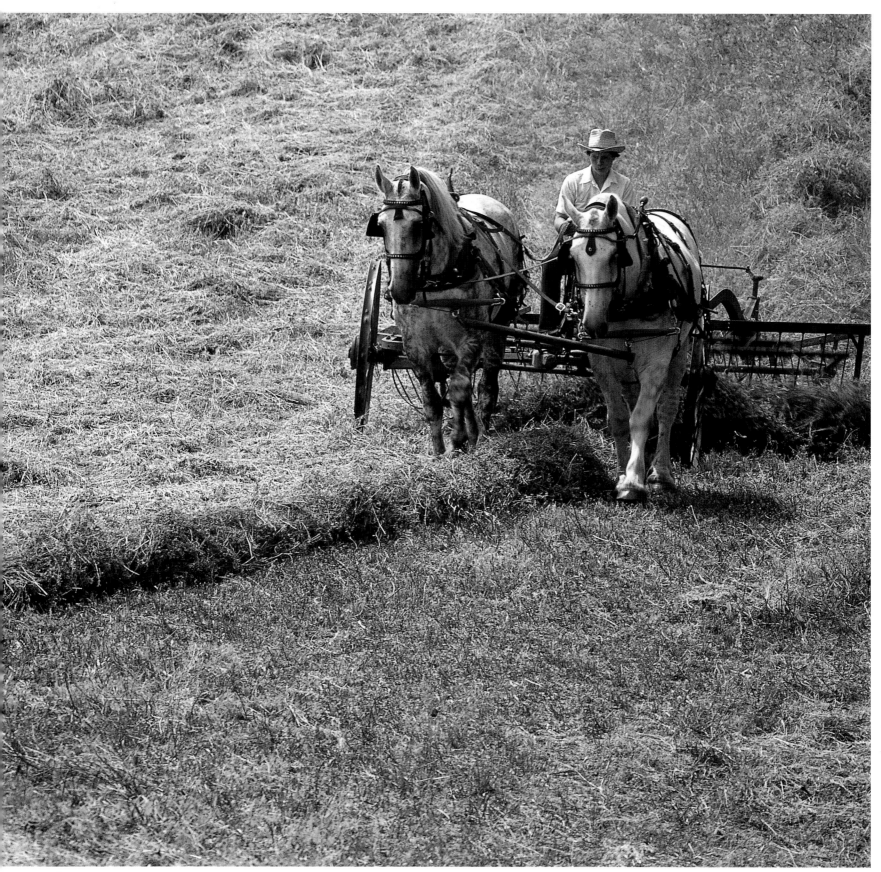

The oats will come off in late June, exposing the alfalfa coming up through the stubble. It will be ready for the first cutting in early fall. "Summer around here starts with cutting the oats," says Leland," then we cut hay, thresh the oats, bale the oat straw, take care of the livestock, maintain the equipment and buildings—with our older buildings, there is ALWAYS something that needs attention—and we start getting ready for fall harvest. But I try to get a week off to go fishing, too!"

Threshing

Wheat, oats, and barley are the big traditional grain crops; harvesting them has long been a part of our collective legend and lore. For about 3,000 years the harvest was brought in with the same simple, laborious process. Ideally, just before the grain reached perfect ripeness, an army of harvesters moved out into the fields armed only with small, curved knives, cutting the standing grain in small clusters. These stalks were gathered into sheaves, tied together with an improvised rope constructed on the spot with a few handfuls of straw. The sheaves were then left standing upright in the field in tidy piles, with one of the sheaves spread as a cap to deflect rain. After a week or so of curing the harvesters, men and women both returned to the field to collect the sheaves for threshing.

The threshing ("thrashing," in the old vernacular, and as still pronounced by our living elders of German, Swedish, Norwegian, and central European descent who've done it), was typically done by spreading the stalks of grain out on the farm's granary floor and flailing the straw with clubs. An alternative method involved using oxen or cattle to tread upon the straw. Both worked, to a degree, but the former method was notoriously tiring and the latter inevitably resulted in grain contaminated with ox or cow "exhaust."

The first improvement in the process was the two-handed scythe, with or without a cradle. There are many farmers alive today who've harvested grain with a cradle, perhaps an acre in a long, hard day. Timing and handling are just as critical today as when all this was done by hand.

Threshing Time in the Old Days

Harvest time has always been a time of celebration and delight on the family farm, back to Biblical times and before. Out on the Great Plains and the big wheat acreages in particular, the summer

When farmers discovered the virtues of alfalfa in the early 1850s, it quickly became the favorite hay crop in most of the country. You can get four or five cuttings from the plant, starting in early spring. Each will put the meat on your stock and money in your pocket. This big crew is making hay on the Watson ranch near Kearny, Nebraska, in 1905. *Solomon D. Butcher Collection—Nebraska State Historical Society*

Milking time is over and the cows are put out to pasture—but they will be back soon enough. Every dairy farmer can predict the future with stunning accuracy, years into the future: morning milking at six in the morning, evening milking at six at night. It will be the same routine, seven days a week, 365 days a year. *Dave Rogers*

grain harvest was—and still is—anticipated with excitement and joyous anticipation. Bascomb Clarke was a *very* old time thresherman, starting down in Arkansas in 1863. That was when the flail and sickle, both technologies as old as the Bible, were still in common use. He described the experience in 1925:

"I can almost feel the bumps on my head now, before I learned the simple twist of the wrist that brought down the flail in such a

manner that it fell flat on the grain and did all the separating. Oh, you Old Terriers with your thirty-six-inch cylinders, self-feeders, automatic weighers and windstackers of today [1925], who back up to a five thousand-bushel job and clean it up in a few hours, what do you know about real threshing machinery—the flail? Do you think we performed this arduous labor for our health? Not so you could notice it." 🍂

A mixed team of mules with a couple of horses provide motive power for this Harris Harvester around 1930. The mule skinner controls the team with a single set of lines attached to the lead mule, normally on the "off" or right side of the front rank.

Out around Hays, Kansas (the "Golden Buckle On The Wheat Belt," the folks in Hays say) the winter wheat forms its heads in late May or early June. If the weather holds, the heads of grain swell and mature. By late June they've entered what grain farmers call the "milk" stage. If you open up one of the little kernels now, it is full of a whitish milky fluid. Full ripeness is only about a week away and the farmer needs to have the harvest fully planned and organized.

That's because grain standing in the field is fragile stuff. If allowed to stand in the field after ripening, the plant will do what comes naturally—scatter the kernels, which are only seeds after all. So wheat farmers try to be ready to cut the grain when the heads are plump and full of protein but just before the heads are ready to shatter, spilling the grain on the ground.

In the distant past that meant long hours in the field with a one-handed sickle, the men of the family cutting, the women and children gathering up the gavels (the loose cut grain) and tying them with bands of straw. So much grain was lost this way that people could come along after the harvest and collect enough wasted grain from the ground to feed themselves—the *gleaners* of legend and lore.

By about 1870 mechanized methods of grain harvest left very little for the gleaners. But there was plenty of well-paying work for any man available then, and farmers scoured the towns for vagrants, bums, hobos, and anybody else who could drive a team, pitch a bundle, or do any kind of labor. It was a kind of dependable annual bonanza for the disreputable element back before World War II, many of whom followed the harvest for a few months.

Shocking wheat and it's 110 degrees in the shade. Hauling a water jug to the field for farmers or threshing crews was one of the first chores for farm children. Threshing crews often hired a small boy just to haul water, but he had to supply his own pony. *J. C. Allen & Son*

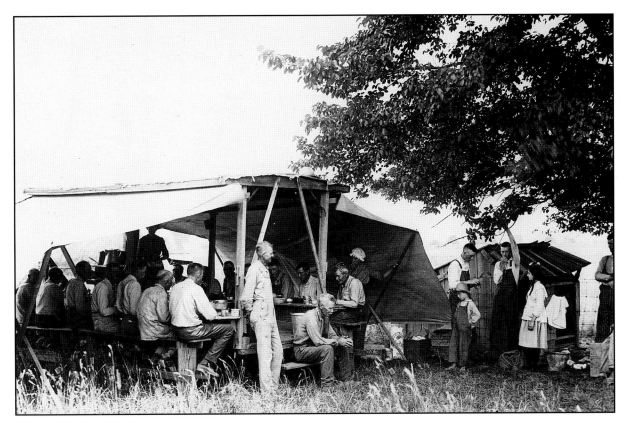

OPPOSITE
Cutting oats with a tiny six-foot binder, near Dundee, Ohio.

Feeding a threshing crew was a huge production and a major event of the year for all concerned. With a dozen or more dirty men to feed, the best place was always outside. *J. C. Allen & Son*

The Threshing Crew

Out on the great plains the arrival of the threshing crew—a ring of neighbors or a contract outfit—was anticipated by children with all the breathless excitement normally reserved for Christmas or the circus. And it was a kind of circus, too, with three rings and a whole platoon of exotic performers.

Early in this century the annual visit of the threshing crew often came after dark, and you could hear them coming long before they arrived. A large steam tractor, with the thresher in tow, would make the exodus from the previous farm just as soon as the neighbor's grain was finished. Speed was and still is important when the grain is ripe, and the rig and its crew wouldn't wait for valuable daylight to move from one farm to the next. At a blazing top speed of about 2.5 miles per hour, that usually took a while.

But once the steam engine turned off the road onto your farm, the engineer sent a greeting to the farm family on his whistle—a long, melodic series of notes rolling across the prairie. Sometime within an hour (depending on the distance of your drive), the thresher rumbled into the yard, and then, by lantern light, to the spot where the work was to be done. Sometime around midnight the engine would at last be shut down and the three men on the crew could go to bed.

The three men who provided the steam engine and the thresher included the engineer,

Guess who's coming to dinner? All 13 of these fellers, and a few others who aren't goofing off. This summer grain harvest scene shows threshing time near Gothenburg, Nebraska, in 1908. That's the straw pile on the left, complete with a couple of kids, and the wooden "separator" down below...but where's the steam tractor for power? There isn't one—the horsepower comes direct from horses. There are 12 of them, turning a gear and shaft system called a "horsepower." *Solomon D. Butcher Collection—Nebraska State Historical Society*

Pink-Eye Purple-Hull Peas

Fresh garden vegetables were a delicious part of summer on the farm. One of David Holcombe's favorite garden memories is of hulling fresh-picked peas under a big walnut tree in his yard:

"My mother got up much earlier than I did. She had breakfast all ready before I even woke up, and in the summer she'd have gone out to the garden and picked a couple of bushels of peas while it was still cool, before the heat of the day. My summer mornings always included helping with jobs around the house—mowing the yard, taking the peelings off tomatoes that had been steamed for canning, or shelling peas.

"Ask anybody in the south and they'll know about pink eye, purple-hull peas. Well, she and I and my little sister would sit in lawn chairs, under the big walnut tree in the yard, and shell these peas— that was one of my jobs. I couldn't go play until we did those peas. Now, the more of these peas you shell, the more of the purple rubs off on your fingers. I always tried to get my hands as purple as my mothers, but she was three times faster than I was. She thought that was really funny! She'd cook those peas up with some chopped onion and we'd have them and corn bread at just about every noon meal during summer vacation and I still shell them and like them today.

"When we finished shelling the peas, I would take the pea hulls and throw them over the pasture fence for the cows. This was a delicacy for them, or so we thought, by the way they would eat them.

"My mother would take the peas and put them in a pan of water to 'look' them; she would take a handful and look for any peas that had bad spots, such as insect stings or bug bites or worm holes. The bad ones were always thrown away. She would 'look' all the peas one handful at a time. Then she would cook the peas on the stove. She'd wash quart jars in hot water, put the peas in the jars, and put can lids and rings on the jars. Next, she'd put the jars in a large pressure cooker than would hold seven quarts and pressure cook them on the stove. The finished product would taste garden fresh in the middle of winter." 🐛

Food preservation took up a major part of the housewife's time in the days before electric refrigerators. Here, prepared green beans already "sorted, snipped and stringed" are being packed into canning jars. The full jars will be tightly sealed and carefully loaded into the oversize pressure cooker on the stove. *J. C. Allen & Son*

who often owned the rig, the separator man, who was in charge of the threshing machine, and a water boy who kept the engine supplied with fuel and water.

These 3 demanded a supporting cast of about 22 additional men and boys, all of whom the farmer was normally expected to furnish. Some would be cooperative neighbors, but others might have to be hired men. All these men expected to be

fed—a snack at midmorning, sometimes, plus a huge midday dinner, another snack in mid-afternoon, plus a supper at the end of the day. The children of the household carried water, sweet tea, and lemonade to the men while they worked.

The army of threshermen each had their duty to perform. Four men or big boys worked as *field pitchers*, loading the bundles of bound grain out in the field, lifting each with a

Merlin Yoder tosses the bundled oats up on the wagon, heads in, butts out. Jacob places each bundle neatly while Young Lewis minds the team.

pitchfork, tossing them up with the heads toward the center of the wagon. Up on top of the wagon, one of the 12 *bundle-haulers* adjusted each bundle to make a tidy, compact load, then drove the wagon from the field to the threshing rig near the barn. It took 12 wagons, with a driver and at least two horses, to keep the thresher fed and working all the time.

The wagons came in from the field with the bundles and were placed in position, one on each side of the feeder. This could be a problem for some horses since the chugging engine and whirring separator were both quite novel objects—and horses don't like much novelty in their simple lives! With the wagons within range of the feeder, the *bundle-haulers* started pitching the bundles into the feeder. There is a bit of skill in this chore. Ideally, the bundles line up on the feeder, head to tail, with the heads going in first. It is important to not pile the bundles into the

July 1907 near Miller, Nebraska. Here's another old summer farm tradition—the steam tractor busting through the bridge. It seemed that every time it happened, some fool photographer (Solomon Butcher in this case) showed up to document the scene. Nobody's smiling, not even the dog, but they'll lever this thing up and have it working again in a few hours. They'd better because thousands of bushels of wheat are waiting for that thresher and a dozen or so farm families are counting on this rig for their harvest. *Solomon D. Butcher Collection—Nebraska State Historical Society*

Pitching bundles is hot, hard work in Kansas during July. These three young men pause for a break in the welcome shade of a header wagon, but they will be back at it in a moment. Although the work is difficult and dirty, a feast awaits them at noontime up at the house. *Halbe Collection, Kansas State Historical Society*

After the binder cuts the grain and ejects each bundle on the field, a crew follows along, gathering the bundles into shocks. A typical shock will have about 10 bundles, with one or two more formed into a cap on top. The cap will shed most rain and protect against some hail. After a week or two (or more), the grain will be thoroughly dry and ready to thresh. Then the bundles are gathered up, tossed in a wagon, and carried to the threshing machine for cleaning. *Halbe Collection, Kansas State Historical Society*

Summer in Kansas and the wheat is ready for threshing. The big steam traction engine has arrived and the whole family turns out for the occasion, recorded for posterity by the visiting photographer. *Halbe Collection, Kansas State Historical Society*

Harvesting oats with a binder, Yoder farm. The oats will be shocked and then threshed in Yoder's barn.

This Wisconsin hay field, tucked in between two stands of corn, has been cut along the contour. *William Garnett*

THE BUFFALO PITTS THRESHER AND CLEANER.

feeder—it will choke, and then you've got to shut everything down while the separator man cleans out the machine.

A *chute man* manages the cleaned grain pouring in a somewhat steady stream out of the machine, sending it into one of the box wagons used to carry the wheat up to the granary. In the really old days (and into the 1930s in California, Washington, and some parts of the Midwest), when grain was bagged instead of handled in bulk, you needed *sack-sewers* to sew up each sack, and *sack jiggers* to lift and carry each 2.5-bushel bag. The sack sewer and sack jigger invariably were powerful men, with good moves and strong arms; they had to be to keep up with the grain

that came out of the thresher at the rate of a thousand sacks a day and more.

Finally, you'd need a couple of *grain men* up in the granary, both husky lads with strong arms, good backs, and big grain scoops. Their job will be to unload each wagon load of loose grain into the bins or to stack the sacks neatly under cover.

Recalling Threshing Time

The annual summer grain harvest is something a lot of men remember with fond affection. The women *sometimes* had a different view. The whole household was disrupted for the few days when the threshing ring was getting the grain ready for market. Quite suddenly, the farm was invaded by hordes of men, some neighbors and some unskilled hired men dredged up from the nearest village or town. Cliff Koster remembers these men, back in the 1930s when the grain harvest was an important element of California's agriculture economy. They were often bums, Cliff says, whose only work every year was at harvest time. They were often men of a rougher character—some of them drinkers, gamblers, and drifters—whose manners, language, and aroma made them

The Buffalo Pitts was one of the first successful threshing machines, a concept that stayed at work and in production for about 100 years. *Hans Halberstadt Collection*

This big combine cuts a 20-foot swath and has its own gasoline engine for power, plus a crew of five to keep it working. The grain will be bagged as it comes out of the combine, each 2 1/2-bushel sack quickly and neatly sewed by one of the crew, the "sack-sewer." Another member of the crew, the "jig," will deftly lift the heavy sack and put it on the slide on the far side of the machine where it will be automatically dropped for later pickup. *Hans Halberstadt Collection*

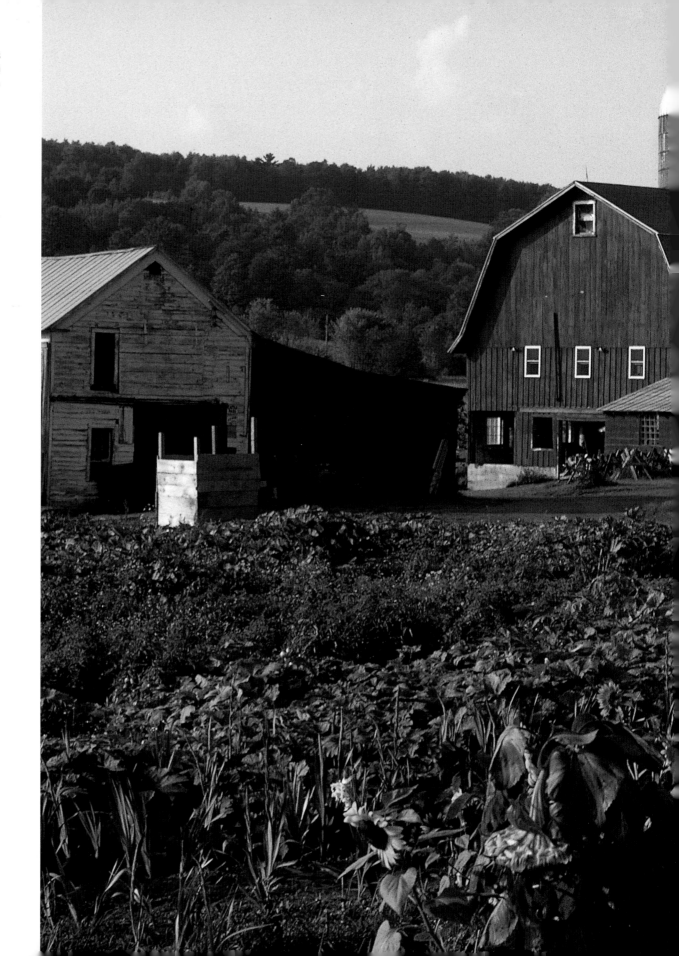

New York and New England farms have their own traditions and their own special look. This place is near Otego, New York. *Howard Ande*

You're not finished with the grain harvest until the grain is in the bin. The "spike-scooper" is the muscular young guy who can shovel left- or right-handed, as required. Here is a wagon load of oats, fresh from the thresher, going into the barn to provide "horse fuel" for the next year. This John Deere tractor powers an elevator that makes the job easier. *John Deere*

The mechanization of shocking oats greatly reduced manual labor. *J.C. Allen & Son*

fascinating to a farm kid. The farm kid's mother, however, was often quite uncomfortable about having these men trooping through the house or camping in the barn—at times with good reason.

But the etiquette of the time was powerful. The farm wife was expected to feed this horde, reputable and otherwise, in a grand manner. Threshing consisted of long, hard days for the men, and certainly longer if not harder days for the women who fed them. Here's what Mrs. R. L. Lewis, of Clearwater, Kansas—a city girl who married a farmer—has to say about it when the first practical combines came into widespread use in the mid-1920s. She wrote this letter in 1925 to the J. I. Case Company, one of the first large-scale manufacturers of the combine, a machine that allowed a farmer to harvest his grain with no more than three or four men and boys.

"To a girl born and reared in a city, the country always seemed to be a sort of fairyland which produced chickens, grains, vegetables, and all products raised there, by waving a magic wand. Instead, I found it to be a grim reality.

"My first summer on a farm was a nightmare. I had to arise at the unheard of hour of four o'clock, and I usually finished my dishwashing around midnight. It was a case of meeting myself getting up as I was going to bed.

"My husband had about four hundred acres of wheat. This meant cooking for from fifteen to twenty men. Only a woman who has cooked for harvest hands knows what they can eat. Food disappeared faster than it could be placed on the table. I learned to dread harvest as I had never dreaded anything in my life. My social activities turned to kitchen activities and my time was spent in cooking and washing dishes.

"I noticed that all the farm implements were made to be of a benefit to the farmer but none benefited his wife. I decided in my mind that the manufacturers didn't know a woman frequented a farm.

"Last spring came in beautifully, but I couldn't see anything but the wheat fields which told me of another wheat crop bringing hours of work and no sleep.

"One day a machine was brought into our yard. It didn't mean anything to me until it was

continued on page 78

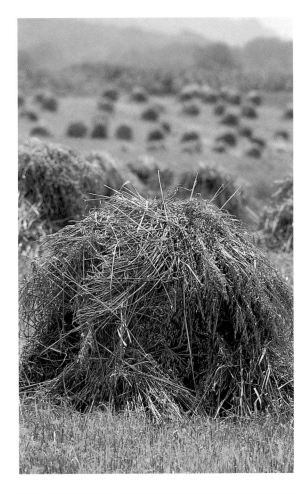

Oats in the shock ready for threshing in Holmes County, Ohio.

Threshing (or "thrashing" as some old-timers call it) was a magic time on the American family farm in the days before World War II. Technology like the tractor and the threshing machine changed the farm and the farmer, and America, too. *J. I. Case.*

Alabama Sharecropper Floyd Burrows

We have a tendency to romanticize the family farm experience, and there has certainly been a lot to love about it. But it wasn't all peaches and cream for many farm families who were happy to get off the land and never looked back. The Farm Security Administration, in response to the disastrous 1930s years of Depression and Dust Bowl, sent out photographers, economists, and others to study what was really happening in rural America. They came back with pictures and stories that shocked the nation and helped with some important reforms.

Walker Evans was one of these photographers. In the torrid summer of 1936, Evans traveled to remote Hale County, Alabama. There he visited and documented the lives of several sharecropper cotton farmers, including Bud Fields, Frank Tengle, and Floyd Burrows. All were neighbors and family farmers. All lived in a kind of stark poverty most urban Americans would think appalling.

Sharecropper farming, particularly cotton farming on the small farms of the South, was an institution that locked the farmer into a situation

Floyd Jr., little "Squeaky," Mrs. Burrows, and Lucille escape the midday summer heat in the shade of their porch. The house is typical of those available to sharecroppers, and better than some. But it has no running water, only a small iron wood-burning stove for heat and cooking, and the toilet is a privy out back. In spite of—or perhaps because of—these conditions, such families tended to have a strong sense of pride and dignity and even accomplishment. The house was clean and neat, and, like its residents, a bit threadbare. *Walker Evans/Farm Security Administration Collection—Library of Congress*

that approached slavery. The basic business deal involved a kind of barter between a landowner and a landless farmer; the farmer got the use of the land—typically five acres or so—and a simple house in return for half of the crop the farmer produced. That wouldn't have been so bad except that the farmer invariably borrowed from the landowner for supplies and staples for the coming year. It was very typical for small tenant farmers to either break even or be in the red after the year's harvest was gathered and sold. And once that happened, the vicious cycle had begun and there was no escape.

But the Burrows family that Walker Evans visited had it bad enough. Floyd and Allie Mae Burrows owned one mule, one cow, a few chickens, a small herd of children—Floyd Jr., Charles, Lucille, and little Othel Lee, known as "Squeaky." Tenant farmers didn't rate fancy houses then and don't get them now; the Burrows home was stark, simple, and drafty. Construction was of rough cut lumber, unpainted. The bathroom was a privy out back, the washroom just a pitcher and pan on the breezeway, with an old feed sack on a nail for a towel. The kitchen was a small wood stove in the corner of one room. As Evans recorded, the Burrows owned very little and lived right at the edge of survival.

And yet...they had something that comes out in the photographs, a kind of dignity and poise that you often see in portraits of farmers. The Burrows were under no illusions about the romance of the land. While some of their neighbors and millions of their contemporary farmers quit and fled the land, the Burrows seemed ready to stick.

Floyd Burrows, cotton sharecropper, Hale County, Alabama. Sharecroppers, white and black alike, were trapped in an economic system from which the only escape was death. *Walker Evans/Farm Security Administration Collection—Library of Congress*

The tractor is belted up for threshing and the farmers are building a straw pile, a skill and an art form that has now nearly vanished from the farm scene. The straw stack has to be built so that it sheds water and the interior construction needs to be uniform and solid. If it sags or dips on top, rain water will puddle and then drain into the interior, rotting out the stack and making the good straw useless for farm use. *J. C. Allen & Son*

OPPOSITE

These two young farmers in their middy shirts and big straw hats are old enough take on one of the hottest, toughest farm chores, cutting and binding the grain. One youngster is driving the Samson, a tractor first built out in Stockton, California but later built by General Motors Corporation. The other youngster carefully watched the operation of a McCormick-Deering binder. *J. C. Allen & Son*

Continued from page 75

explained. I could scarcely believe my ears when I heard what a combine could do. Instead of spending endless hours over a cook stove, I found that I would have only four men instead of five times that many to cook for. For the first time in the six years of my married life, a piece of machinery was placed on the farm that would lighten my work. Now I have time to drive into the city for an occasional picture show, and I am never too tired or busy to entertain my friends when they drop in.

"So this year, as I look out of my window and see the wheat swaying with the Kansas breezes, I can really say, 'How beautiful the country is and how fortunate I am to have such a lovely country home.'" ❧

Bill Vavak is an old-time thresherman from Mead, Nebraska, out west of Omaha where the

prairie is smooth, flat, and sleek—and he remembers the threshing days vividly. He grew up in the days of steam threshing, bought an outfit and worked as a custom "thresherman" himself, and still owns (and sometimes uses) three threshing machines.

The Nebraska prairie around the Vavak farm is a place settled by sturdy European farmers a hundred years ago, and they've left their gentle mark on the ground and on their descendants. The soil is still rich and deep; so is Bill's Czech accent, even though he is a third-generation American. You can tell who settled here by the names of the towns and villages, places like Prague and Swedeburg. It is solid corn and soybean land now, orderly, prosperous, and established. It was a bit wilder 70 years ago, and things have changed quite a bit since Bill's thresherman days.

"My family never owned a steam tractor, but the neighbors did and we threshed with them. They had an Avery Return Flue

Jacob skillfully tosses a bundle into the feeder. The barn is old and timber-framed in the traditional way from huge beams fitted together with mortise and tennon joints.

The Yoders thresh right in the barn, with the cleaned oats going straight into the grain bin and the straw into the barn. The idea is to keep a steady stream of bundles going into the machine, head in, with one bundle following the other. That keeps the load on the machine constant and steady.

machine, and we used it with an Avery thirty-two-inch wooden separator. We were all part of a threshing ring, a group of about eight farm families. We all helped each other with the threshing; five guys would drive hay racks with the bundles, bringing them in from the field, two guys hauled the grain away to the barn. With two guys pitching bundles into the separator, we could keep that thing going all the time. You had one guy on each side of the feeder, each pitching bundles slowly. One

The gasoline tractor changed American farming in many ways, including the summer grain harvest. Gone are the "horse power" and lathered, tired horses; gone is the huge, heavy steamer with its engineer and water boy. The dependable, powerful gasoline tractor chugs away unattended while the thresher boss supervises two "bundle-pitchers" feeding the thresher. A "wind-stacker" automatically builds a straw pile down wind. *John Deere*

man ran the steam engine—the engineer—and another usually hauled water for the boiler. But we had a running creek on our place, so they'd run the engine down by the creek and pump the boiler feed water out of the stream.

"Anybody working on a threshing machine had to be pretty insensitive to dust and dirt. But the thresher was pretty easy to run—you get it in place, then level it off, then belt it up to the engine or tractor. The 'concaves' have to be set right, to knock the grain out of the heads, but that's not too difficult. You've got to run the tractor so the cylinder turns about eight hundred to one thousand rpm, depending on how tight the wheat is, how tough it is to knock out of the head.

"When the wheat turns from green to yellow, you go out in the field and try chewing on a few kernels—as soon as they start to get a little tough, that's the time to start cutting. If you let it go too long, you start losing some from shattering. If it's too green you lose protein, the kernels shrink and shrivel, and it's hard to knock out of the head.

One thing about threshing—we used to hope we'd get a rain after the grain was cut because it seemed like it threshed easier afterwards. We cut a little earlier back then than we do now, with the combine; now you wait until the kernels are really plump because you don't

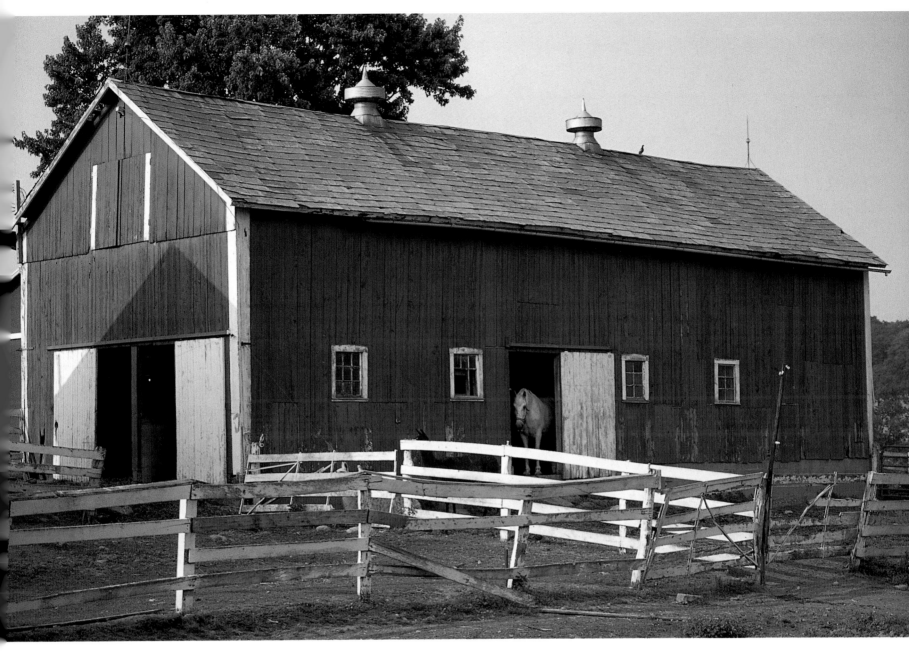

lose so much from shattering. The new varieties are much better than the Turkey Red we used to use—if it was very ripe, every time you moved a bundle you lost some of it.

"I've done all the jobs on the crew—pitched bundles for about four years, drove a hay rack for a few but usually I worked on the thresher or the tractor. Later, when I bought a thresher of my own, I only worked on the rig. Pitching bundles from the hay rack isn't a bad job. Once you learn the rhythm, learn to pick up the bundles and pitch them into the feeder gently, it was quite pleasant. Some guys worked hard at it, never learned quite how to do it; other guys just did it naturally. For them it was easy work. The trick is to feed it head first—and some guys just couldn't manage that easily. Some guys were wonderful at it.

"One of the toughest jobs was stacking the straw as it came out of the machine—that was really dirty! The size and shape of the straw pile was important. There were a lot of little tricks to building the straw pile so it shed rain and didn't collapse.

The horse is old, and so is the barn on this Ohio dairy farm. Both don't get asked to do much anymore but are preserved out of, as much as anything, love and fond memories.

Harvesting oats the modern way, circa 1950. The very idea of one man doing his own harvest was laughable in the 1930s—and then Allis-Chalmers introduced the "All Crop," a simple little pull-type combine that stood the market on its ear. Here's the John Deere version, the little 12A, and some were even smaller. But a farmer could now plant and harvest small acreages of grain that had to be done with a binder, or even by hand with a cradle, before. The little combines were especially popular in New England where fields were too small and irregular for the bigger standard models. *John Deere*

It is the wonderful 4th of July and all three boys are braced to run as soon as the fuse is lit; the girls have wisely found a distant vantage point. *J. C. Allen & Son*

"I still remember when I was eight years old, and the first dollar I ever got. We were sitting on the hill, watching them thresh over at the neighbor's place and mom called up, 'Hey, William, Ed Jacobson wants you to come over and turn the blower for them!' Well, I was over there like a shot. There was a little platform on the machine where I could stand, and a crank to move the pipe. That stacked the straw where the men wanted it.

"At lunch time Mr. Jacobson made me sit right next to him, and he tried to chat with me—but I couldn't speak much English then, and he spoke Swedish, not Czech like we did. He'd pass me dishes and make a fuss over me, the little eight-year-old on his first threshing crew. He made me feel like I was doing something important, and I never forgot it. At the end of the day,

Amber waves of grain lured millions of homesteaders to the Great Plains—Kansas, Nebraska, Oklahoma, the Dakota Territories, Montana—during the late nineteenth and early twentieth centuries. For the families tough enough to stick, to break the sod and get a crop in the ground, the deep and fertile soil offered a rich reward: excellent prices that paid for the land from the very first crop.

BELOW
Early summer on the Great Plains, 1934. Decades of poor farming practices, a long drought, and the worst economic depression in American history have this farmer and most others in a vice. He shows where the wheat would normally be at this time of year. He will be lucky to get his seed back, and there isn't going to be a dime left to pay for that modern tractor or the combine it is pulling. *Library of Congress*

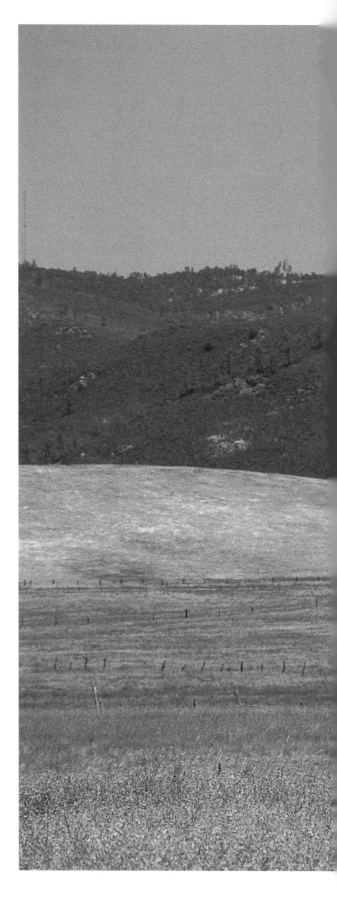

Self-propelled grain combines like this John Deere model from the 1950s simplified the harvest even further, allowing one or two people to bring in the crop from big fields and large acreages. That 16-foot header offers industrial-strength cutting power, unlike the earlier Model 12A with its 6-foot or 8-foot cutter. With a machine like this you didn't need the help of your neighbors any more, and you didn't need to hire extra help at harvest time. *John Deere*

John Tower takes the family's most modern equipment, a John Deere Model 55 combine over 40 years old, out to harvest some weeds. Actually, there is some wheat in there but John gave up in disgust after one circuit. His daughter supervises the operation. The Tower family has owned this ground for nearly 150 years, and another generation is just about ready to take over for a few more.

I rode in the wagon with Dad and as we came by the house Mr. Jacobson came out and slipped a silver dollar in my hand! That wagon was hardly big enough to haul me home after that!

"My dad and uncle bought a rig of their own. When I was old enough—about ten—it was my usual job to stick by the tractor. If something stuck or broke, they'd signal me and I stopped the belt. Then, when it was time to start again, I had to be very careful; you have to be very gentle with belt work. You set the throttle at about halfway, slowly engage the clutch, then advance the throttle so the thresher's cylinder is up to speed—about one thousand rpm. I was also the grease monkey and lubed all nine grease cups on the tractor. You need to go around every half hour or so and give those cups a half turn. Then there were another twenty-five or so fittings on the thresher!

"The meals at threshing time was the big deal—all the men and boys really looked forward to that! The ladies would always try to out-do each other! You wouldn't eat as well at a wedding as you'd get at dinner when you were threshing! They were 'rib-stickers,' for sure. Some of the ladies would do fried chicken, piles of it, and others would do steak, or pork roast—

Boiling down cane to make molasses was another hot and smelly chore, best done in the open air. The women in the bonnet is using a saw to cut another piece of firewood. Northern farmers boiled maple sap to get sugar; southern farmers harvested sugar cane. *J. C. Allen & Son*

OPPOSITE
Summer in South Dakota features the parade of the big combines. Here's a custom crew out of Oklahoma beginning their day in a field of barley. Despite the brand-new, high-tech combine, the crew must wait until late in the morning for the sun to dry last night's moisture from the grain before they can begin cutting. But that big 30-foot header gobbles up the crop at a tremendous rate, one acre every few minutes.

Chore time for the kids in the family was part of the daily routine. One of the chores was, and still is, cleaning the barn of all the manure offered by the cows and horses. The automatic manure spreader, like this John Deere 1926 model, made it much easier for the farmer to apply the manure to the fields, a practice that improves tilth and fertility. But it is a hard, smelly job and one of many reasons farmers were willing to replace horses with tractors. *John Deere*

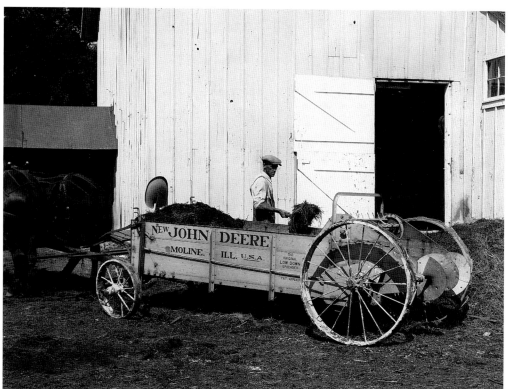

anything you can imagine! And then there would be cakes, and pies, and sometimes even Jell-O! Now, in them days, Jell-O was hard to make and uncommon. I'll never forget one fella, he ate a lot of that Jell-O—so much that he got sick and spent half the afternoon sitting behind one of the shocks, with his horses tied to the hayrack. We *never* let him forget that!

"We ate a lot, but we worked it all off. We were used to physical labor, we worked hard. We plowed with a single-bottom walking plow, behind a horse, sometimes, and we picked corn by hand. You walked, and you worked, and we didn't get fat." ❧

John Slauter is another old-time farmer who has fond memories of threshing time. John grew up in the middle of Iowa—not a bad place to grow up, all things considered. His family's house lacked things like running water, indoor plumbing, electricity, and refrigeration. The lack of what folks call "modern conveniences" today were offset by close personal relationships within the family and within the circle of

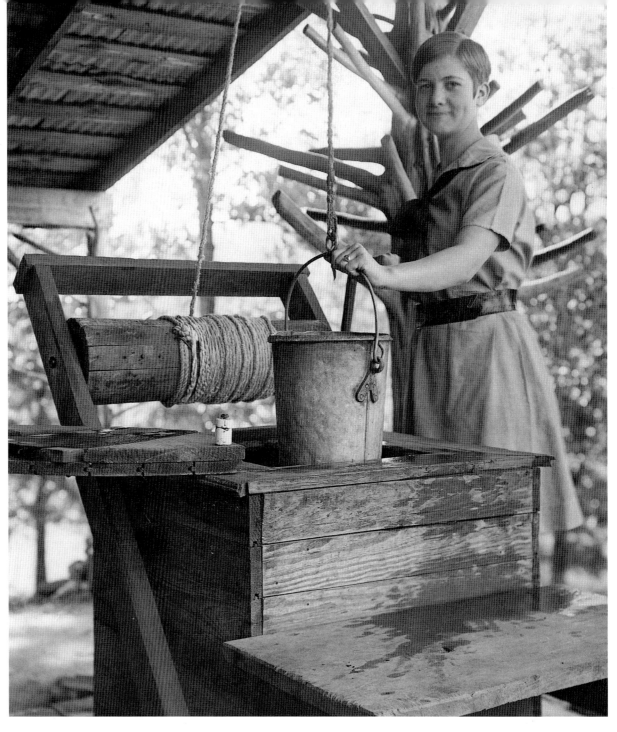

Anna Reed Chapman of Sandy Springs, South Carolina, is neatly starched and pressed as she demonstrates using a windlass to draw water from the well.
J. C. Allen & Son

neighbors. Threshing was one of the great joys of the farm year, especially for young lads during the 1930s.

"Anytime after about the fifteenth of July the neighbors would all get together to thresh the grain. One fella had an old McCormick-Deering steel-wheeled tractor, and he'd pull the threshing machine in to our place. What a thrill for a little kid it was to hear that coming down the lane very early one summer morning! It was quite a production!

"We'd have eight or ten bundle wagons, three wagons to haul the cleaned oats to the granary. My job, at first, was to carry water to all the men. I soon grew out of that. Then I pitched bundles out of the shock into the wagons. When I got older, they put me to work as a 'spike scooper.' That's the guy who stands at the oat bin and scoops the grain into the bins, and can shovel left-handed or right-handed. That was an accomplishment, one I was proud of.

Spraying fruit trees with a portable pump and sprayer was tremendously time-consuming. Horse-drawn pumps and sprayers were available as early as 1900, making it possible to spray an entire orchard in just a few days. *J. C. Allen & Son*

Early automobiles had to do double duty on the farm. This one is hauling bags of wool to the market around 1920. You could also buy a kit for your Model A, converting it to a little tractor. *J. C. Allen & Son*

The bounty of the American landscape is tremendous; very few Americans feed us all, plus much of the world. That is partly thanks to geography, partly to genius. Inventions like this specialized harvester allow farmers to grow and sell commodities like rice very cheaply, with very little physical labor. That is a mixed blessing; our food is, compared to the past, nearly free— but the rich society of rural America has been lost with the growth of the big farms and their efficient machines.

"The big deal of the whole day, though, for all the men and especially for us young fellas, was going in to a great big dinner at noontime. I remember those long thresher tables! There were too many men to feed in the house, so they set the tables up outside, under the trees. One or two of the women stood by with swatters to keep the flies away. There were platters of chicken and gallons of iced tea, plus a freezer of homemade ice cream occasionally. Man, oh, man—I was HUNGRY in them days and couldn't wait for noon to come! If we threshed late, they sometimes fed us supper, too. Then we'd all go home and do our evening chores—and we put in some hours, those days, because we wouldn't get done 'choring' until eleven or midnight!" ❦

Threshing Grain The Old-Fashioned Way

While most farmers converted from the threshing machine to the combine about 50 years ago, some stuck with the older system, and still do.

It's somewhat unusual to see farmers playing croquet; a more typical leisure activity for the old-timers would be a game of horseshoes. *J. C. Allen & Son*

Summer in east central Ohio looks about the same now as it did in 1850, at least in some parts of Holmes County where Amish families still farm and live in much the same way as Americans did 150 years ago.

Here's a good way to keep junior out of the dirt and away from the bugs; put him in his portable playpen while mother cultivates a row of bush beans. This baby has a box seat to watch the show. *J. C. Allen & Son*

Summer in Nebraska, and Solomon Butcher has come to call. Butcher started recording life on the prairie about 1880, visiting hundreds of farmsteads with his big glass-plate cameras over the course of about 20 years. The identity of this particular family isn't recorded but they seem to have settled in pretty well—a nice sod house, a fresh ripe watermelon, and the girls in their best dresses. But the Nebraska landscape can be a terrible place, winter and summer, and not everybody who settled managed to stick. Regardless, these are strong, brave people. *Nebraska State Historical Society*

Homemade Sauerkraut

Quarter cabbage and shred finely. Place 5 lb. shredded cabbage and 3 1/2 tbs. pickling salt in a large pan. Mix well. Pack gently in a large crock, using a potato masher to press it down. Repeat above procedure until crock is filled to 5 in. from the top. Press cabbage down firmly. Cover with clean cloth. Place a plate on top and weigh it down with a jar filled with water. Keep crock at 65° to ferment. Remove skim as it forms. Fermentation will be complete in 10 to 12 days.

Pack sauerkraut in hot sterilized jars to within 1 in. from the top. Add enough juice to cover. Cover jars. Screw bands tight. Process in boiling water bath for 15 min.

Note: 50 lb. of sauerkraut makes about 15 qt.

Courtesy of Mary Djubenski

Most are Amish, like the Yoders, who thresh their oats in mid-July.

The Yoders use a small Dion thresher, a machine built in Canada during the 1950s. American thresher manufacturers stopped offering threshers about this time; the Canadians kept making them a bit longer. None are being offered now. But if you take good care of one, don't push it too hard, and keep it under cover, a thresher will last longer than a thresherman.

The Yoders get the Dion out of the shed and roll it across the drive, up to the barn. The machine fits inside the hay mow, allowing the cleaned grain to flow right into the bin. Jacob and the machine used to be part of a threshing ring, but all his Amish neighbors now have machines of their own. He and son, Merlin, will do their own threshing; the boys, who are too young to help with this part, will supervise.

Even though the family is Old Order Amish, they own and use a tractor—a fairly new diesel made by Massey. But it isn't used for plowing or anything the horses can do, just as a stationary power source for jobs such as the belt work needed for the thresher. The rubber tires have been replaced by steel wheels, one part of the Amish policy for keeping the seductive comforts of the modern world at arm's length.

The oats have been drying out in the field for a week or so, the remaining moisture in the plants evaporating day by day. Finally, two horses are harnessed and hitched to the big wagon, and Jacob, Merlin, and the boys head out to start loading the bundles.

Lewis, who is seven, is now old enough to start learning to drive the team; Jacob hands him the reins and provides advice while Lewis whistles the horses into action. They step into their collars and move off, up the hill to the oat field.

Jacob helps with the navigation, maneuvering the wagon alongside the first row of shocks. Merlin tosses bundles with an easy precision gained from long experience; each bundle is lifted and presented to Jacob head in, ready to stack, Jacob arranges the load and helps Lewis manage the team. The wagon soon fills with oat bundles and Merlin must lift the bundles up well over head high.

The bundles are light and each goes on the wagon with deceptive ease. Getting the bundle up on the wagon is easy, delivering it properly is

A fresh load of manure from the barn and a new 1952 Case tractor and spreader headed for the fields for spreading. As millions of farm kids have been told by millions of farm parents, *chores build character.* J. I. Case

not. Turning the bundle head in, throwing it up into place takes some experience to learn. The Yoders make the whole thing look effortless, and for them it is. Other than the conversation between the family, the creaking of the hitch and harness, an occasional nicker from the horses, and the birds singing in the trees along the lane, the quiet is surprising. There is none of the noise and bluster of a combine or a tractor. The work is done without haste, without delay. No more than fifteen minutes are required for the wagon to fill up. When the wagon is loaded to bursting, Lewis puts the horses in gear and everybody heads back to the barn.

Jacob takes over just outside and the boys and their father climb down. Then he drives the team into position, all the way in the barn with the wagon alongside the feeder section of the thresher. Merlin starts the tractor. When Jacob is ready, Merlin puts the machine in gear and gradually releases the clutch, then adjusts the tractor's speed to drive the thresher's cylinder at one thousand rpm. The twenti-eth century returns with the roar of the tractor and the hum of the thresher.

Merlin climbs up on the load, puts on a dust mask, and starts feeding bundles to the machine. Again, he is a master of an old technique, one bundle neatly following the next. That keeps the machine working steadily at a constant load, something you won't see at a farm show demonstration.

A duct sends the cleaned oats to the big bins on the far side of the hay mow. A few bushels of last year's crop are still present but the bin quickly starts to fill with fresh bushels of home-grown fuel for the farm's motive power. The straw gets blown out of the granary, onto the straw pile. Soon the wagon is empty and the Yoders back the team out of the barn and go back to the field for more. They will be finished with the whole job in one long day, finally finishing up after the sun has set. Another part of another year's farming cycle on the Yoder farm is complete.

Summer is the time for barn building. It used to be a community affair, but that is rarely the case today. The rare examples come from Amish and similar cultures, where barn-raising is still a group effort. Folks come from miles around, and barns go up in less time than it takes a construction company to build one. *Randy Leffingwell*

The Bunnell Farm in Litchfield, Connecticut. *Howard Ande*

August Is the Time To:
Bale straw.
Mend the silo.
Clean the cistern.
Adjust the farm scales.
Kill Canada thistles.
Sow crimson clover.
Harvest legume seed.
Put in a water system.
Vaccinate poultry for pox.
Feed the best animals most.
Plan to use more electricity.
Seed your next year's poultry range.
Get buildings ready for fall pigs.
Inoculate summer-seeded alfalfa.
Spread manure on stubble fields.
Thank your lucky stars you seeded
Sudan grass for late summer pasture.
Farm Journal, August 1941

Fall

Fall begins with scorching daytime temperatures in late September, but the nights begin to cool. The sun rises about 7 A.M. now, and the kids wait out at the road for the school bus. It will set about 12 hours later, nearly due west. The corn finishes its growth cycle, the kernels fill out, and the bright green of summer is gradually replaced by yellow and brown as the plants die.

The fall harvesting season is pay day for a lot of American farmers, in the corn belt and in the West. The corn harvest used to be done by hand, a hot, tiring job; today it is done eight rows at a time, in air-conditioned comfort. It is a busy, exciting season for everybody, the climax of the year. Traditionally, men and boys and hired men and neighbors are busy getting the crops in at the peak of maturity—before winter arrives. Women and children are especially busy with poultry flocks before the heavy market times of Thanksgiving and Christmas. Kids go back to school, sometimes after helping with the harvest, and get back into the routine of morning chores, school, and chores at night. But fall is the beginning

Fall on the American family farm has traditionally been a time to plow under the stubble before winter freezes the ground. That was once done with the single-bottom walking plow celebrated in this painting. *John Deere*

❦

September Is the Time To:

Cut sawlogs.

Sow spinach.

Pitch horseshoes.

Ventilate the barn.

Seed orchard grass.

Finish that corn crib.

Keep young in heart.

Visit the county home.

Ask the preacher to dinner.

Renovate bluegrass pasture.

Fit heifers for fall freshening.

Take grandma a box of apples.

Harvest squashes—leave stems on.

Farm Journal, September 1948

of hunting season, the beginning of a slower time and shorter days on most farms. The year begins to wind down after the harvest and the subsequent plowing and planting of winter wheat. But first comes the major event of the American farm year, the corn harvest.

The Harvest

The harvest season in America is really the entire calendar year. It begins in the south and west, in Arizona and in California's Imperial Valley, in January with the lettuce crop. The citrus harvest, too, gets into high gear in January and February, and will last for twelve months in some groves. Strawberries are the traditional first harvest in many parts of the country, and oats and the small grains become ripe in late spring and early summer.

But across America farmers wait and watch and worry until September when the major crops will normally ripen. A whole year's effort and investment is committed to bringing in the apples, tomatoes, melons, and grapes.

Potatoes in Idaho and Maine finish their growth cycle, after much attention from the farmer, and are ready for digging. They'll be in a dozen major varieties, for baking, boiling, for chips and French fries, enough for a mountain of mashed potatoes big enough to smother Peoria.

nuts, beans of many kinds, tobacco, that ancient American crop, and cotton, too. These and hundreds of others reach maturity, are harvested, and prepared for market. But chief among them all, across the whole nation, is the crop the Indians taught the Colonists to grow, the foundation for everything else, corn.

Shucking Corn

Bill Toms is one of those farmers who keep farming and keep enjoying the process in spite of everything. He's got a little place tucked in up against the Blue Ridge mountains in western Virginia, a little farm with rocky soil. Two-and-a-half acres are in peaches, another acre or so goes into corn to feed a few beef cattle.

Every corn farmer, past and present, with a thousand acres or just one, will keep a close eye on the plants starting about the first of September. When the crop is ready, you have to be ready for the crop. In the old days farmers knew the corn would be fit for cutting and shocking only during a period of a week or two. The new guys haven't forgotten.

For the modern guys with the big silos, that window is pretty early—when the corn kernels are just filling out with the last of their nutrients but while the plant is still green and growing and full of moisture. That's the time to get in the field with a forager, sucking the whole plant right off the soil, chopping it all, stalk, ear, everything, including bugs, then getting it in the silo right away. Then the moisture and the bacteria and the plant material will have a little party, make some alcohol, and get pickled. That's one way to put up your corn.

A week or two later, say the middle of September most places, the corn will be about ready for another window of opportunity for another level of maturity. That's when the green fades and the

Putting in the winter wheat is November work. This farmer races the calendar and frozen ground with his team and John Deere drill on a chilly day 60 seasons ago. *John Deere*

Soybeans by the millions of tons wait in the field to be cut and then combined. They'll feed and fatten cows, pigs, poultry; they'll be refined into oil, ground into meal, and incorporated into hundreds of different kinds of refined foods, from soy sauce to imitation hamburger.

The grape harvest gets into high gear in the Finger Lakes district of New York, and in the great wine producing regions of Washington, Oregon, and California. Some growers in California's Napa Valley will make more than $5,000 per acre for their grapes, the juice from which will sell for $20 a bottle in a few years.

Hundreds of thousands of acres of Thompson seedless grapes will be cut, laid on paper sheets between the rows, and allowed to dry in the sun; that's where the raisins for America's school children's lunches come from—and for the lunches of kids around the world, too.

In September and October farmers harvest a multitude of commodities: kiwi fruit, wal-

But to make the shock tight against the weather you'll need to tie it up. First, run a rope around the stalks up toward the top and pull the plants together as tight as you can, tying off with a temporary knot. Then use binder twine again to hold the stalks together; now untie the rope and walk down between the sixth and seventh rows 12 more paces to start the next shock.

Once you finish shocking all the corn in the field (assuming you wish to continue farming), you can wait about a month to actually shuck the ears out of the shock. This was once the occasion for a grand party and intense competition, a time when all the neighbors gathered to shuck the corn crop. Sadly, neighbors don't do that anymore and Bill shucks his corn by himself.

Fifty years ago you could still buy "shucking pegs" in about a dozen variations for the purpose. The shucking peg is actually a kind of fingerless glove with a hook or pin firmly attached to the palm. Once you get the hang of it, you can use that peg to peel the shuck cleanly off the ear. The ear itself goes in one pile, and then to the corn crib to help feed cattle or pigs through the winter. The stalks go into another pile; they will also provide fodder for the animals. And, once the job is done, you collapse in yet another pile—that's hard work!

"I wish I had the magic answer to the problems of the small family farm," Bill says, "because I love farming. I'm on my ol' granddaddy's home place here. He farmed this place all his life—that was his living. And I just always wanted to be a farmer. I reckon granddaddy spoiled me when I was little, he encouraged me that way, put it in my blood!"

OPPOSITE
Corn harvest, 1929. Mechanical harvesting speeded up the process, although mules continued to help for many years after this shot was made seventy years ago. Both these men probably were well-versed in bringing in the corn by hand, with a knife and shucking peg. *John Deere*

Photographer Frances Benjamin Johnston visited this southern farm around the turn of the century, apparently in the Fall. There are pumpkins in the barn and the hay mow is full to the eaves with fodder. *Frances Benjamin Johnston—Library of Congress*

Potato harvest, in Minnesota. It is late October in the fields near the community of East Grand Forks, and 1937's crop is coming off the ground. *Russell Lee/Farm Security Administration—Library of Congress*

October in Vermont. The trees surrounding these old, small dairy operations are just starting to turn color. In another week or two they will be ablaze; a month after that they will be bare. *Howard Ande*

The rolling terrain of California's Montezuma Hills has a gentle, sleek beauty even a combine operator can appreciate. *William Garnett*

This is young Brian Grow, a fresh tenderfoot on the Flagg ranch in 1903. He's got *two* useless little pistols tucked into his belt, and they've given him a nasty, half-broke little pony who is clearly ready to launch Brian into outer space. By the time this shot was made, the Wild West was dead, killed off by barbed wire and the civilization it enclosed. But the legend of the West still attracted young men to the challenge of "cowboying"—and it still does. *Solomon D. Butcher Collection—Nebraska State Historical Society*

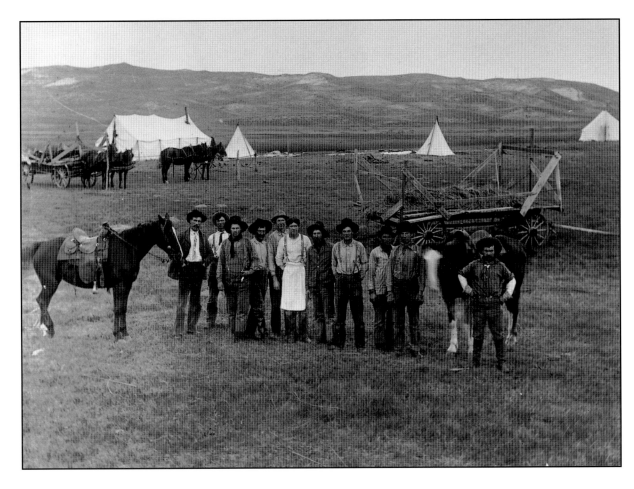

The Harvest on the Boyd Farm

The corn and soybean harvest on the Boyd farm and all the similar operations around central Iowa usually begin about the first of October. The green is gone from the corn fields then, the standing plants bleached almost white, dry and brittle from the early autumn sun. The sky turns very clear, a deep and brilliant blue most days. Nights are cool, then crisp. It is a relief from the oppressive heat and glare of summer.

Leland, Glen, and Duane—like their neighbors and corn growers across the Midwest—spend a lot of September preparing for the harvest. The combine will receive special attention; it, and the corn header attachment, will be crucial to a fast, efficient finish to the growing season. They've got three dryers and all will get attention before the corn starts coming in when the dryers will become essential.

They use a New Holland TR95 combine with all the bells and whistles; a grain sensor with digital display in the cab indicating moisture content of the crop, monitors confirming proper function of all the shafts and systems within the cleaning section of the machine, plus air conditioning, pressurized cab, and more. Like all modern combines, the New Holland uses modular headers that allow quick change from corn to soybeans; the Boyds like the special soybean head New Holland offers, a system that adjusts the lateral tilt of the header and cutter bar to automatically follow the small changes in contour of the ground.

The Boyds will harvest around 100,000 bushels of corn from their operation in a normal year, nearly all "shelled," or off the cob. Half that, 50,000 bushels, will be used during the coming year for the hog and cattle feeder operation, the other half sold. It will join the great annual grain exodus from the Great Plains, barges, truckloads, and 100-car trains loaded with corn, destined for processing plants making corn starch, fuel-additive alcohol, corn oil, corn meal, corn flakes.

continued on page 114

The Wild, Wild West

Cowboys are as much a fixture of cattle country today as ever, and their work really hasn't changed much in 100 years. Cattle drives still take place in the West, although sometimes the animals are trucked from summer range in the high mountain meadows to winter grazing at the home ranch—sometimes 400 miles away. Even so, you'll find week-long cattle drives in Oregon today, across empty country that looks the same today as in 1890, with lean, mean horses and leaner, meaner riders.

Cattle are still branded, just like in the movies, and rustlers still steal cattle although they aren't strung up as often. Cattle brands are serious business in Nevada and across the west; you don't move a truckload of cows very far without a visit from the brand inspector. You can apply your brand with an electric iron, or one heated in a fire built in the back country, but it had better be registered to you or you'll be going to jail—and that happens, too.

The horses are smarter now, and a lot prettier than the ugly little ponies most real cowboys rode in what we call the "Old" West. But those horses get a workout during roundup in the spring and fall, even if they get a ride in a horse trailer.

Roundup

Jim Dunlap is a member of a romanticized breed, the cowboy. He tells about the life of a cowboy in modern times, which hasn't changed all that much:

"After all the cows have calved, normally in early spring, we need to brand them to identify who they belong to. That's because they are on pasture for most of the year, grazing back in the hills. Our ranches are pretty big acreages, compared to the East and Midwest, and sometimes we have the cattle on open range where it's easy for them to get mixed up. My cows are on four thousand acres of private land; it is fenced, but they go through fences. I run my cattle with my dad and grandfather; my brand is the 'Flying J' on the left hip.

"When it is time for spring roundup, in March or April here in Colusa County, we call around to the neighbors and everybody who can will show up, maybe fifteen or twenty riders. I also work for a guy near here, Mike LaGrande; he's "partners" with his cousin on the One Bar Ranch. They run about four hundred head on around six thousand acres. We've got some brood mares and raise some saddle horses. We winter our cattle down here in Colusa County, California, but take them up to Oregon in the summer. Mike's place up there includes about eighteen hundred deeded acres, plus a Forest Service grazing permit for another thirty thousand acres.

"So we round them up twice a year, spring and fall. We plan on doing about two hundred or two hundred and fifty animals per day. The working part of cowboying and roundup hasn't changed in a hundred years.

Fall in cattle country means roundup time. The cattle are driven down from summer pasture to winter range, the new unmarked calves branded, wormed, ear-marked, castrated, dehorned, dipped, and vaccinated. Despite the apparent trauma of all this unwanted attention, the calf emerges from the chute pretty much unfazed, happy to get back to Mom just as if nothing happened. After a day of this and a few dozen bull calves, "Cookie" will have a big bucket of "mountain oysters" (as calf testicles are sometimes called) to fry up for dinner. Yum!

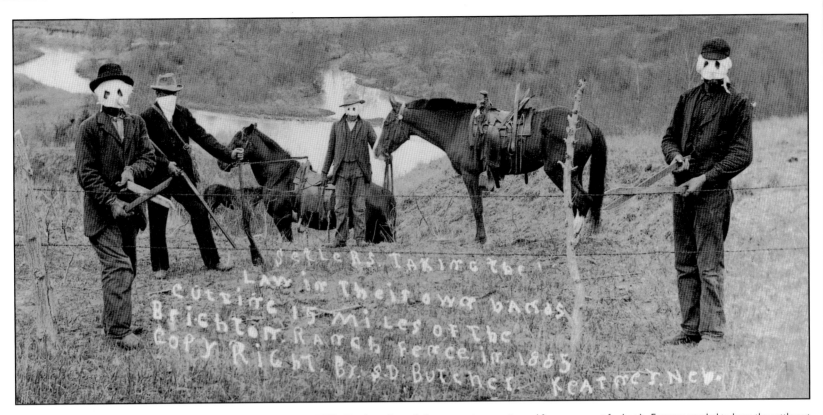

Cattle ranchers and homesteaders went to war in the West back in the 1880s. Ranchers depended on open range grazing and free movement for herds. Farmers needed to keep the cattle out of the wheat and oats, and used barbed wire—in dozens of patterns—to draw the line. These lads cut 15 miles of fence on the Brighton place, near Kearny, Nebraska, in 1885. *Solomon D. Butcher Collection—Nebraska State Historical Society*

Okay, we use nylon rope instead of grass riatas, and we can "doctor" a sick calf better, but the rest of it is pretty much the same.

"We use cutting horses to separate the cows from the calves. That's a horse that will instinctively turn a calf or a cow by running to block it. We do it by putting them all in the corral, with one rider in the gate with two or more pushing the cattle toward him. The rider in the gate lets the cows through and holds the calves back. It is an art, it is interesting, and it is fun to watch; it takes a really good horse and an experienced rider. The horse has to instinctively want to block the calf, but it has to block the calf the rider selects. I consider it an art form.

"Once we get them all separated we can start working on the calves. We rope the calves by "heading" and "heeling" them. That means one cowboy on horseback ropes the head, the other the back feet. We brand them, ear-mark them, castrate the bull calves, and de-horn them. Most of our branding is done with a traditional "wood" iron because we're usually out in the hills, but electric branding irons are handy when you're around the barn.

"Then there are the dogs—I would be lost without my dogs! I use border collies, bred to this work, and from the time they are little pup-pies, this is all they want to do. They allow you to do the work of three

continued to next page

Al Wise, who was an old-time Nebraska cowboy and rancher 100 years ago, marks a steer he's found on his place about 1900. He's using a full-sized branding iron, but it seems pretty cold—there ought to be a fire handy, and there's no smoke from the hide of that steer, so maybe this demonstration is just for our benefit. You can brand with the cinch ring from your saddle, heated in a little fire and held with a pair of fence pliers; then you can put any old brand you want, but don't get caught doctoring brands on somebody else's cattle. It would get you shot when this picture was made, and in big trouble today. Rustling is still a major problem for cattle ranchers. *Solomon D. Butcher Collection—Nebraska State Historical Society*

Mr. C. N. Dunlap, foreman on the Watson ranch out in Buffalo County, Nebraska. Ranch foremen were not always the most charming or diplomatic managers, but men like Dunlap had a direct, efficient, effective style many mangers would like to use today. It started with an ability to beat the stuffing out of any subordinate, a challenging requirement back in 1888. The chaps are called "woollies," and the pistol seems to be a Colt Single Action Army model of 1873. *Solomon D. Butcher Collection—Nebraska State Historical Society*

or four people all by yourself. It is all instinctive with them, just like with the horses.

"Training them, like the horses, involves showing them what they want to do naturally, but on command. Gathering cattle in big open country is easy with the dogs. I can send them out to cattle as far away as you can see them and the dogs will go bring those cows to me. That saves me the ride all the way out there, and it is very helpful during roundup when we need to bring the cattle down out of the hills and bunch them together." 🐾

Livestock Auctions

Another part of cattle ranching was the auction. It was a big event in the old days, as it is now. Jim Dunlap lends a little insight into what goes on at a typical cattle auction:

"Livestock auctions are another part of this business that hasn't changed in 100 years. The big packers send professional cow buyers; they wear fancy suits and boots and sit in the front row. That's all they do, go to sales every day and buy cattle. Then there are "order buyers" who take orders from guys like me—if I didn't have time to go, I can hire one of these guys to get

what I need, for a commission. These are the guys in the front row.

"But I do most of my own buying, and I go to the sales quite a bit in the fall or winter—that's when I do my buying. But a jillion kinds of people come to the sales, for all reasons. Every kind of cattle comes through the sale yard, from day-old calves to old bulls and butcher cows, so people come looking for different kinds of animals. The dairy operations are looking for one sort, for example, and the feed lots and packing houses for another.

"Most people, though, are there for the entertainment. Lots of people go to watch the sale. It's exciting, things happen fast. The sellers show up, too, to watch what happens with their animals, how the prices go. It is a social event where you meet people you don't see often otherwise. Most yards have a sale every week, and the regular sale isn't such a big deal, but the big ones like the Red Bluff Bull Sale in January is a huge social event that goes on for a week.

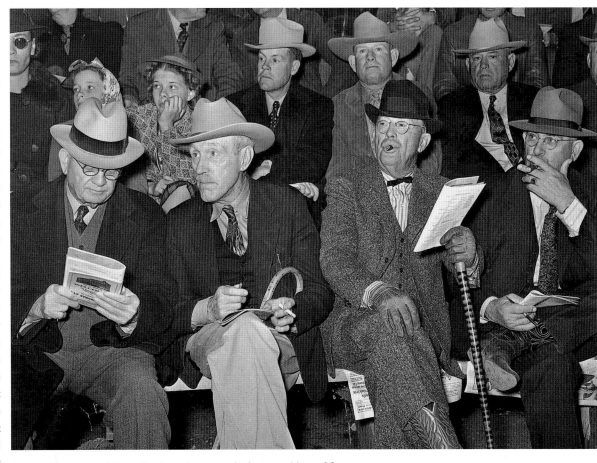

A livestock auction, and the packing house buyers get the front row. *Library of Congress*

"In March I buy yearling steers to turn out and run on grass till June to put some "gain" on them, and in the fall I cull out the older cows who haven't conceived; they get sold and I buy replacements. If I replace thirty or forty, and I can get four or five good new cows a week, that can take some time.

"The way the cattle business works here is like this: We keep the cows long term, till they are ten or twelve years old, as long as they produce new calves. Then they go to make hamburger. The calves are born in early spring, on our ranch anyway, and by October or November they're ready to wean off the cow. I generally sell them then, at about six hundred pounds. But you can also wean them and keep them for another six months or so, till they are yearlings and are up to eight hundred pounds or so, and then sell them to a feed lot." ☙

Continued from page 109

Catching on the Fly

Leland and the hired man attach the corn header to the New Holland TR95 one morning during the first week of October, test it, and wait. The standing corn is losing moisture to the air every day. Finally, on the morning of the fifth, Duane climbs up the ladder to the combine's little cockpit, fires up the diesel engine, and the big machine comes to life. He brings the corn header up off the ground to the travel position, backs the combine out of the yard, then drives out onto the county road to the first field with the hired man following with one of the smaller tractors and the grain bins.

A quarter-mile from the house, Duane turns into one of the fields. He lowers the header into position, engages the power to the header and

The last hay of the year comes off the field at an Amish farm near Jamesport, Missouri. Percherons seem to be replacing a few of the Belgians in this part of America, too.

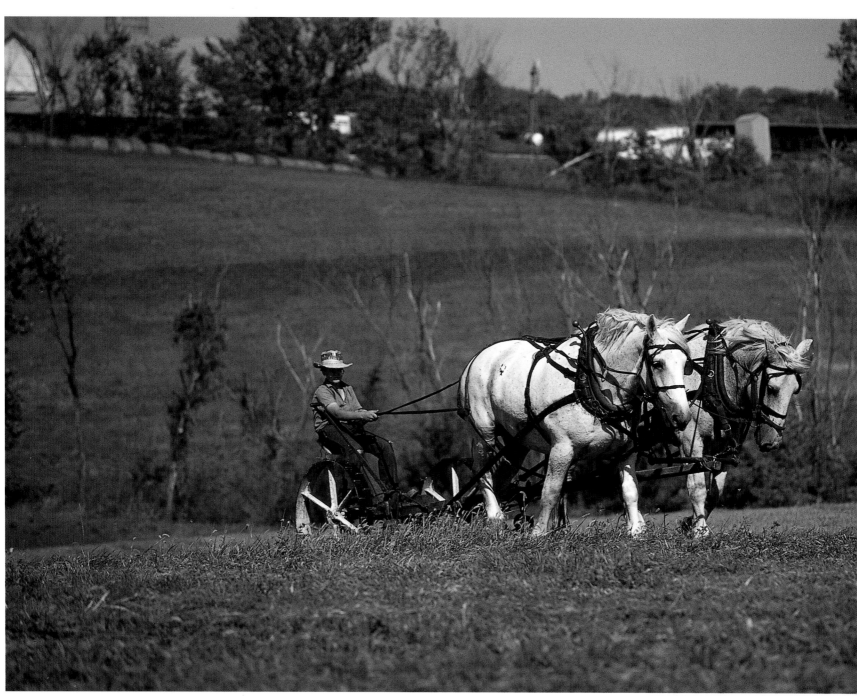

checks to ensure the cleaning sections of the combine are all working. Then he shifts gears, takes his foot off the brake, and the New Holland takes the first bite out of this year's corn crop. It is Duane's fifty-third harvest, Glen's sixtieth.

The year has been a pretty good one for the Boyds and corn farmers across the heartland—not perfect, but pretty good. Rain fell pretty much when it should, stayed away pretty much on cue, late in the summer. The ears filled out pretty much as advertised, the kernels plump and mature, with little damage from the corn borer or other pests. "We're getting 145 bushels to the acre," Leland says. "We've had as much as 180 before, but 145 isn't bad." At 145 bushels to the acre, the bin on the combine fills quickly. Leland maneuvers alongside with the John Deere 4640 trailing a pair of grain hoppers. With speeds matched and the auger positioned, Duane engages a control and the first of the crop pours from the combine into the bin while the harvest continues at about six miles per hour. Then the first load is off to the drier.

They'll cut until early evening, then quit. There is no particular hurry with corn as there is with

Harvesting grain in the old days took several steps. First, the grain was cut and tied in bundles. Then it was carefully stacked in "shocks" with a bundle placed across the top as a moisture shedding "roof." After days, weeks, or even months, it would be hauled in and run through a threshing machine. *J. C. Allen & Son*

Corn harvest today takes eight rows at a pass, in air-conditioned comfort. This big John Deere 8820 today costs about 200 times the price of a corn harvester of the 1930s. The price of corn has hardly changed at all. *John Deere*

The young lady with the big hat, and bigger smile, is helping with the 1930 wheat harvest, and she has reason to be proud. That tractor is a new John Deere, and it is pulling the latest thing in harvesting technology, a "combine," or "combination harvester-thresher." The combine replaced a herd of horses and a platoon of helpers, and the threshing machine, too. But 1930 was a tough year for some grain growers out on the Great Plains. The man behind her, likely her father, watches the sorry crop gathered up by the sweeps, trickling into the header—and he isn't smiling. *John Deere*

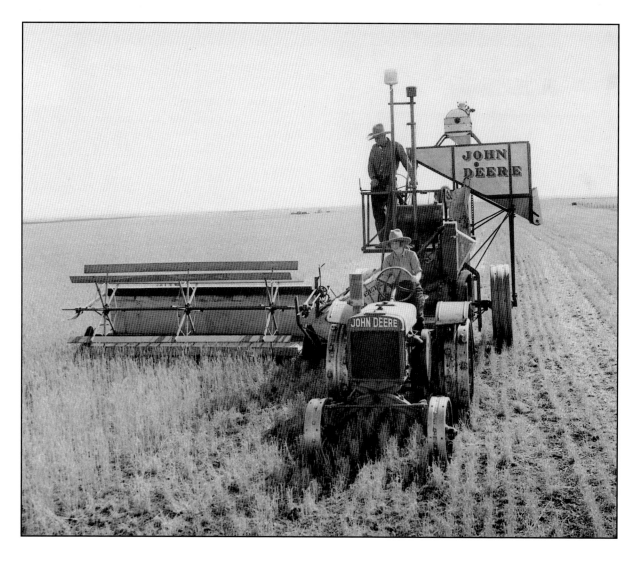

wheat. And this year is a good one for the harvest—cool, dry, and bright. Toward the end, moisture content is down to 15 percent, low enough to sell direct from the field without bothering with the drier.

By late October the harvest is complete on the Boyd farm and on most farms throughout Iowa, Nebraska, and the corn belt. Leland would like to go fishing, but there are chores to do before winter closes in. He'll get back to the livestock, and there's fall plowing to do. Once the crop is off the field, Leland will come along with a Landall machine to prepare the ground for winter and next year's crop. The Landall uses two big rows of disks followed by a seven-shank "subsoiler" that reaches deep into the earth to break up the hardpan that starts a foot below the surface; that will bury about 50 percent of the trash, and the anhydrous ammonia applicator will put the nitrogen in the soil for

next year's crop. And if it looks like the weather is about to turn bad, they'll run around the clock if necessary, cleaning up 150 acres every 24 hours. With 700 acres of corn residue, that will take about a week or so, less if necessary. Once the ground freezes, the field work is over till spring, and another fall on the farm is complete.

Jeanette Monday and the Fruit Co-op

Thousands of farm families produced fruit from apple and peach orchards, a real growth industry after refrigerated rail transportation made marketing of fresh product in distant cities practical. Small fruit orchard operations were highly attractive to many widowed women with children. Here is the story of one of them.

Jeanette Lorimer Monday was taking care of the house and her three young boys back in 1905.

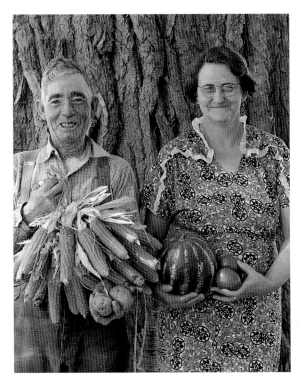

Her husband, a university professor, became ill, then disabled, then he died, and Jeanette and the boys were left to their own devices. Her resources were $10,000, some furniture, the boys, some ambition, and a substantial amount of energy.

Although she had no experience as a homesteader or a fruit grower, she decided in 1905 to buy a 10-acre parcel in Washington state's Onkanagen Valley and get into the orchard business. After a five-day train trip the family found themselves at a remote little depot. The station agent, in a kindness characteristic of the place and the time, had taken the initiative to have tents set up on the undeveloped Monday spread and arranged transportation for the family to the site of their new home. It took two hours on horseback for the weary little family to reach the spot where another happy surprise awaited.

"The tents were pitched upon a pine-sheltered knoll," she reported later, "looking homelike and inviting. A woman came running up to greet

The year has been kind to this couple, with their harvest of corn, potatoes, squash and tomatoes. A farmer never really knows what will end up in the bin, or what the market will pay until the check clears the bank. A year's effort can be wiped out in a momentary hail storm the very day you plan to harvest the crop. Farming isn't a gamble, exactly, but a calculated risk. These folks seem to have calculated right. *Library of Congress*

None of these farmers are smiling because they've all lost their farms in the "Dust Bowl" and Depression of the 1930s. Fifty years of poor farming techniques depleted the soil of nutrients, then let it wash and blow away. The sky went black in these storms. Dust engulfed houses, barns, stock, tractors, and even towns. American farmers learned a lesson about soil conservation; these men learned it the hard way. *Dorthea Lange—Library of Congress*

The soil is still black and deep in many parts of America, even if the plowing is done at high speed with a five-bottom plow. *John Deere*

Fall plowing with a three-bottom John Deere plow and tractor. *John Deere*

A plowed field, in Arvin, California. *William Garnett*

us—Mrs. Molly Magruder—and she gave us a whole-souled welcome. She was our nearest neighbor, only a mile away as the crow flies. She and her six children had been waiting five years for people to come and dwell near them." Molly had been warned of the Monday clan's likely arrival and had prepared supper on a simple camp stove: bread, fried bacon, fresh mushrooms, and coffee with thick cream.

The land and moving expenses cost Jeanette Monday almost $3,000 of her nest-egg and now the four found themselves living in tents on uncleared, unimproved land. But, as the kindness of the station agent, Molly Macgruder, and other neighbors would demonstrate, she wasn't alone. It took another $110 to hire men like Post Hole Bill and others to come clear the land, fence it, $250 for irrigation pipe and the labor to install it. A Jersey cow cost $110, a thousand fruit trees (apple, apricot, peach, plum, pear) cost another $250, 10 Barred Rock chickens an additional $15. Seeds and vines (strawberries, raspberries, currants) cost $25. She bought an Indian pony for $25 and hired men to plant the trees at eight cents apiece, or $80 for the thousand. A hired man, Bob Carter, hired on for six months at $65 per month—another $390. Six months of groceries, delivered to the depot two hours away, took another $300. Her bank balance was soon down to $5,300, with no house to live in and no income from the orchard possible for four years at the earliest.

But with a combination of honest, friendly neighbors, hard work and perseverance—plus three energetic, growing boys and some hired labor, Jeanette Monday's little apple farm gradually turned into a profitable operation. It took most of the rest of her cash to build a house, several years for the trees to begin bearing in commercial quantities, and a lot of innovation before the farm started providing a secure home for the Mondays. She covered living expenses those first years, before the trees started bearing, by teaching and by barter with neighbors. The boys did the manual labor, including the endless routine of pruning and spraying the fruit trees. They made and sold soap to a railroad track building gang working in the area. The neighbors pitched in when they could. And in another family farm tradition, they were scrupulously honest; when the house was built, the contractor returned $250 from the $3,000

advanced by Mrs. Monday since he had been able to get discounts on materials to that amount.

After ten years, in 1915, the Onkanagen valley had 50 such operations, including 8 operated by widows like Mrs. Monday and Mrs. Macgruder. At the end of the seventh year, with the whole family working, the Mondays were about $500 ahead for the year—their first real profit. A cooperative was formed among the growers in the valley as a more efficient way to market the fruit from the orchards. For all the years' fruit and labor that year with the co-op, the Mondays *lost* $7.50. But the management of the co-op was changed, and they saw a profit the next year. The currants brought a whopping $2.50 a crate, strawberries ten cents per pound, apricots $1 per crate, apples $1 per box. The Monday's bought an automobile.

By that time the Onkanagen was settled and productive—and so was the little Monday clan. There were so many women in the area that in 1913 a branch of the Women Farmer's Institute formed in the valley, and 30 of Jeanette's women neighbors and friends joined. Two years later, in 1915, Jeanette and Molly attended a regional convention of the Institute. Jeanette reported the experience to the readers of *The Country Gentleman*:

October Is the Time To:

Fill silo.
Plant tulips.
Hunt pheasants.
Go to the church social.
Kill any weeds on sight.
Run for the school board.
Put ventilators in the corn cribs.
Meet Sister's new boyfriend.
Look at the new tractor models.
Grease the mower and put it away.
Boost the grain rations for the turkeys.
Be careful with the corn picker—
don't loose an arm or leg.
Tell them you'll take that class of boys
at Sunday school that nobody else
wants to teach.
Farm Journal, October 1949

Meet Mr. William Edward Fields, better known as Bud, sharecropper, taking a break from picking his cotton. Bud and other sharecroppers like him were caught in an economic trap that was virtually inescapable, offering only a marginal existence. The sharecropper and his family, as much as anybody else, is another part of the story of the American family farm. *Walker Evans/Farm Security Administration Collection—Library of Congress*

Cotton at the gin about 100 years ago. Wagon loads of hand-picked raw cotton, complete with seeds and a fair amount of trash, is vacuumed up and into the machinery that will start the processing sequence. *Library of Congress*

"It was the first time I had been out of the Onkanagen since my arrival in 1905. I had no new clothes and felt so funny when I saw the garments worn by people who had kept abreast of the fashions. Mrs. Molly Macgruder was the other delegate from our institute, and her remarks on the first day were entirely upon the costumes.

"'I've a skirt that will make me two,' she whispered. 'When I am called to the platform to say my word, please report that I am taken ill.' But when her name was called she forgot all this and made such a rousing speech that no one saw her clothes for all the brightness in her face. How we enjoyed the meeting with other women and trading experiences! They had come from all corners of the earth. They were of every social scale in their other lives, but simply women ranchers when they met together."

The Monday family's experience was pretty typical of the challenges and opportunities for homesteaders during the golden age of American agriculture, just before World War I. It was, as Jeanette has told us, a time when people cooperated

and cared for each other in a way that has often disappeared for many modern Americans.

But the life and lot of a typical farm woman was much more traditional than Jeanette Monday's and a lot like that of many Amish, Mennonite, and modern farm women today. Running a household with a small herd of youngsters was and still is a full-time job that can keep a woman busy from 5 A.M. till midnight with cooking, cleaning, sewing, and child care.

Out in the Orchard in the Fall

One thing that really hasn't changed much at all is the autumn harvest of tree fruit like the apples that farmers have been growing commercially for 200 years and more. It is still done from the top of a ladder, by hand, into bags and buckets, with little difference from the harvest techniques of the distant past. Vast quantities of fruit ripens in September and October, and quite a bit into November. In Florida, Arizona, and California, the citrus harvest will go right through winter. Many thousands of seasonal pickers swarm into the orchards and vineyards to bring in the fruit harvest.

Corn was our primary crop but cutting it by hand was a dreaded chore before the corn binder, then the combine, mechanized the job. *J. C. Allen & Son*

This Amish farmer still uses an International Harvester corn binder to cut the crop on his farm near Jamesport, Missouri.

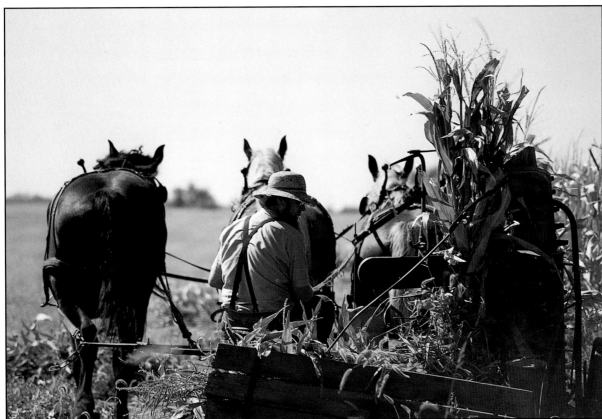

Hauling corn in from the field today with gravity boxes and air-conditioned cabs is a far cry from the horses and wagons of the past.

❦

November Is the Time To:

Pick corn.

Give thanks.

Make an ice well.

Drink sweet cider.

Clean the bull pen.

Mulch strawberries.

Change to winter oil.

Build emergency cribs.

Sell the "ripe" turkeys.

Be careful with that gun.

Put storm sash on windows.

Have cream separator tested.

Butcher a pig—make sausage.

Replace broken ladder rungs.

Put new hasp on granary door.

Quit using open top milk pails.

Put farm machinery under cover.

Eat strawberries from the locker plant.

Invite Aunt Mary's family to come for Thanksgiving dinner.

Farm Journal, November 1940

Cotton Farming

Paul Reno grew up in Oklahoma over 70 years ago, during the 1920s. The family farm was a diversified little place along the Grand River bottom area, near the town of Ketchum. "We grew wheat, corn, barley, flax, cotton, and mung beans," Paul says, "depending on what the weather let you get in."

Cotton was, in the horse and mule days, planted with the same planter used for other crops. Interchangeable plates in the planter mechanized the crop, but the fuzzy cotton seed didn't drop as reliably as corn or other smooth seeds, so it was planted more densely, then thinned by hand, or "chopped."

"Cotton was planted *purty dern thick*," Paul Reno recalls. "Then when it came up and was three or four inches high, the kids had to come along with a narrow hoe with a blade about six inches wide and thinned them to one plant every foot or so in the row. Then we used a cultivator drawn by two

Wheat and oats were harvested by mechanical equipment decades before corn harvesters came along. Here two men are cutting corn by hand, throwing the ears into the header wagons as they walk through the rows. *J. C. Allen & Son*

Corn made great silage, that wonderful animal fodder that kept farm animals going through the winter. The old tractor on the left is belted up to a silage chopper and the chopped material will be sorted in the silo which is attached to the barn. *J. C. Allen & Son*

Brad Thieschaffer's family grows corn south of Council Bluffs, Iowa. He's harvesting the crop all by himself this morning, but the big Case combine gobbles up eight rows at a pass and the field is being cleaned in very short order.

NEXT
Duane Boyd is at the helm of the New Holland combine, with son Leland providing shuttle service to the dryer. The process of transferring the grain from combine to the hopper wagons is called "catching on the fly," and Leland has a lot of flying to do because it is a long way back to the barn.

Fun on the Farm

Bill Vavak is a third-generation American, born and reared near Wahoo, Nebraska. Although his grandparents immigrated during the nineteenth century, Bill grew up in a mostly Czech community, and didn't even speak English until he started school. Amusements for kids on Nebraska farms in the 1920s and 1930s were pretty much home-brewed but probably as much fun and educational as any you'd buy in a store today. As he grew older, card games with his family and weekly dances provided entertainment—pretty much the way they did for millions of Americans at the time.

"We didn't have store-bought toys. I liked to play farmer and had a home-made tractor built from scrap lumber by a neighbor and me. We put four salvaged wheels on it—that was my tractor. I made a toy plow from some scrap metal, and a threshing machine from a packing crate. That threshing machine was really something; our neighbor (an immigrant from Russia) added a crank and pulley arrangement so I actually had power! I had a complete threshing outfit.

"We had a lot of trees down in the creek bottom and we'd cut them for fence posts and sell them to neighbors. That was one way we could get some cash when we weren't busy with other farm work. Two or three of our closest neighbors usually helped, so there would be four or five guys in there working away. My dad was the kind of guy who enjoyed being around his kids and his family and we had a good time—it was fun!

"As I got older I developed friendships with people at church. And we went to dances. We had our little group of friends and we liked to do things together. There was a dance every Saturday night in Brainered, Weston, and Braden. We had a favorite dance band we followed around to these different towns. We'd get together and say, 'Well, where shall we go this week?' And if we went to one dance and didn't like it, we'd hop in the car—my parents car—and go off to the next town. We kinda kept all that running around quiet from the folks!

"Mom and Dad and I played cards at night for entertainment. There were other board games and simple amusements. And we visited with the neighbors within a few miles. One family was just a half mile up the creek—we just walked to their house. When we went over there to play cards at night we came back across the fields by lantern-light." 🍎

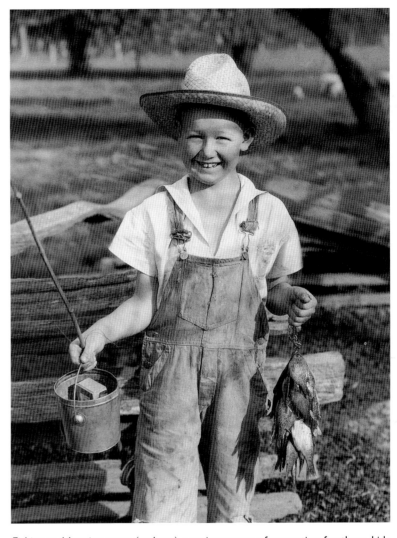

Fishing and hunting were (and are) a major source of recreation for those kids lucky enough to have a good stream or pond on the place, and Mom will fry these up for lunch or dinner. *J. C. Allen & Son*

The steam tractor is providing power to a portable elevator, loading straw to the hay mow. During the winter the farmer will throw forks full of hay or straw into the stalls below, providing clean bedding for the animals. *J. C. Allen & Son*

There are some substantial joys to being a farm kid, and driving the horses is one of them, as celebrated on this John Deere magazine cover of 1922.

mules, the same one used for corn but with different shovels."

Cotton needs good cultivation, and deeper than corn, to thrive. The Reno's little cotton patch was pretty reliable ground and with proper tending and reasonable rainfall, a crop was about ready to pick a few weeks after the kids were back in school.

Picking Cotton

Cotton harvest begins when the plants begin their dormancy, after the first frost. Then, the leaves die and fall off, making access to the open cotton boll—as the pod is called—easier. Attempts to mechanize the picking process had been tried for many years but didn't succeed in a practical machine until the 1950s. Before then, cotton harvest was a job for every member of the family, little kids included, and Paul remembers it well, if not fondly.

"We grew cotton along the creek in a little patch most years, and us kids had to help pick it in the fall. About all I remember of it was hauling that dad-gum cotton sack! There was only one job harder, and that was picking up potatoes. We usually started about the first of Octo-

ber, when the frost knocked the leaves off the plants. We picked after school, on Saturday, and on Sunday, too. Dad and the older brothers, did too. Even the girls! In them days, the girls didn't do much farm work—they were strictly in the house, in the garden and the truck patches. But they helped pick cotton, too! There was a loop on the sack that went over your shoulders, and the bag drug along between your legs as you work up the row. That way you can use both hands to pick. It took me about three hours to fill my old burlap gunny sack. It was one of the few things we kids got money for—a dollar or two for a hundred pounds of cotton." ❦

Putting Food Up

One of the major annual events for the farm household occurs in the fall, the time to put up all those tomatoes, green beans, and cucumbers. That's the time that Mom and the neighbor ladies, along with any kids in range, wage a frontal assault on the bounty of the garden. It doesn't take many tomato plants to produce enough fruit for all the sauce and whole canned tomatoes to feed a family for a year.

YEAR 1922 · THIRD NO. · VOL. XXVII

The FURROW

JOHN DEERE QUALITY GOODS
Sold by
HALL SEED COMPANY
INCORPORATED
VEHICLES—IMPLEMENTS—FERTILIZERS
Preston & Jefferson Sts., LOUISVILLE, KY.

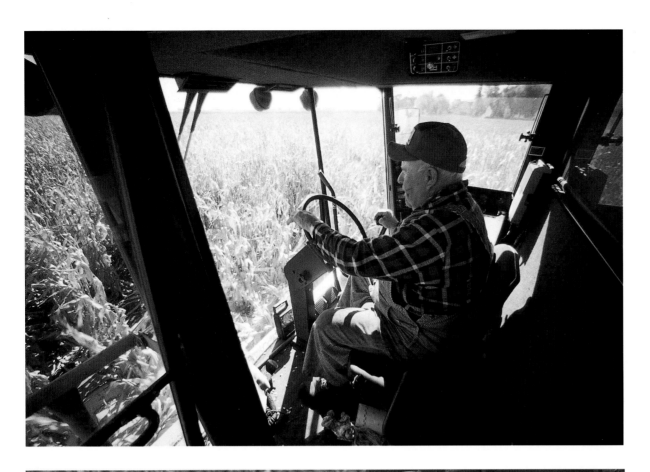

Duane Boyd at the helm of the combine. Duane's family farms 1,200 acres with his brother, Glen, and son, Leland, right down the road from Guy Carpenter. Although Duane is in his seventies and his brother is in his eighties, they still enjoy the business of farming, family style, and still make good money at it.

Payday. Guy Carpenter watches the corn pour out of the grain tank into the waiting hoppers on a cold October afternoon.

Strawberry harvest, Santa Clara County, California. Strawberries have long been a favorite early harvest on American farms but the days when you could put in an acre or so and make money with it are over. Today the harvest is still brought in by hand, although it is frequently done by illegal immigrant labor instead of the farm family, and the acreages are huge.

OPPOSITE
The relatively low height, light ground pressure, and abundance of muscle made crawlers favorites with orchard growers, including apple farmers.

Making apple butter and apple cider was a community project and a lot more fun when several families came to help. Here the apples are being put through a mill to crush them. Then the crushed apples are combined with cinnamon, sugar, and vinegar and slowly cooked to make apple butter. *J. C. Allen & Son*

Pickling is another favorite method for preserving fresh fruit and vegetables. Cucumbers, too, produce a bountiful yield most years and many women put them up as sweet and dill pickles and as relish. But you can make pickles with all sorts of products of the garden, including watermelon rind, and some kinds of meat, too.

Frieda Klancher did plenty of canning and pickling in her life, although that has dropped off since husband, Paul, passed away. As it turns out, he was the one with the passion for pickling:

"We always did a lot of string beans and applesauce, pickled beets and dill pickles and canned corn. My husband was a great one for canning, and he went overboard—100 quarts of applesauce, 100 quarts of blackberries—we gave a lot of it away. How can you use up 100 quarts of applesauce?" ❧

Apples too small or blemished for sale generally end up in cider, vinegar, and applesauce—and there's lots of apples on the ground, even after the trees in the yard yield hundreds for eating fresh or packing carefully in barrels to store in the root cellar where they will keep till Christmas.

Mary Djubenski still makes apple cider on occasion, and remembers putting up quart after quart of cider in the fall:

"We had our own apple trees when I was a kid, and we made cider. We had a press, and made juice from the windfalls. The juice wasn't as clear and pretty as the stuff you get at the store, but, oh, it tasted so sweet! After the first frost, then it was sweet! We'd preserve that, too, by putting the juice in a kettle, bringing it to a boil, then pouring that into quart jars and sealing. We did a lot of that!"

Livestock

A big part of almost every farm is the livestock—the horses, cows, pigs, sheep, chickens, ducks, turkeys, and even Guinea fowl and ostriches bred for sale or for use on the farm. For some farms and farmers, each

Apple Strudel

Strudel dough:
2 cups flour
1 egg
1 tsp. salt
3 tbs. sugar
1 tsp. salt
1/4 tsp. baking powder
1/4 cup salad oil
1/2 cup warm water

Filling:
1 stick melted butter
1 egg, beaten
2 qt. thinly sliced apples
1 1/2 cup sugar
1 cup bread crumbs
1/2 tsp. cinnamon (optional)

Knead dough for about 20 minutes, until soft and pliable. Let dough rest in warm oven for about 1 hour. Roll out paper thin. Stretch dough as thin as possible. Spread on melted butter, then beaten egg. Spread on the apples. Cover with sugar. Add bread crumbs. Sprinkle with cinnamon. Roll up and bake for about 1 hour or until done at 350°.

Do not crowd strudel in pan. Grease pan well before putting in the dough.

Courtesy of Frieda Klancher

Cliff Koster and this tractor both fought in World War II and both still are hard at work. The tractor came up for sale at an auction and required some conversion, but it has been working on the old Koster place for many years.

When the Christian Brothers winery decided to get rid of their very old, but very well maintained, Caterpillar D2 tractors, Bill Garnett snapped one up for his little vineyard operation. It is the perfect machine for doing the fall cultivating, part of the annual cycle for grape growers.

of these could provide a focus for the operation; for most, a few of each was more likely.

Cattle and swine are a huge portion of the American farm scene today, as are dairy cattle, poultry, and—to a much lesser extent—lamb. Technological changes in transportation and marketing have eliminated the huge stockyards at Kansas City, Missouri, and Chicago, Illinois, where live animals were once brought for slaughter and processing. Today, the animals are transported by trucks rather than trains, and often slaughtered at the farm by mobile specialists who then ship the refrigerated carcass.

Farm women once tended small flocks of poultry as a matter of course and money from the eggs and culled birds often paid the farm mortgage during lean times. The farm wife often sold the eggs from a basket, door to door, in towns and villages. Now poultry comes from huge operations, owned by large companies or under contract to them, done on a grand scale. The old way helped keep small family operations in business; the new way makes poultry safer, eggs fresher, and still provides a living to many rural families.

Cattle Country

You can make some money growing corn and beans and alfalfa, but the normal way to make serious money with corn and beans and alfalfa is to turn them all into pork chops, spring lamb, steak, and hamburger. Now, it doesn't always work that way (and beef prices are way down at this writing, after eight years of good prices) but the best way to sell your corn is usually on the hoof, with a feeder operation alongside the corn fields.

The whole western half of the country is pretty much cattle country, one way or another. Sure, there's some corn grown—mostly for fodder, plenty of fruit, field crops, and other crops, but huge sections of Colorado, Wyoming, Nevada, Oregon, Montana, and all the rest of the left side of the map are dedicated to running cattle. If you live in the East or Midwest it is hard to imagine but for hundreds of miles in some states the only agricultural commodity is half-wild cattle grazing the prairie and desert. Sheep are a major crop out this way, too, still tended by Basque shepherds from Spain who live alone in remote parts of Nevada for months at a time. The sheep crop the grass lower than cattle do, and can be hard on the land, but you'll find both grazing on many ranches of the West.

Ducks

Giant expanses of land flooded with herds of cattle are great for cowboys and movie sets, but no matter what anybody else tells you, the very best kind of livestock anybody can raise is ducks. Sure, hogs have less waste, beef and chicken are more in demand, and lots of other stock is easier to bring to market. Ducks, though, are delightful. They (unlike chickens) are intelligent and gregarious. A duck will amble up, look you in the eye, and strike up a conversation. I have never figured out just what they are saying, but it seems well-informed and friendly. A garden-variety duck makes better conversation than most people you meet at cocktail parties or conventions. Ours liked to follow us around companionably, right into the house if they had the chance, keeping up a running monologue on current events, weather, and the state of the world as seen from close to the ground.

Cooking was an art in the days before automatic timers and reliable thermometers. Big kitchen stoves were used to heat the house as well as feed the family. *J. C. Allen & Son*

Leland Boyd scurries off to the dryer with a hopper of fresh-shelled corn. By the time he gets back to the field with the empty hopper, another load will be waiting.

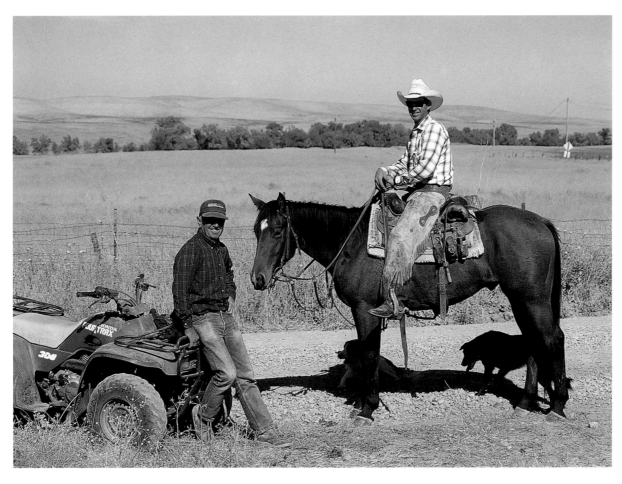

Here's a pioneer family that came, stayed, and made good on the Nebraska prairie. That's Jack Bush with the portrait of the late Mrs. Bush and the kids, with the hired hands at a properly respectful distance in the background. You see them on a summer day in 1903 in front of their prosperous home, complete with windmill. *Solomon D. Butcher Collection—Nebraska State Historical Society*

That's Jim Dunlap on "Little Joe," the wonder horse, and Nicanor Salaverria with his trusty Honda. All of them work for the One Bar Ranch, with help from Nip and Rush, the border collies sensibly resting in the shade supplied by Little Joe. They've just finished bringing some cattle from summer range in Oregon back to the One Bar in Northern California, but part of the modern cattle drive is now done with the help of trucks.

Ducks will clean up those snails and slugs from the garden, devouring them with all the enthusiasm of an epicure. They don't tear things up the way geese do, and they don't leave as much mess, either. Oh, sure, they'll nibble up all your lettuce seedlings if they get a chance, but if you let the plants get established, they'll leave them alone and go after the weeds. They produce lots of eggs—big ones, and tasty. They forage for themselves quite well and grow rather quickly. They are probably the cleanest animal on the farm. And, best of all, sometime in the fall, after a few months of their charming society, you can put them in the pot for dinner—delicious! It's not a kind thing to do to such witty conversationalists, but there's a lesson in that: don't let your livestock become pets. Every farm kid learns that lesson sooner or later.

Doing Chores

The Yoder's children, and those on millions of American farms over the years, have chores suitable to their years. That typically starts with helping care for the poultry, feeding small animals, then graduating to more responsible chores with each new year. John Bird describes his chores on his folks' Kansas farm 70 years ago:

"The first chore for us kids on my dad's farm was watering the chickens. We kept about three hundred hens and their watering pans were under the trees in the yard, in four or five places. You had to go around two or three times a day in the summer to keep those pans filled. The water came from a well, and you drew it with a hand pump. We had no electricity back then—we didn't even have a windmill! So we carried the water in small buckets, and it took a few trips.

"Feeding the hogs was another chore for the kids. Dad would tell us how much corn to feed, and we'd go get it and carry it in buckets to the hog pen. The hogs got plenty of water, too.

"We pumped water for the horses into a stock tank. If Dad came in for dinner from working in the field, it was my job to feed each horse a gallon and a half of oats, with plenty of hay in

Combination stock barn and machine shed, Floyd County, Iowa.

Pops is sitting a spell reading the jokes from the *Farmer's Guide* to his young companion. Most farm papers like this one had a section for children and for farm wives as well as general articles on farm practices. *J. C. Allen & Son*

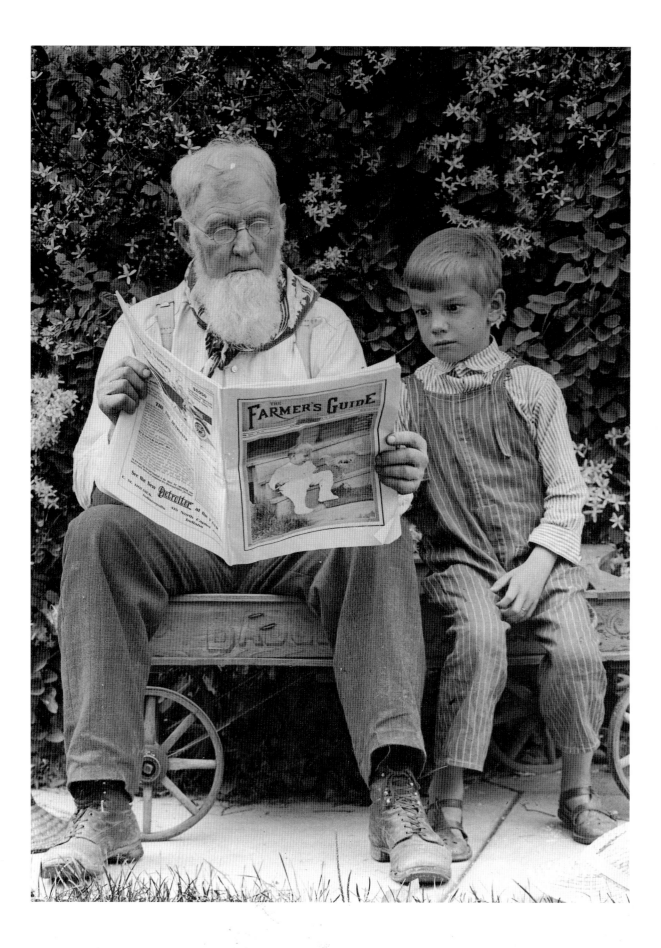

the rack above their stalls. We had to feed them again in the evening, make sure they had clean bedding—and you had to check their feed box, too, because sometimes a hen would get in there and lay an egg! Each horse got another ration of oats—almost two gallons apiece when they were working hard. That would get cut down to half a gallon in the winter, when they weren't working.

"As we got older we'd get to take care of the horses, feeding them, bringing them in from the pasture, and currying them at night. The hair would fly in the spring sometimes, when they'd be shedding their winter coats! If you were out in the field, plowing, and the wind was right you could get a mouthful of hair from them. It was different then than now, but it was natural and normal at the time; we all had the same experience. But it sounds so strange today! Today you push a button, back the tractor up, and away you go for the same job that meant a lot of work back then.

"Personally, I am glad we aren't working the horses any more. I used to feel sorry for them when it was hot. They worked very hard, and sometimes got sores from the collars. They had to pull a heavy load all day long. And some farmers didn't really care for the horses, didn't treat them very well. The horses suffered sometimes. It bothered me, so I was glad when the tractor took over the plowing. If you made the tractor suffer it just cost you money! Now the horses are mostly for show and for pleasure—and that's fine with me!" ❦

Barns

By summer's end stock barns everywhere across the country are filling with forage for the animals—with big bins full of freshly threshed oats, hay mows jammed with aromatic hay, and silos newly filled with fermenting corn silage. The barn is a pleasant place at any time of the year, but particularly in autumn

Most folks like barns, pretty much for the same reasons: they are beautiful in many ways, nearly every way related to a purpose. Barns are

Dairy farms were one of the first agricultural operations to become organized into co-ops, primarily to process the milk efficiently. Milk co-ops were first established more than a century ago. *J. C. Allen & Son*

designed to serve a function, pure and simple, although the function for one may be quite different from another. One old farm cliché is that the farmer is usually housed in a worse structure than his livestock. That is sometimes true. The livestock represents an investment and potential income while the farmer and his family are accustomed to getting by.

The Classic Dairy Barn

Almost everybody is familiar with the appearance of the dairy barn. They are a fixture on farms all over the country, particularly in the East and Midwest. Lovely examples can be found in Oregon and Washington, Ohio and by the tens of thousands in Pennsylvania. All have the same function and the result is a similarity of form.

The barn itself is usually placed at a convenient distance from the farm house, but downwind. The preferred site is on a slight slope that will assist with drainage. Cows and horses produce large volumes of "exhaust" and managing this material is a basic problem for any barn designer.

The ground floor of a stock barn is a carefully contrived set of small compartments, each with traditional dimensions. Most American stock barns from the pre-World War II era were designed for both horses and dairy cows, both of which needed to be attended to twice a day. The cows got one end of the barn, the horses got the other, with somewhat different accommodations for each. The cows, for example, got stalls three feet six inches wide, four feet eight inches deep with a manger at the head for feeding and a gutter at the other end for cleaning up the exhaust. A "feed alley" runs down the middle of the barn, right past the mangers of all the animals, making feeding time convenient. A "litter alley" runs down the outside of the barn, also designed to enhance the convenience of the stable hands.

Horse stalls are typically five feet wide and nine feet deep. Good ventilation is essential in a barn because the ammonia and other fumes from manure can be hard on both the confined animals and their harness, too. That's the function of those pretty little structures on old barns; they are the outlet for exhaust ducts leading up from the ground floor and help pull contaminated air out of the stable. Some barns have tack rooms where harness can be cleaned and stored. Box stalls are also a common fixture, a place for a mare to foal.

The classic stock barn is a tall structure. It is a pretty shape, generally, but that attractiveness is incidental. The height is intended to accommodate a large volume of loose hay, the normal feed for stock during the long winter months when they often don't get on pasture. While even Amish farmers sometimes bale their hay now, 50 years ago the common practice was to fill the upper portion of the barn—the "hay loft" or "hay mow" with the loose hay just as it came from the field. This once required a lot of work with a hay fork, moving the hay in small quantities. Then somebody invented a trolley system, with a rail running along the ridgepole of the barn, that let you hoist a very large volume of hay in a single hoist, position it where you wanted it, and drop it in place. Some systems used a sling to lift the hay, others used a big fork that dropped on the load and snagged it. That made life a lot easier for a lot of hired men and farm boys.

But loose hay takes up a LOT of space, and that's why barns are so big. The hay mow has a chute, normally in the middle of the floor, where hay can be tossed down to the "feed alley" running down the middle of the barn, between the stalls.

A Bull in the Hay Mow

Walt Buescher spent a career selling tractors and implements to farmers, and he picked up this story (and a lot more) along the way. He tells this story about his uncle's attempt to get an independent-minded bull into the back of a truck to go off to slaughter:

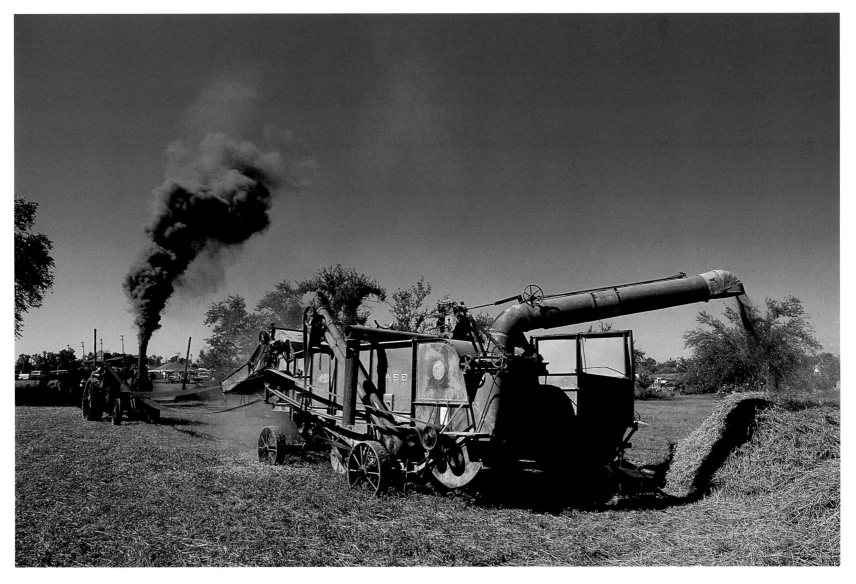

"My first agricultural experience came on my uncle's farm, a half-mile south of town. I was there one day when Uncle Carl was making hay. Farmers had huge barns then that held loose hay. The horses and cows were one level below the barn floor. At hay-making time, the farmer hitched a team of horses to the end of a hay rope. Each wagon held two slings full of hay. The horses pulled these half wagon loads of hay to the ridge pole of the barn. There, the car on a track switched the sling full of hay to either the south hay mow or the mow on the north side of the barn.

"At least those were Jack Annis and Uncle Carl's intentions. The bull had other ideas. He resolutely refused to get into Jack's truck. He must have had a premonition. The bull got the two-by-four treatment and that didn't work. He got the pitchfork treatment and that didn't work, either. He just stood there and bellowed.

"Then Uncle Carl got an idea. He placed a halter on the bull and led him over to the hay making operation. Without fanfare or bodily injury, Uncle Carl placed a hay sling under the bull. The idea was to lift the bull just high enough to slip Jack Annis's truck in under him and let him down. It was a world-class idea, except for one minor detail. The bull had never been airborne before. He was, as are so many human 'fraidy-cats, afraid of flying.

A muscular steam tractor powers up an old Case threshing machine at a fall harvest show in Missouri.

Tractors helped deliver all sorts of crops but this load of cabbages still had to be picked by hand. Even today, mechanical pickers have not been designed for lettuce, cabbages, broccoli and many other row crops. *J. C. Allen & Son*

"When the last of the bull's four hoofs left the ground, that bull let out a beller that chased the pigeons out of the courthouse steeple eight miles away. The outburst scared the horses on the other end of the hay rope, of course. They took off as if they were racing at Churchill Downs. The bull shot to the ridgepole of the barn at the speed of a Cape Canaveral rocket. The hay

car shunted the critter over the south mow where he continued his high-decibel protest.

"He bellered. He kicked. He fought. He struggled. He, uh…you know what bulls do when they're excited. He did that, too. One flailing leg caught the trip rope, and the bull fell into the hay mow. Uncle Carl had something that few North American farmers have or hope to have—a bull in

a hay mow. Advice from visitors came freely. Uncle Carl should have charged admission. This bull in the hay mow was a greater curiosity than a two-headed calf at the county fair.

"One spectator suggested that Uncle Carl pile a bunch of loose hay on the barn floor and push the bull overboard. Another suggestion was, 'Take some boards and make a slide. Slide him out of the hay mow.' Another suggestion was 'Take him down the way you brought him up. Put a set of slings under him.' That's when Uncle Carl blew his stack.' 'You crazy nut! If I got anywhere near the critter with a set of slings, even if he was blindfolded, he would kill me.'

"Two days later, that bull was still up in that hay mow. He was still attracting attention. He had become infamous. His story was on the front page of the *Bremen Inquirer* and on the front page of the second section of the *Plymouth Pilot* and the *South Bend Tribune*. After all the freely offered suggestions were rejected, Uncle Carl told Jack Annis to go up in the hay mow and butcher the bull there instead of out at the slaughter shop. The bull came down in quarters." 🍎

A Roll in the Hay

Hay mows are wonderful places for many things. It is the ideal place for children to have a Tarzan rope swing. As long as there's a supply of loose hay on the floor, you can fall or jump into it in perfect safety—provided the pitchfork isn't hiding in there somewhere. Hay has a nice perfume, a nice color. It is pleasant stuff. Kids can build forts in it, loose or baled. It is a quiet place, a place to be alone. The hay loft is the most likely place on the farm for the kid's first romantic encounter, a traditional role that is another part of the history of the barn. Mom and Dad know all about hay mow encounters, however, and its hard to get all the hay out of your hair, so there are some hazards involved.

The Silo

Fall is time to fill the silo, too. Until around 1900 farmers relied on hay, in the stack or in the barn, and grain from the bin to feed the stock through the long months of late fall, winter, and early spring. Then an old idea suddenly swept the nation's farmers and changed the landscape of the country. Now you'll find nice pre-Revolutionary New England barns from the early 1700s with 1900-era silos attached, and similar additions to all kinds of barns in all corners of the country.

If you take the whole corn plant, chop it, and place it in an air-tight container (the silo, for example) the sugars in the plant, the moisture, and the oxygen in the air within the mixture will cause a fermentation. The result is a lot of carbon dioxide, a bit of acetic acid (the kind in vinegar), and a lot of perfectly preserved animal feed. Cows love the stuff because it tastes great—and is less filling. Farmers like it because it uses the whole plant rather than just the kernels of corn; nothing goes to waste. And not only do livestock love the stuff, they get fat on it.

The idea is as popular as ever but you will see plenty of silos in decay, ready to fall over and empty to the sky. Instead of filling the silo now, many farmers use huge plastic bags for their silage; it works just as well, doesn't require maintenance, and makes feeding easier for some farmers.

As fall draws to a close, the silo is filled, the barn stuffed with hay, and the grain bins and corn cribs are overflowing. Apples have been picked, pickled, and squeezed into cider. Fruits, vegetables, and cotton have been harvested, and tobacco is drying in the barn. Pantry shelves are groaning under the burden of canned fruits, vegetables, and meats, and the cellar is packed with potatoes, onions, and smoked sausage and hams.

The leaves turned from green to an autumn tapestry to bare, and Indian Summer gives way as winter bares its teeth. At Thanksgiving time, farm families across the country are treated to a harvest of their own, with platters of food celebrating the passage of another fall. Winter is on the way.

Winter

By early December, winter has settled in to stay on Pat McRaith's old home place in Minnesota. The cows' breath produces clouds of vapor, even in the barn, at early milking. The ground across almost all of the northern tier of states is frozen, even before the calendar proclaims the arrival of winter.

Winter on the calendar is just another three months, starting on the 21st of December and lasting till the third week in March, but to most American farmers it is an unpredictable, dreaded time, full of hazard and uncertainty. The first snowfall can come early, and catch your stock unprotected in the high pastures, or it can come late. The first rains of winter in the West can be gentle and refreshing after the long annual dry spell, or they can hit you like a fire hose. You never know what will happen. But the work of the farm never stops; there is wood to cut and fence to mend and machines to maintain and kids to get to school. The new lambs will soon start to drop, and you'd better be ready for all the calves and foals and shoats that will start arriving soon enough.

Kids still have to get to school, although it is harder in winter most places in rural America. In the past farm boys and girls walked to school, in rain or snow; now they take the bus but it can still take an hour

A farm in Bethlehem, Connecticut, in February. *Howard Ande*

❧

December Is the Time To:
Chop wood.
Haul bedding.
Read Matthew 5:1-12.
Tarry under the mistletoe.
Keep clean litter in laying houses.
Make a start at those bad weather jobs.
See if you can beat Shorty
at playing "Scrabble."
Order repair parts.
Get your Santa Claus suit out and see if
it still fits…or if Mom will have
to let out some seams.
Farm Journal, December 1953

to get there, and the trip can be even more hazardous today, with icy roads and washed-out bridges.

Winter is wood-cutting time, just as in the past. Chain saws and hydraulic splitters make the job a little easier today, or at least faster, but it is still hard work.

Winter on the farm, 50 or 100 years ago, was a time to butcher pigs and put up meat; it still is today although it goes in the freezer instead of the smokehouse. It was, and is, a time to enjoy antelope chili, or venison stew, or—if you've been good—a steak from a young moose taken from those swamps along the creek in your "lower forty."

Winter is a fallow time, today as much as ever, and a culling time for stock and sometimes for people. The winter takes its toll on the very young and the very old. Despite many changes on the American family farm over the years, winter is as much of a challenge today as it was at the turn of the last century.

Ruth and Milton Good's farm in east-central Ohio is pretty typical of dairy operations around the country, particularly in the Midwest. The first snow of winter usually comes to their farm after Thanksgiving, a beautiful warning of things to come.

Milton watches the first flakes of an approaching storm float past the yard light on the way in to the house after evening milking. It is early December and bitterly cold outside the barn. At least the cows provide some

This happy farmer doubtless considers himself well-blessed, despite the cold, snowy day. That's because his mail comes right to the end of his lane, now, rather than to the post office in the village a few miles down that road. Rural Free Delivery (RFD) was one of many improvements to farm life introduced in the years before World War II. Electrification was another, but there are still plenty of places in rural America where you still have to go to town for your mail, and a few where the wires still don't go. *Library of Congress*

Pat McRaith repairs the horse collar, and little Jerry studies the work on a cold February morning in 1942. Pat still operates that same farm in northern Minnesota, although he is in his eighties now, and the horses have long since been retired. Jerry must have liked the job—he went into the hardware business. Winter was, and still is, a time to work in the barn, fixing things and waiting for spring. *John Vashon/Farm Security Administration—Library of Congress*

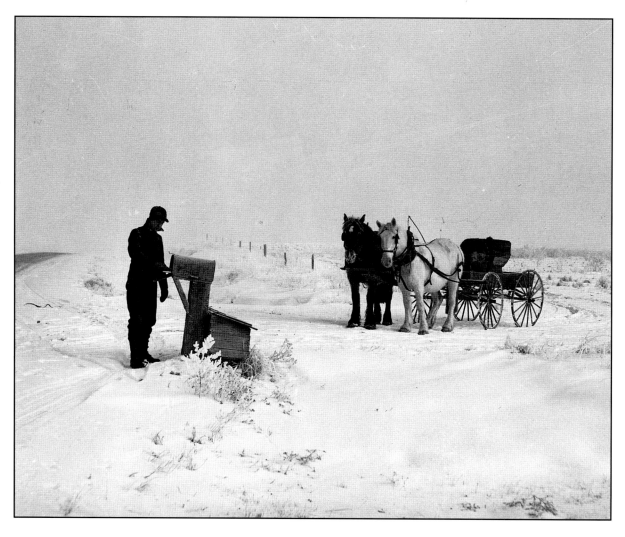

warmth, and a milking parlor full of them can be downright toasty. Milton, Richard, and Karen slip in the side door by the kitchen. Ruth and Jean have supper ready and on the table while the milkers peel off their heavy coats and wash up. Everybody sits at the big table in the kitchen and bow their heads. "*We thank thee, O Lord...*" Milton begins the grace, the way he always does.

Snow falls all night. It is still falling when Jean, Benjamin, and Irvin step out the side door just before six the next morning and crunch their way across the yard to the barn and morning milking. After breakfast, Milton fires up the tractor with the plow mounted on it, then clears the lane out to the county road. It keeps falling after he gets back. The radio reports a snow emergency, but the milk truck still manages to arrive for the routine pickup. School is canceled and Irvin stays home. Milton tries clearing the lane again late in the morning. Another four

inches have accumulated, with no signs of the storm slackening. By the time he's done Milton wonders why he bothered because snow continues to accumulate. The family spend the afternoon quietly, reading and writing letters. Some of the kids do schoolwork. Richard and Ben putter in the barn. At six the milking begins again, at eight-thirty, the cleanup is done. Snow still falls, drifting through the light in the yard.

By morning the storm is finally spent and the day dawns clear and sparkling white. Eighteen inches of snow cover the ground, the barns, the sheds, and the few machines still outside. But the county has the road plowed and sanded, schools are open again, and the routine returns to normal.

Chore Time Across America

Winter might be a fallow time for many farmers and their stock, but there are still plenty of

chores for everybody and some are much harder to do in winter than in the warmer months of the year. Even the simple act of providing water for the home or for the animals was—and sometimes still is—a challenge when the pump froze up and the stock pond iced over. About the best thing any farm kid can say about winter chores like hauling water is that it "built character."

Farm houses were often uninsulated, drafty structures with a cast-iron stove in the kitchen for cooking and heat. The fire in that stove was, and often still is, fueled with wood grown on the farm. Cutting the wood for the stove was another important winter chore, usually assigned to one of the elder boys. Today it is commonly done with a chain saw and hydraulic splitter but in our grandparent's day it was with ax, buck saw, sledge, and wedges.

Until World War II it was quite normal across rural America for farm houses to be heated with wood or corn cobs, and it still isn't unusual in many parts of the country. Consequently, a routine developed to supply fuel for the stove, another winter chore that could be anticipated by the menfolk of the farm household.

Trees felled in springtime, or by storms, would be dry and ready for cutting six or eight months later, in winter. Although the legend features the ax for this chore, it is an inefficient and slow tool for cutting wood into stove lengths; for that you want a saw. One hundred years ago that would be a big, beefy one- or two-man crosscut saw with teeth two or three inches in length for big logs, and the smaller "buck saw" for logs about twelve inches in diameter or smaller. Then, with the introduction of the steam engine and tractor, portable sawmills took over some of the work. With a three-foot circular saw belted up to your Avery steamer or even a Model T with a pulley attached to a rear wheel you could cut many cords of wood in a day. The wood still needs to be split, but that's what teenage boys are for—it builds character, and muscles, too. Once the trees are a big pile of fourteen-inch logs the wood is much more manageable. That hasn't changed a bit.

John Slauter's family had a wood lot on their Iowa farm, as most farmers did in the 1920s and still do in the 1990s. As a boy he helped with the winter wood cutting, and the daily splitting of the logs for fuel year round. Wood cutting was a

This radiant creature is Miss Elaine McRaith, Pat's niece, and they are both doing the morning milking on a frigid Minnesota winter morning over half a century ago. They milk the old, traditional way, by hand, although mechanical milkers had been in common use since 1920. Some farmers with small herds, particularly in Amish communities, still milk this way. *John Vashon/Farm Security Administration—Library of Congress*

Two kittens patrol aggressively while the young hired man transfers the milk from pail to can. Although not a problem on this February morning, rapid cooling of the raw milk to reduce bacterial contamination was an important part of the process. The McRaiths, along with most other American dairy farmers half a century ago, could expect to get about a penny per pound of milk—if the bacterial count was low and the butterfat content was normal. *John Vashon/Farm Security Administration—Library of Congress*

Winter closes in on the Fall River valley in November, with early storms coating the peaks standing sentinel around the old farms and ranches.

social event in John's youth, a time when the neighbors assembled for a day of shared labor on each farm. It was a day of hard work, and fun. Here's what John says about winter wood cutting and his routine chores:

"Mother cooked and heated the house with a cast iron stove. Corn cobs and wood from our farm fueled the stove. My father and I went into the timber on the place every spring and cut down a substantial number of trees. Those trees lay out there all summer, drying, then in the fall we took the horses and pulled those logs out and piled them by the house. Every farmer in the neighborhood did the same thing, then we all got together with a buzz saw for a wood-sawing day. That happened twice during the winter. Then you'd have a big pile of logs in short lengths. After that, it was my job every day after school, to split wood. I really enjoyed that! If the wood was dry and the ax was sharp and you knew how to do it, you could split those logs nice and easy. I'd split all the wood we'd need for the evening and stack it on the back porch, night after night. That was one of my chores.

"Saturdays my chores expanded to cleaning out the hog shed, horse barn, and the cow manure that had added up all week. I pitched that on our flatbed wagon, then took it to the field where we pitched it off by hand— in the days before we got a manure spreader, a happy day for us all. Water came from a well outside, pumped by hand and carried in a bucket. No matter how cold it might be, it was my chore to keep my mother supplied with fresh water." ❧

For John and thousands of farm kids like him, chore time started early in the morning,

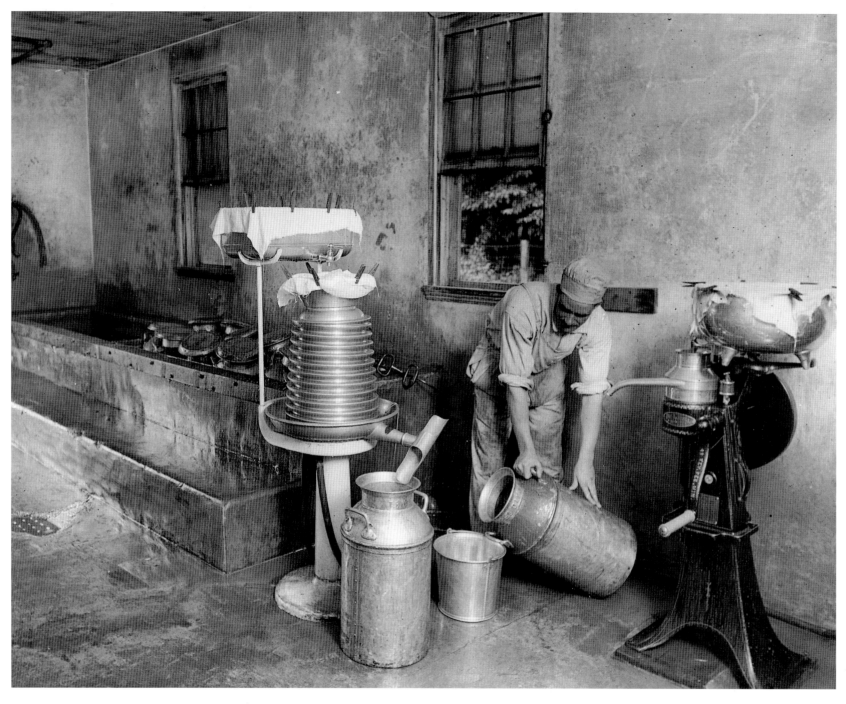

The local co-op creamery could afford the fancy new cream separators; they were too expensive for most farmers. Here the large milk cans from the farmers are cooled, opened and readied for processing. *J. C. Allen & Son*

even for the youngest children. Frieda Klancher recalls starting her days with the sun, even when she was just a little kid:

"My family had a dairy farm, and we all had to help out. By the time I was five years old I was expected to be in the barn at five, morning and evening, to help with the milking. We milked by hand then, and everybody had to pitch in." ❧

Mary Djubenski also recalls starting chores early, and going barefoot as well:

"I grew up on a dairy farm, and there was never any time to be idle. You learned to milk at the age of six, and started helping then. You'd get hit in the head by the cow's tail a lot. And we went barefoot, too, and when that cow stepped on your toes—ouch! We cultivated corn, not just in the garden, but out in the field,

too. But I survived everything—I am eighty years old now!" ❦

One good things about growing corn, you could usually talk the folks into growing a row or two of popcorn. This little group is stringing popcorn in decorative garlands. Kernels that broke were eaten! *J. C. Allen & Son*

Cutting Ice

Every farm in the northern part of the country, and anywhere else where it was practical, had an ice house across from the kitchen in the days before electricity arrived. The refrigerator then was a wooden box, well insulated with sawdust, kept cold by a big block of ice. Many American homes, on and off the farm, used block ice for preserving food well into the 1950s. While urban dwellers bought their ice from a delivery man, farmers made their own in winter.

As long as you had a good-sized pond and the water froze solid to a thickness of ten inches or so, you could have ice for your lemonade right into September. Again, this was a chore your neighbors would likely help with, and on a frigid January day they'd gather to put up ice. The usual technique involves using a horse (shod with caulked shoes to

Winter can be harsh or mild, depending on where you live in rural America, but if you're a kid you can expect to be in school regardless. These kids are enjoying recess on a crisp, breezy day on the Great Plains. Little one- and two-room schools like District 112 were often built and operated without tax moneys, the land donated by a farmer and the building put up with volunteer labor and contributions. The teacher, normally an unmarried woman, was paid $65 to $100 per month, depending on her experience and the affluence of the farm families who sent their children to the school. *Library of Congress*

January Is the Time To:

Pop corn.

Crack nuts.

Grind the ax.

Pay the doctor's bill.

Study the farm business.

Start keeping farm accounts.

Put a new wick in the lantern.

Clean the trap of the kitchen sink.

Disinfect dairy utensils thoroughly.

Get new rubber for the
milking machine.

Buy baby chicks for June-laying pullets.

Let Dobbin stretch the tugs—
exercise, you know.

Tell your neighbor that last
funny story you heard.

Run corncobs through hammer mill
for baby chick litter.

Go to the locker plant and make
a list of all the food you have stored.

Ask your wife how long it
has been since she visited her sister's
family in Indiana.

Farm Journal, January 1940

The Pine Hill Farm near Burlington, Connecticut. *Howard Ande*

The one-room school was often another part of the farm experience, although not all were *this* small. *J. C. Allen & Son*

OPPOSITE
Winter in Wisconsin, where the dairy farm family's routine goes on pretty much as during the rest of the year. Between the chores, though, you can zoom around on your snowmobile or glide through the woods on cross-country skis. *Dave Rogers*

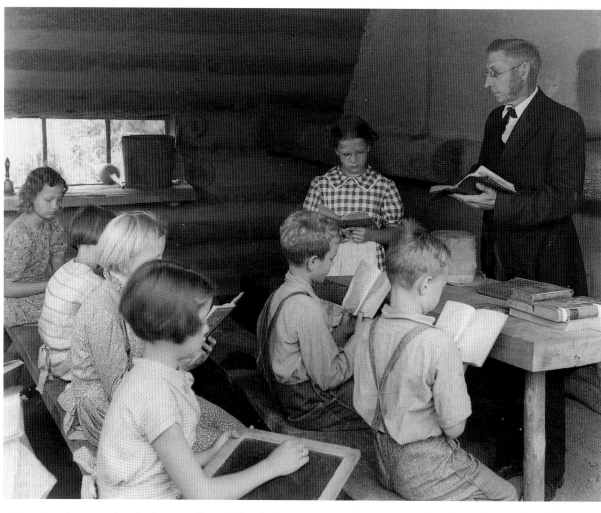

Church was, and often still is, the foundation for the farm family and the farm community. Sunday services at simple little churches like this one in Alabama, recorded by Walker Evans in 1936, provided tremendous comfort and reassurance to people struggling with survival. *Walker Evans/Farm Security Administration Collection—Library of Congress*

allow traction on the ice) to pull a little sled equipped with two special saw blades. These blades cut into the ice to a depth of four inches or so, providing a fracture line rather than going all the way through. Another, harder, way is to cut the blocks by hand, with a big coarse-toothed saw designed for the job, going all the way through.

Once the ice is scored it is a simple job to break it into blocks. Those are fished out with poles and hooks, then loaded on a sled. If you store these blocks in a simple shed, even one without any insu-

The corn cribs are full from a good harvest and the cows have been allowed out to look around but they won't find much grass on the pasture. *Dave Rogers*

lation, and cover with a thick layer of sawdust, you can keep the ice for many months without excessive loss. Many farms, particularly in New England, installed special ice houses specifically for this storage function. If the walls of the structure were insulated in addition to the sawdust covering the blocks you'd lose even less.

Morning Chores on the Good Farm

The first day of winter on the Good family farm begins, as every day does, at 6 A.M. with the first milking, a chore now assigned to the four unmarried children who share the responsibility in rotation. Actually, the whole Good family is up and working by six, summer and winter; Ruth and one of the girls will start breakfast while the other five are out in the barn.

On this first day of winter, Richard and Benjamin—both in their twenties and out of school—handle the milking. That begins with purging the automatic milking system with disinfectant, then the first six cows are admitted to the milking parlor. Each udder is washed and the milking machine attached. While some of their neighbors use computerized systems that automate almost the entire process—and while other neighbors still milk entirely by hand—the Good family uses the most standard milking technology, a vacuum system that reduces the work load to a reasonable level. Even so, milking 75 cows takes two hours, plus another half hour for clean up.

Breakfast for the cows is served by father Milton Good this morning, a nice helping of silage for each cow after milking. Silage, in case you

don't feed cows, is the stuff in all those silos you see next to barns. It is normally hay or corn that has been chopped, mixed, and packed in the silo shortly after it is cut. The moisture in the plant allows fermentation to occur, and acids are formed that "pickle" the plant material. The result of which is a form of animal feed with a sweet, tart flavor cows and horses usually relish. The silo acts like a big tin can, keeping the air from the silage. It will remain fresh and tasty for years, an important feature in places like eastern Ohio where the growing season is only six months long. Today's feeding was cut more than a year ago. The cows pitch in with obvious pleasure.

Feeding the cows is a lot easier now than in Milton's grandfather's day when the silage had to be chopped from the silo and carried with a pitchfork to the troughs. Today, Milton flips a switch and an auger removes the morning ration direct from the silo to the feed troughs without any physical labor.

Breakfast for the Good clan is served only after the morning chores are completed, with vast

quantities of pancakes, eggs, sausage, and coffee—with plenty of fresh butter and milk. The family consumes about a gallon of milk every day, and when they run out nobody has to go to the store. One of the family says grace before the meal; Milton reads a passage from the Bible afterward. Then everybody gets back to work or off to school.

School Days

Winter is the one part of the year children could most easily be spared from their farm labors for the luxury of learning, normally in a one-room school serving a few families within walking distance. But walking distance could be quite a ways and a hike of four or five miles wasn't uncommon. It wasn't uncommon, either, for kids to board with a family in town during the week while attending school and return to the farm on weekends, walking both ways or sometimes riding a horse. And that's still the way it is done in Amish communities, where you'll find one-room schools with horses tied to a hitching post outside.

That legendary one-room schoolhouse was a fixture in every agricultural section of the

After the harvest, after the grain is sold and paid for, the farm family visits the village store to settle up the account. The storekeeper usually offered credit to farmers, and farmers usually were good about paying their debts after the harvest, particularly if they expected to charge things during the next year. Little country stores like this still exist, with a little of everything—flour, dishes, kerosene lamps, replacement handles for tools, canned goods, ammunition, and soap. *Walker Evans/Farm Security Administration Collection—Library of Congress*

"Old-timers" we called them, and they usually had an opinion whether you asked for it or not. The stove sat in the middle of the store, providing heat for the entire room. Shelves in this store have many familiar products: Lava soap, Brillo pads, and Drano are recognizable containers. Lounging and socializing at the village store was a common activity in rural areas. *J. C. Allen & Son*

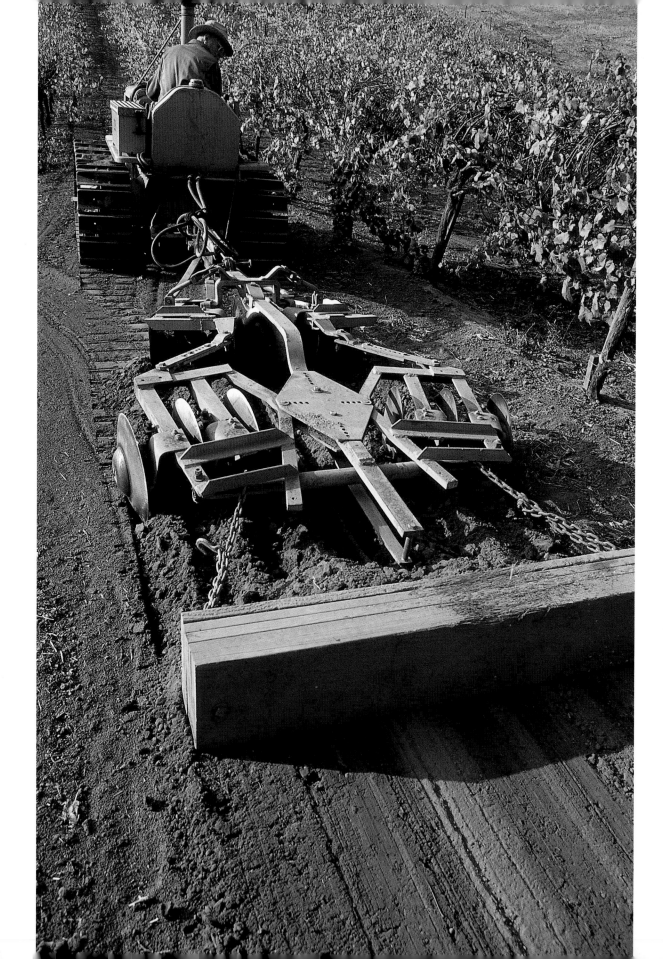

Not all farmers have to deal with snow. Early in winter, before the rains begin, grape growers disc the vineyards to capture moisture for the following year.

country until the consolidated school districts and yellow school busses finally replaced nearly all of them in the 1950s, although a few still survive and function in the traditional way.

The whole issue of education was regarded with a certain amount of suspicion by American farmers of the past, although most embrace advanced education now. Many considered a lot of it a waste of time and effort. Kids often provided an important source of labor on the farm, particularly in summer, and our school year still makes children available for help with the summer harvest by providing a long vacation during those months. Amish families maintain this old tradition by limiting schooling to eight years, and by schooling their children in small,

one-room schools just like those common everywhere in the 1930s.

Those schools could be cold, drafty, and sometimes chaotic. The teachers were often young, untrained, and unable to control a small mob of children who probably ranged in age from 5 to 15. Those older kids could, and did, intimidate some teachers and make life miserable for the teacher and the whole class. Bill Vavak attended three one-room rural Nebraska schools as a child in the 1920s and 1930s. He and his wife went to the same school, over 60 years ago, and both remember these schools with mixed feelings.

"I attended three one-room country schools as a child, and two of them were on top of hills. Let me tell you, it BLEW up there! It was a simple

Late winter, while the snow lies thick on the ground across most of rural America, is when the cycle of the seasons begins anew, starting in Arizona, Florida, and California. The fruit trees start to blossom in February, the days begin to lengthen, and it is time to get out in the orchard with the old tractor again, to disc under the weeds and start the work of another year.

How To Milk A Cow

There are two ways to milk a cow, by hand or with a milking machine. They both take about the same amount of time, but you can keep your fingers warmer on chilly winter mornings with the first method.

The cow knows what the routine is, and she's resigned to the experience. She has reconciled herself to the necessity of having you toying with her extremities before breakfast and dinner, just one of life's indignities if you are a cow.

She will find her stanchion and start in on her ration of silage while you pull up the milking stool— on the right side only, if you know what's good for you! With a pail of warm water and disinfectant, wash the udder thoroughly. Then move on to the next cow while the disinfectant works, a period between one and five minutes.

Now comes the tricky part: countless beginners have tormented regiments of poor cows by pulling on the poor animal's teats. It looks like a technique that should work, but it doesn't. You must use your hand the way the calf uses its mouth; your thumb and forefinger close off the teat up at the top, at the udder, then your other three fingers can apply pressure to the little bag of milk, squirting it out into the pail (or the kitten pestering you for a drink). It takes some practice but anybody can do it.

It takes about 10 minutes, on average, to milk a cow by hand or machine. An Amish cow barn, like Eli Herschbergers, at milking time, though, is a much quieter, more peaceful place than a modern milking parlor. The milkers chat and visit in low voices while the cows munch breakfast or supper. You can hear the *swish* of the milk squirting into the pail and the mewing of impatient kittens. It can be a pleasant time – if the cows don't try to kick you.

The modern operation is noisy by comparison. There are more cows, the vacuum system that powers the milkers makes a little racket, there are pumps going in the background. The basic process is the same: wash the udders, allow the disinfectant to work, attach the milkers. It still takes about 10 minutes per cow. Your fingers get colder. The cow still has to put up with it to get breakfast. And the cat is pretty much out of luck.

Kitty has come out to supervise, hoping that a stream of milk will be directed her way, as it surely will. This cow must be extremely reliable and gentle because one twitch or tail swish could easily knock over the milk pail or the farmer. *J. C. Allen & Son*

Small, simple little cabins like this were home to millions of American farm families during pioneer times. Frances Benjamin Johnston found these folks still getting along with this little house, with its hand-split shingles, long after most pioneer homes had been abandoned. *Frances Benjamin Johnston— Library of Congress*

building, without any insulation and with a single layer of boards for the walls. There was a big pot-bellied stove in the middle of the room, for heating, and on cold mornings we were allowed to sit close to the stove to keep warm. The big boys carried in the fuel— coal and kindling— and the fire usually had to be started fresh each morning; that first hour in that big one-room schoolhouse was cold. If your desk was over by the window, it was cold! The country school was a kind of life city kids couldn't imagine today. It was very enjoyable. Everybody in the school was like a family, and with as many as thirty kids or as few as ten. The bigger ones helped the younger kids. But on the school ground, teacher was boss! If there was a problem, the school board and the parents backed up the teacher. You didn't go home complaining about Teacher.

"When I started school I didn't know any English at all; we only spoke Czech at home. That was true of most of the kids in that section; we didn't learn English until we started school.

Finally, the teacher laid down a rule that we could only speak English at school; if we got caught talking Czech we had to stay after school. Of course she was Czech, too, and I remember her sitting me on her lap that first day of school and explaining things to me in Czech.

"When it was time to leave and go home for the day, the teacher told us to get our warm clothes on. Then we returned to our desks to be dismissed in an orderly fashion. When we were quiet and ready she would first say, 'Turn' – that meant you turned to the aisle, moved your feet from under the desk...then, 'Rise,' then you stood up...and when she said, 'Pass,' you walked out of school in order, without running. But as soon as we got outside, we yelled and whooped and made a lot of racket! We were free!

"But the teachers we got didn't have much training, and their ability varied a lot. The school boards always wanted to hire ones with some experience, but sometimes they had to settle for ones with none. The teacher had to

Early winter, before the heavy snow flies, is traditionally a time to hunt pheasants and waterfowl, to relax a bit from the long days and nights of harvest season, and to prepare for the approaching ordeal. *Dave Rogers*

Only in winter could many families travel far or fast. Ice and snow on the roads made it easy for a horse or team to pull a sleigh. Since many farm operations were closed down by cold weather, winter was the best time to socialize with friends and neighbors or run into town. *J. C. Allen & Son*

have control of the kids— if she didn't, she was in trouble! Some of us eighth grade boys were big, tough lads, and at one point we got a teacher we could intimidate. The big boys ruled the school that year! We made that poor teacher's life miserable.

"Well, the board got rid of that teacher and hired another—paid her $90 a month, up from the $65 the earlier one earned. The first day of school, five of us had to stay after class. The first day of school was normally a "honeymoon" day, but not with THAT teacher. She was going to be the boss, and within a week we knew she wasn't going to put up with any nonsense. And, we liked her. We would do anything for her after that!

This farmer has shocked his corn in the traditional way, rather than shell it with a combine or chop it for silage. Now, during the long fallow time, it can be shucked by hand or run through a stationary sheller, the old method of preparing the crop for use. *Dave Rogers*

"In fact, I remember her throwing one boy out of the school—physically! There were five steps up to the room, and he didn't touch one of them! She threw open the door, grabbed that kid, and he hit the ground like a brick! You couldn't do that today, but that guy learned, and he behaved after that. She meant what she said, and enforced it. And the school board backed her up, too." ❦

A good education for a kid in a farm family has traditionally included basic mathematics, some history, a bit of literature, and simple written composition, the traditional "three R's" of reading, 'riting, and 'rithmatic. Eight years was considered a quite generous amount of time to produce the desired results and very few kids went past eighth grade. In 1925 only about one child in four attended high school. The rest went to work.

"We walked about a mile and a half to our little country school. The snow was so deep sometimes that Dad would hitch up the team of old gray mares to the sled and take us to school. The snow sometimes froze so hard that we could travel across country, over fences and everything, and the horses didn't break through the crust." ❧

One-room schools had some virtues but once roads improved and school busses made it practical, most rural districts built schools in town to consolidate all the little local schools. Many kids still had to walk to school, and it was still common for children to board in town during the school week and come home on weekends—the school was just farther away now than before. It still works that way in parts of the rural southwest, particularly on tribal lands in Arizona where kids board during the week even today. Frieda Klancher of Willard, Wisconsin, walked to school as a kid, and remembers a day she just about didn't make it home:

"When I went to first grade I had to walk at least three miles to school. At that time, the first and second graders were dismissed a half-hour earlier than the older kids. One winter day, two boys and I started for home, and we took a shortcut across country. At one point I decided to follow the road while the boys went across a pasture. I was going up a hill and got stuck in a snowdrift—up to my neck, and I couldn't move! Well, my dad hauled pulp wood to town that day, and on his way back he heard some whining noise. He stopped the horses and found me about nine at night. I had been there since about four in the afternoon. My mother hadn't worried because she had an arrangement with a friend that if the weather got bad I would stay overnight at her house, and that's what she assumed had happened. She went wild when she found out what happened!" ❧

While most kids commute to school daily, a growing trend in farm families today is to home school, either independently or as part of a program offered by local school districts. That is really the most practical alternative for ranch families in places like eastern Nevada, where school bus routes can be 100 miles long, morning and evening, through areas where houses are 10 miles apart.

Food on the Farm

If autumn was a good time for canning and preserving the flood of tomatoes, beans, peas, and apples that the typical farm garden provided, winter was the time for butchering and for sugaring. Prime an old-timer a little and you might hear of the delights of home cured and smoked hams that might spend five years in the smokehouse, or pickled pigs' feet, or home-canned chicken or beef.

Early telephones were not for chit-chat; you frequently had to holler to make yourself heard. To talk with anyone you had to turn the crank on the side and alert the local Operator. When she answered you told her who you wanted to talk with and she connected the wires at her switchboard. *J. C. Allen & Son*

As John Slauter explains, "We had about fifteen dairy cows and raised two batches of about forty hogs each year. My mother had a hen house and raised chickens. Butchering was a winter activity on our place and around the neighborhood. Three or four other farm families nearby would meet to share the labor, going from one farm to the next. Everything we ate was grown on that farm!" And that's how it worked on most places back then, and some yet today.

In the past you either provided for yourself by preserving the bounty of the land, or you went hungry. Running off to the store to pick up something for dinner was not an option for most American family farmers until quite recently. So the family farm yearly routine normally involved plenty of winter work "putting up" food for the following year, primarily meat but also "homegrown" sugar.

The meat—wild game or farm-raised animals—typically got canned and smoked. Canning is a good way to preserve food, but the cans and jars cost money; smoking doesn't have to cost a dime. But before you can hang those hams and big slabs

Ice is starting to form on the stock pond. No more fishing for this year, but in a month or so you'll be able to skate on it. In the meantime, the duck season opens and the geese who've been feeding on the fields all spring, summer, and fall are now fair game themselves.
Dave Rogers

The kids have finally talked the folks into a little recreational ice-skating on the stock pond. Surprisingly there was more time for family activities in the winter than in the summer. Winter was often a time of hibernation, but on a sunny day everybody might go skating.
J. C. Allen & Son

of bacon in the smokehouse, you've got to get them away from Mr. Pig.

Frozen Food in the Good Old Days

One of the ways a family might preserve food during the winter was the simple expedient of leaving it outside. This is guaranteed to prove effective in many parts of Vermont, Montana, and other portions of rural America from November to March on most days. The food could be hung in a shed, in a root cellar, or—as the Slauter family liked to do—hung out on the clothesline. John recalls, "My dad liked to trap and hunt. That was a major wintertime activity and he usually had some wild game hung up on Mom's clothesline out behind the house. That kept the game out of reach of the dogs or any varmints that might be around. Mom would go get one of these from the "freezer" and fry us up a big fat rabbit!

Butchering Hogs

Winter is butchering time, the end of the cycle of life. Just about every farm family had a hog or two selected for personal use, to be kept and butchered for sausage, ham, bacon, and lard to supply the household during the following year. You'll still find a smokehouse on the Koster place, and a scalding tub on Bill Toms' little Virginia farm. In fact, you'll still find packages of curing salt in many rural stores for the people who still "put up" pork the old way.

Hogs give back more of their weight than any other meat animal, about 80 percent of live weight, and they gain that weight with an appetite that isn't real fussy. Got some blemished or windfall apples? Feed 'em to the hogs. Table scraps, worm-eaten cabbages, wilted lettuce, a bumper crop of turnips when the market goes to hell – your pigs will thank you for them all, with a snort and another couple of pounds on that round, solid carcass.

While hogs yield a lot of meat, some of that is fat. That was one of the virtues of pork in the past because it made the curing process more successful than with other meats, keeping the lean part from hardening and adding flavor. Pork was the most popular meat in the United States during the early years of the century, since displaced by chicken and beef. But you don't hear much about people canning, smoking or curing chicken or beef for

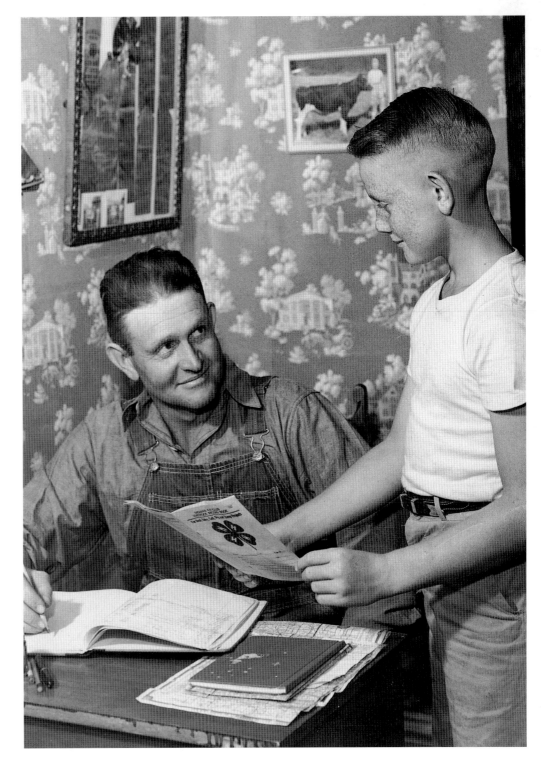

home use; they just don't work as well as pork, and for preserving them you really need a big freezer.

In the days before refrigeration the family could expect to eat the most perishable cuts immediately, and everything else went into brine, the smokehouse, and canning jars. The extra fat made

Four-H Clubs were a good way for youngsters to learn farm practices. Raising a calf or a lamb as a Four-H project and then showing it at the county fair started many farm children on the way to their own farming career. The four Hs stand for "head, heart, health and hand." *J. C. Allen & Son*

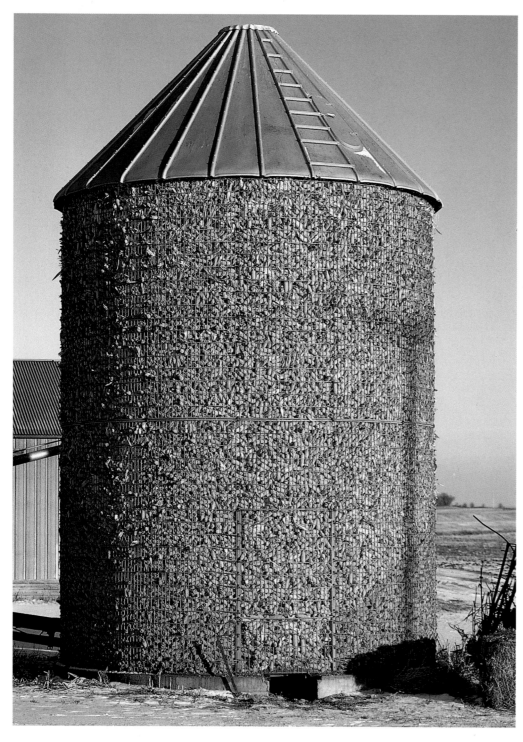

When city folks think of important farm crops wheat comes first to mind. But farmers know that corn is king of them all, the stuff that puts the meat on the hogs and cattle and the money in the bank. *Howard Ande*

"We usually killed and butchered two or three hogs. We shot them, then bled them. Then they went into a big barrel of hot water. You've got to scald them to get the hair off. Then they'd get hung in the barn by a block and tackle, cooling over night.

"We split them then, and hung them in the cellar for the women to 'work up.' I remember as a very little child this was a spooky experience to have those carcasses hung in the basement overnight. We sat in bed, on those cold winter nights, thinking about those cold dead hogs hanging in the basement.

"But then the women got together and went to work. They rendered the lard, ground the sausage, and cold-packed the meat in jars. I still yearn for that taste yet; we don't have anything quite like it now. And of course they smoked the hams and the shoulders, rubbed salt into the meat so it would keep." ❧

There is an art to smoking meat and people who do it well have always been locally famous. The Smithfield ham of Virginia is one example, available commercially today across the country. But many farmers experimented with ways to improve the flavor and keeping qualities of their smoked meats, by controlling the ration fed to the hogs, by the seasoning of the curing salt and brine mixture, and by the kinds of woods burned in the smokehouse. And the longer the bacon and ham smoked, the better the meat kept and the more intense the flavor. A ham that's hung in a hickory-fired smokehouse for five years would probably keep forever—if people didn't keep whacking slices off for sandwiches.

Making Sausage

The follow-up to butchering often included making sausage. Sausage was usually made after it was cold enough for the meat to keep, and some families butchered several times during the winter, and made sausage afterward. Mary Djubenski made sausage for many years on her farm in Wisconsin, and still makes sausage with her family each year. She describes making meat and rice sausage:

"We make pork sausage on our farm by first grinding up the pork, and sometimes venison,

lard for cooking and soap for washing. Even the feet got pickled; everything Mr. Hog had to offer, minus the squeal, went to good use.

John Slauter tells about his family's experiences butchering hogs, which was part of how many, if not most, farm families were fed in the past. John tells it as follows:

Dancing Days

Farm families often played just as hard as they worked. One of the favorite social activities was dancing. Frieda Klancher recalls the dances of old times fondly, and still polkas regularly. "We usually had a dance every Saturday night, in Willard. There were two dance halls, and a dance at least at one of them. That was our only real form of entertainment. In those days, around here, it was pretty much polkas! One hundred peo- ple would show up, maybe more. The whole neighborhood would go, and the orchestra would be local people, too. They started at nine and ended at one in the morning. There was no such thing as baby-sitters then, so the whole family would go. You could buy beer and get a "lunch," hot dogs or a hamburger.

"All my brothers, my sister, and I loved to dance—still do to this day!"

Saturday night, when chores were done and the fire stoked up, the family would often pile into the wagon or the car and head to the dance hall. *J.C. Allen & Son*

You don't see much of the sun in January around Wahoo, Nebraska. On the days when you can even see it, the sun rises late—almost 8 A.M.—and seems cold and distant. It disappears before 5 P.M. after providing only nine hours of daylight. The cows and horses stay in the barn and farmers dream of Florida vacations and far-off spring.

February Is the Time To:
Fan grain.
Order seed.
Tap maples.
Curry the cows.
Bake a batch of biscuits.
Give the birds a handout.
Read 2 Corinthians 8:1-24.
Treat the horns of young calves.
Build an incubator for weak lambs.
Farm Journal, February 1953

and then adding all the seasonings. My daughter's family raises lots of hogs, and they butcher their own. And around here, a lot of the men like to hunt, and they like to make sausage and salami from the deer.

"We grind the meat and spread it on a big table about three inches thick, then the venison if we're going to use it. We mix it about half and half, when we have venison, but you can vary the proportions to suit yourself. Then we add the salt and pepper, and the garlic puree from the blender—we like that. Years ago we just used salt and pepper but now you can buy seasonings. Then we put them in a press and put the meat in casings. Then some of them will be smoked. We keep them in the freezer.

"Years ago, when I was young, we used to make something called Rice Sausage that used all the trimmings from the hog, and whatever else was around, plus rice. We didn't have freezers or refrigerators then so here's how my mom preserved the meat: First, she put the sausage in a large roasting pan, and

With a properly heated shop, winter was a good time to fix machines and work in the shop—it still is. *J. C. Allen & Son*

Chores were those activities that had to be done every day; rain or shine or snow. One of the most important was hauling feed to the animals. *J. C. Allen & Son*

put it in the oven to cook. She didn't allow it to finish cooking but took the meat out when it was about half done. Then the sausage was packed in jars and canned with the water-bath method. We smoked pork sausage, too, and put that in jars as well—100 quarts sometimes. That's a lot, but there were nine of use to feed!"🍓

Sugaring Time

Early farm families had no sweeteners for their food unless they made their own. The best way to do that, particularly in New England, was from the sap of the maple tree in late winter, as the juices start to flow. It takes a lot of sap to make much syrup, though, and much more than that to make concentrated maple sugar. But both are worth the effort.

Farm and bean field in Shabbona, Illinois. *Howard Ande*

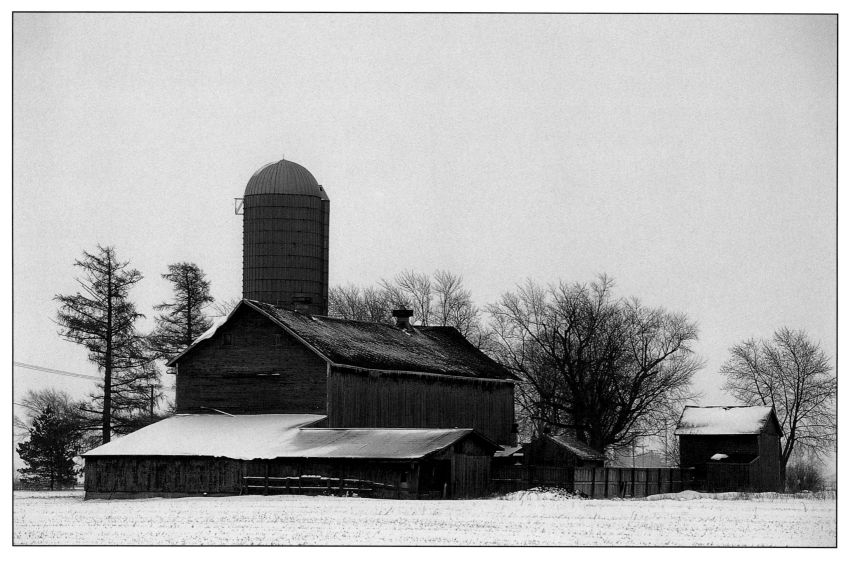

Farm near Virgil, Illinois in January.

Frieda Klancher spent most of her life farming in Willard, Wisconsin, a small Slovenian community in the north central part of the state. Her husband, Paul, made maple syrup each winter:

"My husband did the maple syruping, and it started in March, when the nights were still cold but the days turned warm. He took copper tubes and pounded them into holes in the maple tree, then hung pails on them and let them drip. We hung about fifty buckets, and they'd fill up fast. But it took an awful lot of sap—gallons and gallons—to make just one pint of syrup. You boil it down until it gets thick. Most people just make it for their own use; we never sold it but we gave some away as presents. My husband, Paul, had a big aluminum pan, with a fire underneath. He would have to keep it boiling all day, and two days sometimes. Then you pour it hot into the jars, and seal them." ❦

As described, the process isn't complicated: just bore a hole in a maple tree and catch the sap in a bucket. Then boil it down and you've got your sweet syrup or sugar. The only problem is that it takes a LOT of sap and a lot of attention to concentrate the material. This was yet another community event 200 years ago, when neighbors would gather to help with the sugaring. While some tended the fire under big pans of sap, others collected buckets, placed them on sleds, and brought them to a special little out building constructed for only this process. Over days or even weeks, one or two members of the family would tend the fire under the pan, feeding it with wood split and stacked nearby. Some sugaring houses

were equipped with bunks since the fire must be kept burning constantly and the attendants had to stay close by until the job was done. The result was a small hoard of wooden buckets full of thick, sweet, amber liquid to add to cornmeal mush or any other dish, a little luxury in the wilderness.

Feeding the Farm Family Today

Many farm families still put up their own food today, as in the past. Almost anybody with cattle will select a young steer for the larder, or a lamb or hog, just as before. The difference now, though, is that you will probably call a mobile slaughtering service to kill and cut up the animal; instead of a communal project of neighbors and family members cooperating and

Meat could be canned, smoked, or dried to preserve it. Another preservation possibility was to make it into sausage, especially those bits of the carcass that were too small to make into a meal. The girl on the left is feeding meat scraps into the hopper of a grinder while the man in the plaid shirt turns the handle. *J. C. Allen & Son*

Pork Sausage

32 lb. of lean ground pork
8 tbs. canning salt
2 1/2 tbs. black pepper
3–10 cloves garlic, chopped fine

Mix first three ingredients well. Add garlic to taste (fry sausage to taste). Add warm water until the sausage in the consistency of stiff oatmeal. Run through sausage machine and pack the sausage in casings 6 to 8 ft. long. Fold or tie the casings into 6 in. links.

To smoke the sausages, drape the strings of sausage over clean poles and hang in smokehouse. Use green wood (apple tree wood works well) and keep a smoldering, cool fire going. Smoke 4–6 hours for flavor, more to cure. Let hang overnight before freezing.

Courtesy of Frieda Klancher

socializing (and saving a little money). It is easier to call somebody else and pay them to do it. You end up with a small truck load of wrapped packages of meat ready for the freezer. It is quicker, cleaner, probably more sanitary, but without the cultural seasoning that is added when a tradition is maintained…or when you understand just what happens when a life is taken.

The tremendous economies farmers have brought to the business of agriculture have come home to roost at the farm house. Some families still cultivate big gardens full of tomatoes,

It was possible to preserve meat by canning it, another lengthy process that the lady is demonstrating. Partially cooked beef or pork could be put into jars and covered with meat broth. The sealed jars were then put into a pressure cooker or canning kettle like the one shown on the stove. *J. C. Allen & Son*

Not everyone had indoor plumbing and frequently the "indoor plumbing" was a pump just like this one inside the house. Drawing water from a well outside the house was a common chore for many kids back in the 1930s or even 1940s, but Mom's doing the duty this time. *J. C. Allen*

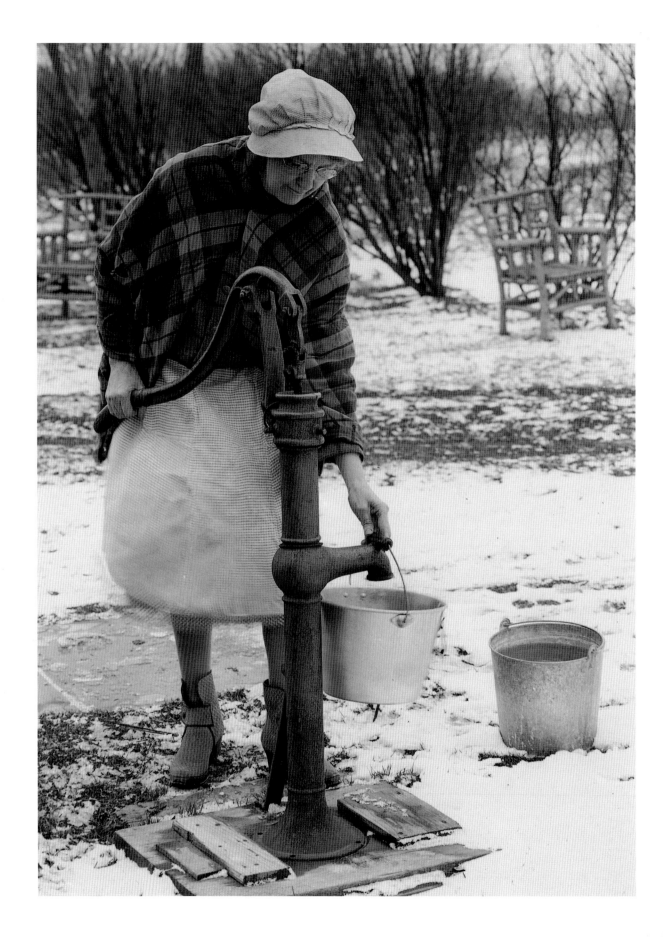

beans, peas, squash, and lettuce—but lots of folks today would rather stop by the Piggly Wiggley in town for the same items instead. Not the Amish, though, where wives still cultivate big gardens and put up huge supplies for the family's meals. Winter is indeed the time to sit around the stove at the store in town, visiting with neighbors and comparing notes on the season just finished and the year about to begin. Winter begins, according to the calendar, on the twenty-first day of December, the shortest day of the year. This is a season of suspended animation on most farms, particularly in the North. It is a time for Florida vacations, for restoring tractors in the barn. For dairy farmers it is a time to keep doing the same routine as the rest of the year, milking in the morning and again in the evening.

Winter is a resting time for people, stock, and the land in most parts of rural America. But there is still work in the field and in the barn on most places, and harvesting of some crops still proceeds. Orchards are pruned and sprayed in winter. Citrus fruit from Florida and the Southwest is harvested and sent to market. Dairy farms continue to churn out milk. Late winter is lambing time in the West, and the chickens don't lay as many eggs.

Winter could be party time in the heartland. While the extreme cold and deep snow could be deadly 150 years ago, the first snowfall often signaled the beginning of the best time for driving and visiting. The sleigh came out of the barn, the big lap robes came out of the blanket chest, and the best carriage horse was groomed and hitched. Then, on a cold, crisp December morning, the family piled in the sleigh for a long round of social

calls, dances, parties, receptions, concerts, school plays, dinners, courting, and shopping expeditions to town. The snow makes for easy footing for the horse, and on level ground the sleigh is an almost effortless load, even with Mother and Dad and a gaggle of children. Everybody snuggles up

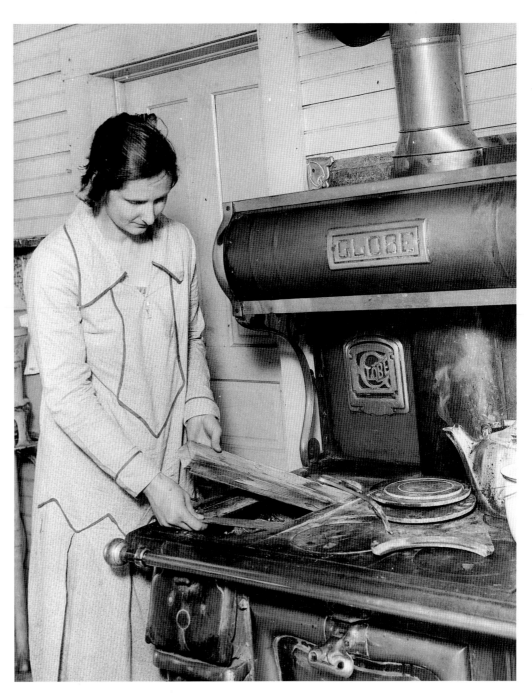

close under the lap robes, and little charcoal-burning foot warmers help ward off the cold. Bells on the horse's harness add a little music as the horse trots away the miles across the otherwise silent world. Winter, despite snow and cold, could be at time of joy.

Today it is sadly difficult to go visiting in a sleigh, but family farmers still do some visiting and partying. Even though a lot of crops are now harvested in winter, even though cows have to be

The first chore in the morning for the farm family was to turn up the fire in the big stove. Wood, split by one of the boys, provided all the heat for cooking and comfort in many homes of the past and present. *J. C. Allen & Son*

NEXT
Farm near Kent, Connecticut, in January. *Howard Ande*

Farm near Malta, Illinois, in January.
Howard Ande

milked, poultry fed, and equipment maintained, it is a season of resting for many American farmers. After nine months of hard work, some take off for vacation homes in warmer places. As Indiana farmer J. R. Gyger says, "My rotation plan is corn, soybeans, and *Florida*."

Life slows down in central Iowa in December, January, and February. Leland Boyd and his wife get away for a week or two, and there's always a week long meeting of the REC, a farm co-operative group, in February. Leland's on the board and winter is a good time to be indoors working on policy for the co-op.

Winter Harvests

While the Boyds, the Goods, and everybody else in middle America is freezing, the harvest season is just beginning for others. Oranges and lemons are ready to pick in California any time after Thanksgiving, and the harvest will continue for months. Cool weather crops like lettuce, broccoli, artichokes, asparagus, and cauliflower thrive in vast fields across Arizona, California, and Florida during the winter months. The early strawberry crop will get the farmer's attention

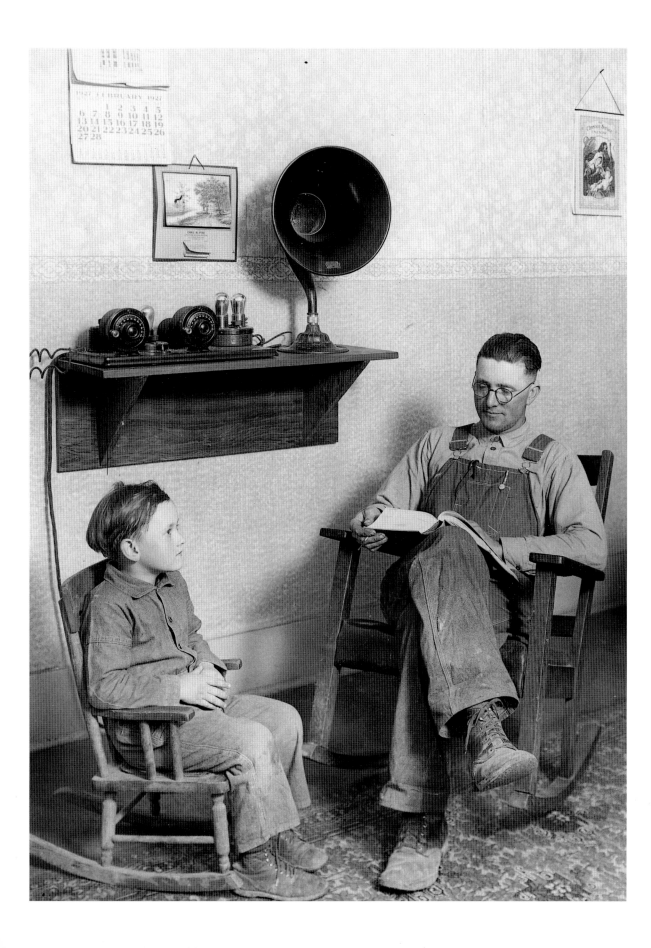

Listening to the radio and reading aloud were common activities in the evening. You had to sit pretty close to the old Atwater Kent to be able to hear well because the reception was not all that reliable, but it was like magic early in the century. *J. C. Allen & Son*

Winter is party time in farm country, past and present, a time to gather with friends and neighbors to celebrate the harvest, to eat and drink and dance. This man entertains the Pie Town, New Mexico, crowd with a jig in 1940. *Russell Lee/Farm Security Administration—Library of Congress*

now, too, and the harvest will begin in late winter or early spring.

On the Koster place, Billy spends much of this January straightening posts that will support new walnut trees. The posts are recycled from an earlier planting. The trees will be planted in February, if the rains hold off long enough. Everywhere on American farms, the American farmer is busy with winter work, getting ready for the new year just beginning.

Renewing the Cycle of the Seasons

Winter ends on the twenty-first of March, according to the calendar, with the vernal equinox. Out in Iowa, in the heartland of America, the sun crosses the horizon about a quarter after six in the morning. The Good family will be milking their cows, and Leland Boyd will be getting ready for spring plowing. The Yoders will feed the calves and if the fields aren't too muddy still, get to work on their plowing, too. Cliff and Onalee Koster will be watching the fruit trees closely and may get to do some spraying. On the first day of spring the air is suddenly, noticeably warmer, drier, and smells fresh. The apricot and apple orchards, in their regimental order, explode into glorious bloom again, a little green appears on the grape vines in Bill Garnett's vineyard. A new crop of lambs, all leggy and playful, appear on the emerald pastures of the West. On the One Bar Ranch, Jim Dunlap suddenly has dozens of beautiful new calves to attend to. Chickens everywhere start pumping out eggs. David and Stacey Nickell's horses start shedding their shaggy winter coats, and tractors roar to life after three months of confinement in the shed. Another spring begins on America's family farms.

Appendix

Reading and Resources

Anybody with an interest in traditional American family farming techniques and heritage will enjoy *The Small Farmer's Journal*, a very unusual magazine devoted primarily to horse-farming today. Editorial content varies widely, from reprints from old magazines and books to well-crafted essays from modern farmers; old or new, articles tend to be highly entertaining—and the extensive letter section is always a treat. No ads for combines or herbicides. Lots of interesting writing from all kinds of folks, young and old, who like to farm in traditional ways. There are very few magazines available anywhere that people devour, cover to cover, at a sitting, but this is one of them. SFJ is a phenomenon and a delight. $22 per year (at this writing); Small Farmer's Journal, P. O. Box 1627, Sisters, Oregon 97759.

Antique Power, a great magazine dedicated to old tractors and traditional farming from the 1930s, '40s, and '50s. Plenty of color and lots of legend and lore of early tractors. Some great stories, like Walt Buescher's Plow Peddler column. Antique Power, P. O. Box 562, Yellow Springs, Ohio 45387 (800) 767-5828.

Farm Shows

Farm shows are a phenomenon that seems to have started in the 1950s, just about the time a lot of people thought all the steam tractors were headed for the scrap pile and all the draft horses were going to work in a glue factory. Informal gatherings and demonstrations of farming tools and techniques started getting pretty popular. The steam tractors that had been in the back of the barn for thirty years got dusted off and fired up. The ones that didn't explode (and some did) chuffed and puffed to the delight of small but growing crowds. A few old threshing machines, and a few even older threshermen, were likewise dusted off and fired up to show how it all was done during the good old days. Those farm shows have since turned into a new tradition of their own. There are now hundreds of these events around the United States and Canada, in most states and in all seasons. For my money, they're more fun than any professional spectator sport, amusement park, or casino review.

Western Minnesota Steam Thresher's Reunion Rollag, Minnesota

Anybody who thinks the days of the steam tractor are over hasn't been to Rollag lately. This is where the iron monsters go to relive the days of steam power. And they live it up here in fine fashion every Labor Day weekend when over 100,000 people make the long pilgrimage to this little community up by the Canadian border. Another 1,500 locals help out with the show. It is the event of the year, out at the northern edge of the Great Plains.

Rollag is the steam-powered farming capital of the universe. Anything that moves with the help of hot water will be on display here, chuffing away and showing its stuff. That included more than 50 steam tractors at the 1995 show, plus steam "donkey" engines for the log derrick, a steam

locomotive on a track circumnavigating the grounds, and demonstrations of every kind of farm machine imaginable, all powered by steam, horse, or antique gasoline engine power.

Rollag is a huge show, and a delightful one that you can enjoy for three or four days and still not see it all. The crowd is predominately of Scandinavian ancestry—the Norwegian, Swedish, Danish, and German immigrants and their descendants who settled to this part of the world in the late 19th and early 20th century, making Rollag a cultural experience, too. American family farm heritage is preserved here in a charming, enduring way. But come early if you plan to park an RV because over a thousand families had the same idea last year and space filled up early.

Midwest Old Thresher's Annual Reunion
Mt. Pleasant, Iowa

Here's another monster show with just about every kind of obsolete technology on cheerful display. You'll see over a thousand stationary gas engines, hundreds of steam tractors, and many gasoline and distillate tractors from long ago. Like Rollag, this show has its own steam train line, with many operating locomotives and cars available for a ride. Eight old trolley cars putter around the track, too, and draft horses strut their stuff. You can eat yourself sick on all the barbecue, tenderloin, and home-brewed baked beans you can manage. Major country and western bands generally show up each year. So do the crowds, every Labor Day weekend.

Hamilton, Missouri

My very favorite farm show isn't one of the big ones where the crowds go, but a little local event held annually in the old Missouri backwoods town of Hamilton. The Hamilton show is much more like the traditional gathering of farm neighbors typical of 50 years ago, and it draws primarily from the farmers in the immediate vicinity of this old little town. There are plenty of tractors, but not the hundreds you'll see at Rollag or Mt. Pleasant. Instead of 50 steam tractors there will be only two or three, perhaps half a dozen. But there, those steamers will all be working, powering a threshing machine, a sawmill, or plowing. You can visit with the owners and maybe get a little driving lesson. Attendance was about 7,500 last year, over three days; the big shows have more vendors than Hamilton gets at the gate.

Very few tourists attend so the crowds are small. You can see the action, visit with the owners and operators, and get a good sense of how things were done. The pork tenderloin sandwiches are tasty and cheap, and you don't need to stand in line for half an hour to get one. But you do have to drive a bit because Hamilton is in farm country, not an amusement park, about 60 miles northeast of Kansas City, Missouri.

The Saturday afternoon "Parade of Power" includes anything on wheels that the owner wants to show off—and that always includes beautifully restored tractors of all shapes and sizes, older tractors that the owner thinks are interesting, a rich variety of antique automobiles, and (best of all) the

little kids on the pedal cars and tricycles. While some of the machines are a bit modern, the sense of community and small-town hospitality are right out of a Norman Rockwell painting, pure American and deep-dish traditional. Come to think of it, maybe I shouldn't recommend the Hamilton show—it is perfect just the way it is, without the crowds.

Well, you can come to Hamilton if you want to, but there is probably a little farm show right in your neighborhood, just as much fun. They don't usually get very much publicity, and that's a shame, but there are a lot of them. Most, but not all, can be found in the annual directory of these events, the *Stemgas Directory*.

Stemgas Directory
Stemgas Publishing Company, P. O. Box 328, Lancaster, Pennsylvania 17608.

The Hamilton show is only one of dozens or even hundreds of such community gatherings around the country, many listed in the *Stemgas Directory* of farm shows.

Living History Farms and Museums
During the past 10 years or so a number of demonstration or "living history" farms have been developed around the country. These places are educational theme parks intended to show how farming was done in the past, and they are partly successful. They typically are a little too clean and tidy for my tastes. As far as I'm concerned, they'd let the kids watch a pig getting butchered once in a while, and maybe install some privies to replace them modern water closets, if they really wanted to recapture the past. The aroma of a ripe privy or a well-stocked pig pen is the kind of thing that could leave a lasting memory of life in days gone by. Maybe sex education classes ought to watch a stallion cover a mare—and the birth of the foal the next year. And those kids who don't want to help with the weeding might get some valuable lessons from a trip behind the woodshed, a familiar experience to many farm lads. So the experience is sanitized a bit, but it is still a fascinating look at life in the past.

Farm Museum Directory
Stemgas Publishing Company, P. O. Box 328, Lancaster, Pennsylvania 17608.

Stemgas also published a guide to living history and other agricultural museums across the United States.

Index